Photographer's Guide to the Panasonic Lumix LX5

Photographer's Guide to the Panasonic Lumix LX5

Getting the Most from Panasonic's Advanced Digital Camera

Alexander S. White

White Knight Press
Henrico, Virginia

Published by
White Knight Press
9704 Old Club Trace
Henrico, Virginia 23238

ISBN: 978-0-9649875-9-3

Printed in the United States of America

This book is dedicated to my wife, Clenise.

Contents

Author's Note and Acknowledgments 13
Introduction 15
1. Preliminary Setup 18
 Charging and Inserting the Battery 19
 Inserting the Memory Card 21
 Setting the Language, Date, and Time 25
2. Basic Operations 27
 Taking Pictures 27
 Fully Automatic: Intelligent Auto Mode 27
 Basic Variations from Fully Automatic 30
 Focus 31
 Manual Focus 35
 Exposure 37
 Exposure Compensation 37
 Flash 39
 Motion Picture Recording 41
 Viewing Pictures 43
 Basic Playback 43
 Playing Movies 46
3. The Recording Modes 49
 Preliminary Steps Before Shooting Pictures 50
 Intelligent Auto Mode 51
 Program Mode 54
 Aperture Priority Mode 56
 Shutter Priority Mode 61
 Manual Exposure Mode 65
 Scene Mode 67
 Portrait 69
 Soft Skin 70
 Self-Portrait 70
 Scenery 70
 Panorama Assist 71
 Sports 72
 Night Portrait 72
 Night Scenery 72
 Food 73
 Party 73
 Candle Light 73

Baby 1 and Baby 2 73
Pet 74
Sunset 74
High Sensitivity 75
Hi-Speed Burst 76
Flash Burst 77
Starry Sky 77
Fireworks 78
Beach 78
Snow 79
Aerial Photo 79
My Color Mode 79
Expressive 82
Retro 82
Pure 83
Elegant 83
Monochrome 84
High Dynamic 84
Dynamic Art 86
Dynamic (B&W) 87
Silhouette 87
Pin Hole 88
Film Grain 88
Custom 89
4. The Recording Menu 91
Film Mode 94
Picture Size 99
Extra Optical Zoom 100
Digital Zoom 102
Quality 102
Sensitivity 104
ISO Limit Set 106
ISO Increments 107
White Balance 107
White Balance Bracket 110
Face Recognition 111
Autofocus Mode 112
Face Detection 112
AF Tracking 113
23-Area 113
1-Area 114
Pre AF 115
AF/AE Lock 116
Metering Mode 116

Intelligent Exposure 119
Multiple Exposure 120
Minimum Shutter Speed 121
Burst 122
Intelligent Resolution 123
Intelligent Zoom 124
Digital Zoom 124
Step Zoom 125
Stabilizer 125
Autofocus Assist Lamp 126
Flash 127
Flash Synchro 129
Flash Adjustment 130
Red-eye Removal 131
Optional Viewfinder 132
Conversion 133
Auto Bracket 133
Aspect Bracket 134
Clock Set 135
5. Other Controls 136
Aspect Ratio Switch 136
Autofocus Switch 137
Flash Switch 137
Mode Dial 138
Shutter Button 138
Zoom Lever 139
Power Switch 139
Play Button 140
Rear Dial 140
Exposure Compensation 141
Program Shift 141
Quick Menu/Trash Button 143
Quick Menu Function 143
Trash Function 145
AF/AE Lock Button 145
Five-Button Array 146
Top Button: Focus 147
Right Button: ISO 148
Down Button: Fn 148
Left Button: Self-Timer 149
Center Button: Menu/Set 150
Display Button 150
6. Playback 153
The Playback Menus 154

The Playback Mode Menu 155
 Normal Play 155
 Slide Show 156
 [Play] All 156
 Play Picture Only/Video Only 158
 Category Selection 158
 Favorite 159
 Other Playback Modes 160
 Mode Play 160
 Category Play 160
 Favorite Play 161
The Playback Menu 161
 Calendar 162
 Title Edit 162
 Video Divide 163
 Text Stamp 164
 Resize 165
 Cropping 166
 Leveling 166
 Rotate Display 167
 Favorite 168
 Print Set 169
 Protect 170
 Face Recognition Edit 170
 Copy 171
7. The Setup Menu 172
 Clock Set 173
 World Time 173
 Travel Date 174
 Beep 174
 Volume 175
 Custom Set Memory 175
 Fn Button Set 179
 LCD Mode 179
 Display Size 180
 Guide Line 180
 Histogram 181
 Recording Area 183
 Remaining Display 183
 Highlight 183
 Lens Resume 184
 Manual Focus Assist 184
 Economy 185
 Play on LCD 185

Auto Review 185
Start Mode 186
Number Reset 187
Reset 187
USB Mode 187
TV Aspect 188
HDMI Mode 188
VIERA Link 188
Scene Menu 189
Menu Resume 189
User's Name Recording 190
Version Display 190
Format 191
Language 191
Demo Mode 192
8. Motion Pictures 193
Basics of LX5 Videography 194
Choosing the Shooting Mode 194
The Motion Picture Menu 199
 Film Mode 200
 Recording Mode 201
 Recording Quality 201
 Exposure Mode 202
 Sensitivity 203
 ISO Limit Set 203
 ISO Increments 203
 White Balance 203
 AF Mode 203
 Continuous AF 204
 AF/AE Lock 204
 Metering Mode 204
 Intelligent Exposure 204
 Intelligent Resolution 205
 Intelligent Zoom 205
 Digital Zoom 205
 Stabilizer 205
 AF Assist Lamp 205
 Conversion 205
 Wind Cut 206
Recording Time 206
Dealing with Purple Lines 207
Recommendations for Recording Video 208

9. Other Topics 210
 Macro (Closeup) Shooting 210
 Using RAW Quality 212
 Using Flash 214
 Infrared Photography 217
 Street Photography 219
 Making 3D Images 221
 Digiscoping and Astrophotography 223
 Connecting to a Television Set 227
Appendix A: Accessories 229
 Cases 229
 Batteries 230
 AC Adapter 230
 Viewfinders 232
 Add-on Filters and Lenses 234
 External Flash Units 237
 Cable Release Adapter 240
Appendix B: Quick Tips 241
Appendix C: Resources for Further Information 246
Index 250

Author's Note and Acknowledgments

In October 2009, I published my first camera book, *Photographer's Guide to the Leica D-Lux 4*, which I followed in July 2010 with a similar book about Panasonic's Lumix DMC-LX3, which is in most respects identical in features and operation to the D-Lux 4. When the Panasonic Lumix DMC-LX5 began shipping in the United States at the end of August 2010, I could not resist turning my attention to that camera for another book, because of my familiarity with its predecessor. (There was no DMC-LX4, because the number 4 is considered unlucky or undesirable in some parts of Asia.)

I began this book in September 2010, as soon as I was able to get my hands on an LX5, so all of the information here is based on an early production model of the camera. All of the photographs illustrating the camera's features are ones that I took with my LX5; the photographs showing the LX5 itself were taken with my Sony Alpha DSLR-A850.

With respect to the contents of the book, I have tried my best to provide accurate information, but inevitably there may be mistakes or typographical errors. I would greatly appreciate hearing from any readers who find such errors, or who have comments on the book. Please provide any comments at http://www.whiteknightpress.com. I will try to post errata and updates on that site from time to time.

In writing this book, I have been fortunate enough to have assistance from a number of dedicated users of Panasonic cameras who read a draft and provided tremendously useful comments. I am extremely grateful to them for their insights

and suggestions for improving the text. I am particularly indebted to Gary Babcock, Michael Benedik, Clare Din, Thomas Falzone, Guy Parsons, and Ragnar Våga Pedersen.

Finally, as always, my most supportive and encouraging partner in this endeavor has been my wife, Clenise, who not only edited the final text, but who provides inspiration, both photographic and personal, every single day.

Introduction

This book is a guide to the operation, features, and capabilities of the Panasonic Lumix DMC-LX5, one of the most sophisticated "point-and-shoot" digital compact cameras available today. I chose this camera to write about partly because of my experience with its predecessor, the DMC-LX3/Leica D-Lux 4, but also because this camera stands out from the broad run of compact cameras for several reasons.

Consider the list of features you don't find every day in a compact camera that is not a DSLR (digital single-lens reflex): RAW shooting mode; complete manual control of exposure and focus; burst capability for continuous shooting; a large, 3-inch (7.6 cm) diagonal and very sharp (more than 460,000 pixels) LCD screen; a high-quality Leica-branded lens with a wider-angle-than-ordinary 24mm equivalent focal length and a faster-than-ordinary f/2.0 - f/3.3 maximum aperture; HD (high-definition) motion picture recording with advanced features; excellent overall image quality, owing in part to the high quality of its "intelligent" exposure and focus controls and image processing; and excellent performance in low light, owing in part to its fine performance at high ISO (light sensitivity) levels.

Moreover, the LX5 has a CCD (charge-coupled device) light sensor considerably larger than those of most other "point-

15

and-shoot" cameras, resulting in greater image quality.

The LX5 also has a solid feel, partly because of its metal body and classic appearance. Many photographers will welcome the inclusion of physical switches to control many functions, so they don't have to navigate through menus to change the aspect ratio, focus mode, ISO, and other settings. And, in addition to its useful pop-up flash, the camera is equipped with a hot shoe, which accepts powerful external flash units that communicate with the camera for automatic flash control.

Also, the LX5 includes the basic functions that all cameras in its class have: self-timer, macro (closeup shooting) mode, a wide range of shutter speeds (1/4000 second to 60 seconds), and many different "scene" modes (portrait, night scenery, fireworks, scenery, food, pet, beach, baby, etc.).

Is anything lacking in the LX5? Some people would prefer a lens that goes beyond the 90mm equivalent of its maximum optical zoom; others would like a built-in optical viewfinder. Of course, the camera does not accept interchangeable lenses, and is equipped with a digital sensor, which, although larger than average for a camera of this type, cannot provide the image quality of the larger sensors found on DSLRs. It could use better audio recording features to support its video capability.

But given that no camera can meet every possible need, the LX5 is an outstanding example of an advanced compact camera. It received an enthusiastic welcome by many photographers upon its release, sometimes to supplement a DSLR for occasions when it's inconvenient to carry a heavy load of gear, and sometimes as the photographer's only equipment to record vacation and family scenes. If you carry this camera with you, you will be ready to record a breaking news event (with still photos or movies), to capture an especially appealing scenic view that catches your eye, to grab spontaneous "street photography" shots, or to experiment with the camera's many fea-

tures to try new combinations of color effects, shutter speeds, and other settings from the LX5's wide array of possibilities.

This camera's quality and features have made it a winner by many measures. However, the documentation that comes with it does not always do justice to its capabilities. In addition, the documentation is split between a brief printed pamphlet and a much longer, but less convenient document that is provided on the CD-ROM that ships with the camera. I find it's a lot easier to learn about a camera's features from a single book, with illustrations, taking the time to explain the features fully and clearly. That is the purpose of this book.

My goal is to provide a solid introduction to the LX5's controls and operation along with tips and advice as to when and how to use the various features. This book does not provide advanced technical information. If you already understand how to use every feature of the camera and when to use it and are looking for new insights, I have included some references in the Appendices that can provide more detailed information. This book is geared to the beginning to intermediate user who is not satisfied with the documentation provided with the camera, and who is looking for a reference guide that provides some additional help in mastering the camera's features.

One final note: As I write this in fall 2010, Leica has started shipping the D-Lux 5, its version of the Lumix LX5. I plan to publish a revised version of this book covering the D-Lux 5 before the end of 2010 if possible. However, because that camera is practically identical in features and operation to the LX5, the information in this book about the LX5 should be useful to D-Lux 5 owners as well.

Chapter 1: Preliminary Setup

I will assume your LX5 has just arrived at your home or office, perhaps purchased from an internet site. The box should contain the camera itself, lens cap, lens cap string, battery, battery case, battery charger, neck/shoulder strap, USB cable, A/V cable, SilkyPix and PHOTOfunSTUDIO software on one CD, the longer user's manual on another CD, and one or two other pieces of paper, such as a warranty card.

One of the first things you should do with your new camera is attach the lens cap string, a small loop supplied in a plastic envelope that is easy to overlook. Loop it through the small opening on the lens cap and then through the neck-strap bracket closest to the lens. Now your lens cap will be attached to the camera and can't be misplaced.

Some people don't like the removable lens cap provided with the LX5, because the cap has to be removed when you take a picture, may bother you as it dangles while you aim and focus, and has to be put back on the lens when you're done. I haven't found the cap to be a problem, because I'm used to cameras with removable lens caps. I see the point, though, because many other small cameras have built-in lens covers that automatically open up when you turn on the camera and close back down when the camera is turned off.

Some users of this camera deal with the lens cap situation by

attaching the lens cap string to the right-side neck strap bracket rather than the left, so it's easy to hold the cap in the right hand while shooting, to keep it from flapping around.

If the lens cap situation really bothers you, there are "automatic" lens caps available for the LX5, as there were for the earlier model, the LX3. This sort of cap has leaves that open up as the lens extends, so the cap can stay on and open and close as needed. I have not tested one myself, but you can find them by searching on eBay for "LX5 automatic lens cap." One company that offers this sort of product is at www.jjc.cc.

As for the neck strap, it is quite useful when you're carrying the camera outside of its case, but I have found the strap to be a nuisance when placing the LX5 into its case, because of the strap's bulk. You might want to look for a wrist strap instead, which gives you a way to keep a tight grip on the camera but doesn't make it difficult to stow the camera safely in a case.

Charging and Inserting the Battery

The LX5 ships with a single rechargeable Lithium-ion battery, the DMW-BCJ13PP. You can't use batteries from earlier models, such as the LX3. This battery has to be charged in an external charger; you can't charge it in the camera, even if you connect the camera to the optional AC adapter. So it's a very good idea to get yourself an extra battery. I'll talk about that later. For now, let's get the battery charged.

You can only insert the battery into the charger one way; look for the set of four goldish-colored metal contact strips on the battery, then look for the corresponding set of contacts (three, not four) inside the charger, and insert the battery so the two sets of contacts will connect up.

With the battery inserted, plug the charger into any standard AC outlet or surge protector. The green light comes on to indicate that the battery is charging. When the green light turns off, after about two and a half hours, the battery is fully charged and ready to use.

Once you have a charged battery, look for the little gray latch on the memory card/battery door on the bottom of the camera. Push the latch to the left to spring the door, and let it open up. To insert the battery, look for the sets of metal contacts on the battery and inside the battery compartment, and guide the battery accordingly. You may need to use the right side of the battery to nudge the gray latching mechanism inside the battery compartment to the right, to allow the battery to slide in.

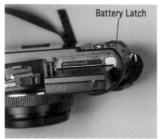

Slide it all the way in until the gray internal latch catches above the battery and locks it in place. Then close the battery compartment door, slide the external latch back to the right, and you're done.

Inserting the Memory Card

The LX5 does not ship with any memory card. With this camera, unlike some others, this is not a fatal omission, because the LX5 has built-in memory that will let you take a few photographs even with no memory card inserted. The amount of built-in storage capacity is only about 40 megabytes (MB), which is pretty minuscule compared to storage cards of today that can hold up to 64 gigabytes (GB), or about 1,500 times 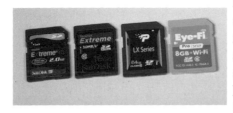 more. But if you're in a situation where you need to take a picture and don't have an available card, 40 MB is a lot better than nothing. (If you do record some images to the built-in memory, you can later copy them to a removable memory card; see the discussion of the Copy command at the end of Chapter 6.)

You shouldn't rely on the built-in memory if you don't have to, so you need to insert a separate memory card. The LX5 uses three varieties of card: Secure Digital (SD), Secure Digital High-Capacity (SDHC), and Secure Digital Extended Capacity (SDXC). The image above shows all three of these, from left to right, along with a special type of SD card, the Eye-Fi card, which I'll discuss a little later.

All three types of SD card are small, about the size of a large postage stamp. The standard card, SD, comes in capacities from 8 MB to 2 GB. The high-capacity card, SDHC, comes in sizes from 4 GB to 32 GB. The newest type, SDXC, at this writing is available only in a 48 GB or 64 GB size, though its maximum capacity theoretically is 2 Terabytes, or about 2,000 GB. What type and size of SD card you should use depends on your needs and intentions. If you're planning to record a good

21

deal of high-definition (HD) video or many RAW photos, you need the biggest card you can afford. There are several variables to take into account in computing how many images or videos you can store on a particular size of card, such as the aspect ratio you're using (1:1, 3:2, 4:3, or 16:9), picture size, and quality. To cut through the complications, here are a few samples of what can be stored on a given card. If you're taking RAW images at the highest quality in the 4:3 aspect ratio (that is, the image is 4 units wide for every 3 units high), you can store just 2 images in the built-in memory, but you can store 9 of the largest JPEG images in Fine quality or 400 images of the smallest size and lowest quality. I often use a 16 GB SDHC card. Given the conditions just mentioned, it can store 1,260 RAW images, 3,680 of the largest Fine-quality JPEG images, or 123,540 of the lowest-quality images.

If you're interested in video, here are some guidelines. You can fit only 2 or 3 minutes of HD video on a 512 MB card, but you can store one or 2 hours of it (depending on format) on a 16 GB card. (Note: you can't record much video at all to the built-in memory; you can record about one and a half minutes in the lowest quality; you can't record in any other quality of video to the built-in memory.)

One other consideration is the speed of the card. I'm currently using a 16 GB SanDisk Extreme card, Class 10, rated at a transfer level of 30 MB/second, well beyond the minimum transfer speed for that class of 10 MB/second. That speed is more than enough to get good results for recording images and video with this camera. You should try to find a card of Class 6 or higher if you're going to record HD video.

Also, you need to realize that, if you have an older computer with a built-in card reader, or just an older external card reader, it may not read the newer SDHC cards. In that case, you would have to either get a new reader that will accept SDHC

cards, or download images from the camera to your computer using the camera's USB cable.

Using the newest variety of card, SDXC, can be even more problematic; at this writing there are compatibility issues with some computers. I recently tried a 64GB SDXC card, and my MacBook Pro could not read it at all at first, even when I left it in the camera and connected the camera to the computer by USB cable. I eventually found an SD card reader, the Sonnet 21-in-1 ExpressCard/34 Memory Card Reader & Writer, that could read all the images and movies from the SDXC card on my MacBook Pro, with a software driver provided on the company's web site at www.sonnettech.com. I was fortunate that my computer has an ExpressCard/34 slot, which not that many Mac computers have nowadays. As an added benefit, after I downloaded the driver from the sonnettech.com site, my computer was able to read the files from the SDXC card when the camera was connected to the computer by its USB cable, without even using the ExpressCard reader.

The situation with Windows is less troublesome: The images on the card were easily readable by a notebook PC using Windows 7, when the camera was connected by the USB cable or with any SDXC-compatible card reader. As I write this, though, SDXC cards cost at least $200.00, and usually more, so I don't recommend getting one until the prices come down, unless you absolutely need the 48 GB or 64 GB storage capacity, and can deal with the compatibility issues.

Finally, if you will have access to a wireless (Wi-Fi) network where you use your camera, you may want to consider getting an Eye-Fi card. This special type of storage device looks very much like an ordinary SDHC card, but it includes a tiny transmitter that lets it connect to a wireless network and send your images to your computer on that network as soon as the images have been recorded by the camera.

I have tested my 8 GB Eye-Fi card, the Pro X2 model, with the LX5, and it worked well. As soon as I snap a picture, a little thumbnail image appears in the upper right corner of my computer's screen showing the progress of the upload. When all images are uploaded, they are available in the Pictures/Eye-Fi folder on my computer. The Pro X2 model can handle RAW files and video files as well as the smaller JPEG files. (At this writing, the Pro X2 is the only variety of Eye-Fi card that can handle RAW files.) An Eye-Fi card is not a necessity, but I enjoy the convenience of having my images sent straight to my computer without having to put the card into a card reader or to connect the camera to the computer with a USB cable.

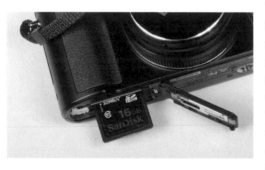

Whatever type of SD card you get, once you have the card, open the same little door on the bottom of the camera that covers the battery compartment and slide the card in until it catches. The card goes in with its label facing the battery. Once the card has been pushed down until it catches, close the compartment door and push the latch back to the locking position. To remove the card, you push down on it until it releases and springs up so you can grab it.

One note for when you're shooting pictures with the camera: When it's recording to an SD card, a red icon appears on the right side of the screen showing an arrow pointing to the right inside a little box representing the SD card.

If no SD card is in the camera, the red card icon flashes with the word "IN" added, showing that the camera is recording to the built-in memory instead of to a memory card.

When that indicator is lit, it's important not to turn off the camera or otherwise interrupt its functioning, such as by taking out the battery or disconnecting an AC power adapter. You need to let the card complete its recording process in peace.

Setting the Language, Date, and Time

It's important to make sure the date and time are set correctly before you start taking pictures, because the camera records that information (sometimes known as "metadata," meaning data beyond the data in the picture) invisibly with each image, and displays it later if you want. Someday you may be very glad to have the date (and even the time of day) correctly recorded with your archives of digital images.

25

To get these basic items set correctly, remove the lens cap and turn the camera's power switch, on the top right of the camera, to the On position. Then press the Menu/Set button (in the center of the array of five buttons on the camera's back). Push the left cursor button to move the selection triangle into the column for selecting the menu type (Record, Motion Picture, Scene, Play, or Setup, depending on the mode the camera is in). Push the down cursor button to highlight the wrench icon that represents the Setup menu. Push the right cursor button to enter the list of Setup menu items.

Highlight Clock Set, then push the right button to get access to the clock and date settings. Navigate with the left and right cursor buttons and select values with the up and down cursor buttons. When you're done, press Menu/Set to save the settings. Then navigate to the Language option if necessary and change the language.

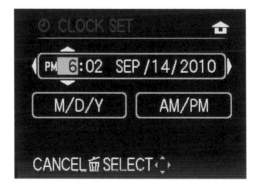

Chapter 2: Basic Operations

Taking Pictures

Now the camera has the correct time and date set and has a fully charged battery inserted, along with an SD, SDHC, or SDXC memory card. Let's look at some scenarios for basic picture-taking. For now, I won't get into discussions of what the various options are and why you might choose one over another. I'll just lay out a reasonable set of steps that will get you and your camera into action and will deposit a decent image on your memory card.

Fully Automatic: Intelligent Auto Mode

Here's a set of steps to follow if you want to set the camera to its most automatic mode and let it make all the decisions for you. This is a good way to go if you're in a hurry and need to grab a quick shot without fiddling with settings, or if you're new at this and would rather let the camera do its magic without having to provide much input.

1. Look on the top of the lens barrel for the slide switch that selects among the four possible aspect ratios: 1:1, 4:3, 3:2,

and 16:9. Unless you know you want one of the other three aspect ratios, slide the switch over to the third position from the left to select the 3:2 aspect ratio for now. That aspect ratio is similar to that of standard 35mm film, and produces an image the same shape as the camera's LCD screen. It also is the best choice if you're going to take your memory card to a photo lab for standard-sized prints of 6 inches by 4 inches in the U.S.

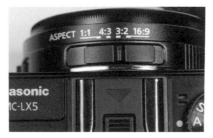

2. Remove the lens cap and let it dangle by its string (or cup it in your hand to keep it from flapping around).

3. Move the power switch at the right side of the camera's top to the On position. The camera makes a whirring sound, the lens extends outward to its open position, and the LCD screen lights up.

4. Turn the black, ridged dial on the camera's top (the Mode dial) so the "iA" inside an icon of a camera body is next to the white dot to the left of the dial. This sets the camera to the Intelligent Auto mode of shooting.

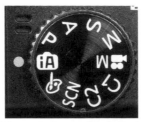

5. Find the slide switch on the left side of the lens barrel and notice it has three settings, reading from top to bottom: AF, AF macro (with image of flower), and MF. Slide the switch

to its uppermost position, AF, for autofocus. With this setting, the camera will do its best to focus the lens to take a sharp picture within the normal (non-macro) focus range, which is from 1.64 feet (50 centimeters) to infinity.

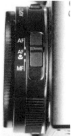

6. If you're taking a picture indoors, or it's dark enough that you think you might need the camera's built-in flash, find the little slide switch next to the word "Open" and the little lightning bolt on the far left side of the top of the camera. Push that switch to the right, and the flash will pop open. The camera will decide later whether the flash needs to be fired or not.

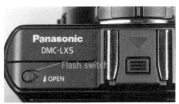

7. Aim the camera toward the subject and look at the screen to compose the picture as you want it. Locate the Zoom lever on the ring that surrounds the shutter button on the top right of the camera. Push that lever to the left, toward the W, to get a wider-angle shot (including more of the scene in the picture), or to the right, toward the T to get a telephoto, zoomed-in shot.

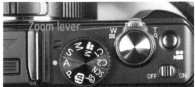

8. Once the picture looks good on the LCD screen, push the shutter button halfway down. You should hear a little beep and see a steady (not blinking) green dot, indicating that the picture will be in focus. (If you hear a series of 4 quick beeps, that means the picture is not in focus. Try moving to a slightly different angle and then test the focus again by pushing the shutter button halfway down.)

9. Push the shutter button all the way down to take the picture.

Basic Variations from Fully Automatic

At this point I won't say much about the various still-picture shooting modes, except to name them. Besides Intelligent Auto, which I just described, there are Program, Aperture Priority, Shutter Priority, Manual, and Scene. There are also two Custom modes, C1 and C2, which you can set up yourself, and the My Color mode, which gives you some creative options for the look of your images. I'll talk about all of those shooting modes later on. For now, I'm going to discuss the various functions and features of the LX5 that you can adjust to suit whatever picture-taking situation you may be faced with. Not all of the settings can be adjusted in Intelligent Auto mode, so we'll set the camera down to the next lower level of automation, to the Program mode. In that mode, you'll be able to control most of the camera's functions for taking still pictures, but the camera will still adjust the exposure for you.

I'm not going to repeat the basic steps for taking a picture, because those were pretty basic. If you need a refresher on those steps, see the list in the above discussion of Intelligent Auto mode.

Start by setting the Mode dial on top of the camera to P, for Program.

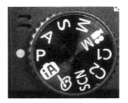

You will immediately see some different indications on the LCD screen, to show that some of the Intelligent Auto mode settings have changed, because you now have much more control over matters such as picture size and quality, white balance, and others. Using the Program setting, the camera will determine the proper exposure, both the aperture (size of opening to let in light) and the shutter speed (how long the shutter is open to let in light). In this mode you won't be making decisions about those settings; you will have control over those decisions in other modes, which I'll discuss later. That still leaves lots of choices you can make, though, so let's talk about the various settings you can adjust in Program mode.

Focus

Now that you're not using Intelligent Auto mode, you have control over focus. Your first choice is between manual focus and autofocus. In other words, you have the option of setting the autofocus switch on the left side of the lens barrel to the MF setting, for manual focus. (If you try that in Intelligent Auto mode, you'll get an error message on the LCD screen.) You also have the ability to select which of several types of autofocus operation you want the camera to use.

I'll discuss the various autofocus modes later in some detail. Here we'll use the camera's menu system to make sure a standard autofocus mode is selected.

To enter the menu system, locate the circular group of five buttons to the right of the LCD screen.

The center button is marked Menu/Set. Press in on that button and you will see the menus. You navigate through the menus with the five buttons, as well as the button at the lower right of the camera's back, next to a trash can icon. The button beside the trash can icon, in this context, acts as a "cancel" button.

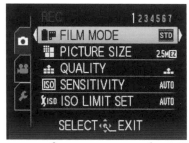

When the menu system first appears on the LCD, you should see the Film Mode setting on the top line of the Recording menu. Press the down cursor button (the one directly below the Menu/Set button) several times to navigate down to the line that says AF Mode. Press the right cursor button (the one directly to the right of the Menu/Set button) to navigate to a sub-menu that shows an array of the various autofocus modes. You navigate among those modes by using the up and down cursor buttons.

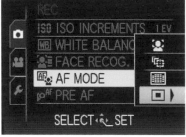

Go ahead and select the bottom icon in the vertical array of autofocus modes. This icon is a rectangle with a smaller rectangle inside it. You may need to consult the full user's manual at page 134 to translate these icons; this one means "1-Area." In this mode, the camera will autofocus based on whatever is shown in the one area in the center of the screen. If you want

to get a bit fancier, once you have moved to this icon, you can press the right cursor button, which will take you to a screen where you can move the focusing box around and place it where you want it over the image. If you don't want to do that, then go ahead and press the Menu/Set button to select the "1-Area" autofocus mode and exit the menu system.

Okay, we have selected our autofocus mode, which, in this case, will display a focusing bracket in the center of the screen. (In some modes, no bracket is displayed until after focus is achieved.) When you aim the camera at a subject, be sure that the focus bracket, outlined by four white corners, is over the part of the picture that needs to be in the sharpest focus. When you press halfway down on the shutter button, if the camera is able to focus successfully, you will hear a beep, the white brackets will disappear, and a large green dot will appear, unblinking. If you see a blinking green dot, that means the camera was not able to focus, either because the subject was outside of the focus range, or, perhaps, the subject was too difficult to focus on, as can happen with a subject that is too bright or too fast, lacks contrast, is behind glass, or is too dark. If everything looks okay to you, go ahead and press the shutter button all the way down to take the picture.

Suppose you want to take a picture in which your main subject is not in the center of the screen. Maybe your shot is set up so that a person is standing off to the right of center, and there is some attractive scenery to the left in the scene. One way to focus on the person on the right is to use the technique described above: that is, to go into the menu system, select this autofocus mode, and then press the right cursor button to move the focusing brackets over to the area of the subject.

Here's another, easier way to do this. Aim the camera at the subject, then press the little button labeled "Focus," which is also the top cursor button in the array of five buttons on the back of the camera.

When you press that button, you will see the focus area outlined in yellow, and you can move the focus block to various locations on the screen with the four cursor buttons. You can also change its size by turning the rear dial, at the top right of the camera's back, to one of four positions, producing a focus block from very small to extra large.

Once you have the focus area located where you want it and at your chosen size, press the Menu/Set button to lock in your selections. Then go ahead and snap the picture.

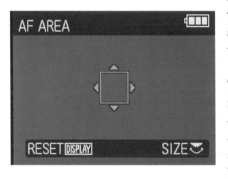

There's one more way to focus on a different area of the screen, and this one is probably the easiest of all. Place the focus brackets over the part of the picture that needs to be in focus: in our example, the person to the right. Then press the shutter button halfway down until the camera focuses and beeps. Keep the button pressed halfway while you move the camera back to create your desired composition, with the person off to the right. Then take the picture, and the area you originally focused on will be in focus. With this method, though, you need to realize that the half-press of the shutter button locks the exposure as well as the focus. If the exposure is different at the point where you locked focus from what it is at the location where you will take the picture, you may need to use exposure compensation to adjust your final image.

Manual Focus

There are several other autofocus modes, but I won't discuss those at this point. I'll talk instead about manual focus, the other major option for focusing. Why would you want to use manual focus when the camera will focus for you automatically? Many photographers like the amount of control that comes from being able to set the focus exactly how they want it. And, in some situations, such as when you're shooting in dark areas or areas behind glass, where there are objects at various distances from the camera, or when you're shooting a small object at a very close distance, and only a narrow range of the subject can be in sharp focus, it may be useful for you to be able to control exactly where the point of sharpest focus lies.

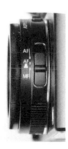

To take advantage of this capability, go to the autofocus slide switch on the side of the lens and push it all the way down to MF, which puts the camera in manual focus mode. Instead of relying on the camera to focus automatically, you now need to use the rear dial (which we just used to change the size of the focus block) to adjust the focus manually. You can also use the left and right cursor buttons to fine-tune the focus to its optimal sharpness.

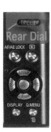

After setting the autofocus switch to the MF position, you need to check the LCD to make sure the letters MF appear in yellow in the lower right corner of the screen. If they are white instead of yellow, press firmly in on the rear dial once or twice until the MF turns yellow. Once you see those yellow letters, all you have to do is turn the rear dial left or right until you achieve sharp focus for whatever part of the picture you want to focus on. The LX5 has quite a user-friendly manual focus system. De-

35

pending on your menu settings, as soon as you move the rear dial you will immediately see either an enlarged image of the center part of the screen, an enlarged image of the whole screen, or just a normal-sized image.

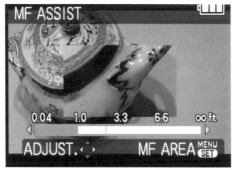

Whichever one you see, turn the rear dial left or right until the image is in focus, then stop. (In Chapter 7, I'll discuss how you can select which of these three settings is in effect using the MF Assist item on the Setup menu.)

At this point, you don't have to do anything else, just press the shutter button all the way down to take the picture. If you would like to tweak the focus a bit further, though, just to make sure you have it as sharp as you can at your selected focus point, you can use the left and right cursor buttons for some final adjustments, if you press them quickly, while focusing is still active. You can hold either of those buttons down for continuous adjustment.

If you are using the enlarged screen of the MF Assist option (either MF Mode 1 or Mode 2), you can choose what part of the image is enlarged. To do this, while the enlarged area is on the screen, press the Menu/Set button, at which point a yellow box will appear on the screen with four triangles pointing in each direction. Use the four cursor buttons to move that box around the screen, and then press Menu/Set again to set the new location for the enlarged focusing area. You can press the Display button to reset the enlarged area back to the center of

the screen.

Also note that, even if you have the camera set to manual focus, you can still call on the camera for assistance. Just press the Focus button (the top cursor button), and the camera will focus automatically for you, though you can still fine-tune the focus manually after that. In fact, if you want, you can begin the manual focus process by pressing the Focus button to reach a rough approximation of focus, and then use the rear dial and the cursor buttons to make fine-tuning adjustments.

Exposure

Next, we'll consider some possibilities for controlling exposure, beyond just letting the camera make the decisions. The Intelligent Auto mode is very good at choosing the right exposure, and so is the Program mode. But there are going to be some situations in which you want to override the camera's automation.

Exposure Compensation

First, let's look at the control for adjusting exposure to account for an unusual, or non-optimal, lighting situation. Suppose your subject is a person standing in front of a window that is letting in sunlight. We'll say the LX5 is set for Program mode. The camera will do a good job of averaging the amount of light coming into the lens, and will expose the picture accordingly. The problem is, the window and its frame will likely "fool" the camera into closing down the aperture, because the overall picture will seem quite bright. But your subject, who is being lit from behind (by backlight), will seem too dark in the picture.

One solution here, which the LX5 makes very easy to carry out, is the exposure compensation control. You would likely

never realize this without reading the manual, but the rear dial is also a button you can press in. It has various functions, both as a dial and as a button; one of the button functions is to activate the exposure compensation control.

Go ahead and set up your picture in Program mode, and aim at your subject. Now press in sharply on the rear dial (it may take a good deal of force), and look at the small black and white block in the lower left of the screen, with a plus sign and minus sign. That block should turn yellow. The change of color means that control is now active. Now, when you *turn* the rear dial (rather than pressing in on it), you will see yellow numbers appear on the screen, indicating a value ranging from -3 to +3 in increments of one-third EV.

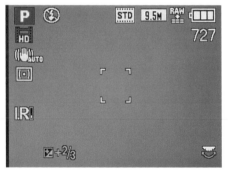

The EV stands for Exposure Value, which is a standard measure of brightness. If you move the value down to -3, the picture will be considerably darker than the automatic exposure would produce. If you move it to +3, the picture will be noticeably brighter. The camera's screen shows you how the exposure is changing, before you take the picture.

Once you've taken the picture, you should reset the EV compensation back to zero, with no numbers showing beside the exposure compensation icon, so you don't unintentionally affect the pictures you take later. You need to be careful about this, because the camera will maintain any EV value you set, even when the camera is turned off and then on again.

There's one pitfall to be careful about when adjusting exposure compensation with this camera. You have to make sure the exposure compensation icon has turned yellow, meaning it is active and ready for adjustment. (See the image on the previous page.) If it's black and white, that means that turning the rear dial will adjust something else (such as manual focus, for example, if the camera is set to focus manually). One thing to watch for in general is to check to see what icon, if any, has turned yellow, so you will know what value or option is currently set to be adjusted when you turn the rear dial. I'll discuss this point again when I discuss the settings for the other exposure modes.

Flash

Later on, I'll discuss other topics dealing with exposure, such as Manual mode, Aperture Priority mode, Intelligent Exposure, and others. For now I'm going to discuss the basics of using the LX5's built-in flash unit, because that is something you may need to do on a regular basis. Later, I'll discuss using other flash units, and other options for using the built-in flash, such as controlling its output and preventing "red-eye."

Here is one fundamental point that you need to be aware of: The built-in flash on the LX5 will not pop up by itself, as such units do on some cameras. If you are in a situation in which you think flash may be needed or desirable, you need to take the first step of popping up the flash unit. To do so, find the small, round slide switch on the far left of the camera's top. The word "Open" is beside the switch. Slide the switch to the right, and the flash springs up into place. (Later, when you're done with the flash, just push down on the unit until it catches.)

Even though you have popped up the flash unit, in some shooting situations it will never fire. In the situations in which you're likely to want it to, though, it will be ready and willing to illuminate your subject as well as it can.

39

Let's explore a common scenario to see how the flash works. Turn on the camera and set the shooting mode to Intelligent Auto with the Mode dial on top of the camera. Pop up the flash unit.

You will see the flash icon appear on the top of the LCD screen, to the right of the icon mode setting, which, in this case, is the letters iA inside a red camera icon (unless the camera has detected a particular scene type, in which case it displays the icon for that scene type, such as portrait or scenery).

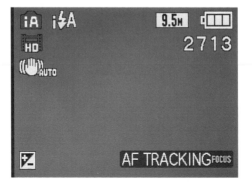

The appearance of the flash icon will vary depending on several settings, which you can choose in some shooting modes, but not others. Since you're now in Intelligent Auto mode, your choices of most functions, including flash, are limited. If the flash unit is popped up, the camera will select what it believes to be the appropriate flash mode for the current conditions and will display an icon to announce that mode. If the flash is stowed away in its compartment, you'll see the "flash off" icon at the top of the screen. That icon is a lightning bolt inside the

universal negative sign, a circle with a diagonal line through it. There is no way to make any other flash settings in this situation. You don't have any choice, but that's presumably what you wanted when you chose Intelligent Auto mode.

Next, try setting the Mode dial to P, for Program mode. Now, if you go into the Recording menu and select the Flash item, you will find several options available: Auto, Auto/Red-Eye, Forced Flash On, and Slow Sync./Red-Eye.

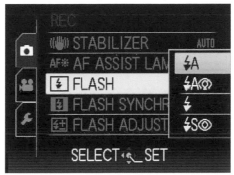

There's one point here that may be slightly confusing when you read the user's manual. The manual (long version, page 68) discusses the various flash options, including the ones just listed, and a final one, Forced Flash Off. Reading the manual, it sounds as if you can select Forced Flash Off from the Recording menu options, but the only way to select Forced Off when using the built-in flash is to push the flash unit back into its compartment. It may be fairly self-evident that the flash is forced off when it's not popped up, but the camera still announces this fact with an icon at the top of the LCD screen. (The Forced Flash Off setting has more meaning if you're using an external flash unit that communicates with the camera; I'll discuss that situation in Chapter 4.)

Motion Picture Recording

Let's try recording a short video sequence with the LX5. Later, I'll discuss some of the other options for video recording, but

for now, let's stick to the basics. Once the camera is turned on, set the Mode dial to Intelligent Auto, press the Menu/Set button to enter the menu system, and then press the left cursor button followed by the down button, to activate the Motion Picture menu, symbolized by the icon of a movie camera.

Press the right button to go to the list of menu options. At the top of the screen, highlight Rec Mode and press the right button, giving the choices of AVCHD Lite and Motion JPEG. (AVCHD stands for Advanced Video Coding High Definition; it and the Lite variation are video encoding formats.)

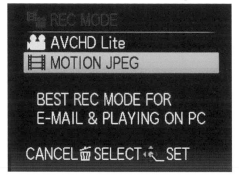

Highlight Motion JPEG and press the Menu/Set button to select it. Then go back to the menu screen and highlight the next option down, Rec Quality, and select HD, for High Definition. Then press the Menu/Set button to exit the menu system.

Be sure the slide switch on the left of the lens barrel is set to AF for autofocus, unless you want to use manual focus.

Now compose the shot the way you want it, and when you're ready, press the red button on top of the camera, to the right of the shutter button.

You don't need to hold the button down; just press and release. The LCD screen will show a blinking red dot as a recording indicator along with a countdown of recording time remaining, and the camera will keep recording until it runs out of storage space, or until you press the movie button again to stop the recording. Don't be concerned about the level of the sound that is being recorded, because you have no control over the audio volume during the recording process. Note, though, that the LX5 does a very nice job of changing its focus and exposure automatically as necessary, and you are free to zoom in and out as the movie is recording.

This leads to a point that's not specific to the LX5: Unless you have a good reason to do otherwise, I recommend that you refrain from zooming during your shots and that you try to hold the camera as steady as possible, and move it only in very smooth, slow motions, such as a pan (side-to-side motion) to take in a wide scene gradually. Video from a jerkily moving or zooming camera can be very disconcerting to the viewer.

Viewing Pictures

Before we delve into more advanced settings for taking still pictures and movies, as well as other matters of interest, I'll talk about the basics of viewing your images in the camera.

Basic Playback

Playback is activated by pressing the Play button, the button at the top right on the back of the camera under a green triangle, below the rear dial.

When you press that button, if you have any pictures in the camera's built-in memory or on the SD card, you will see one of the pictures displayed. It will be whatever image you last displayed; the camera remembers which picture is on display

even after being turned off and then back on.

 To move to the next picture, press the right button; to move back one picture, press the left button. (If you prefer, you can move through the pictures with left or right turns of the rear dial.) The display on the screen will tell you the number of the picture being displayed. (If it doesn't, press the Display button until it does.) This number will have a three-digit prefix, followed by a dash and then a sequence number. For example, the card in my camera right now is showing picture number 100-0037; the next one is 100-0038.

If you would rather see more than one picture at a time, use the Zoom lever on the top of the camera. Move it to the left, toward the W, one time, and the display changes to show twelve images in three rows of four.

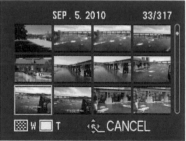

Move it to the left one more time, and it shows thirty pictures at a time.

Give it one final leftward push and the screen shows a calen-

dar from which you can select a date to view all images taken on that date.

You can also move the Zoom lever to the right to go back through the options for multi-image viewing.

Move the Zoom lever once to the left to see the twelve-picture screen. Note that the right and left buttons now move you through the pictures on this screen one at a time, while the top and bottom buttons move you up and down through the rows. If you move to the last row or the last image, the proper button will move you to the next screen of images. Once you've moved the selector to the image you want to view, press the center button, and that image is chosen for individual viewing.

Once you have the single image you want displayed on the screen, you have more options. Press the Zoom lever once to the right, toward the T, to zoom the image to twice its normal size. Press the lever repeatedly to zoom up to sixteen times normal size. Press the Zoom lever back to the left to shrink the image down in the same increments. Or, you can press the center button to return the image immediately to normal size.

While the zoomed picture is displayed, you can scroll it in any direction with the cursor buttons. Also, you can review other images at the same zoom level by using the rear dial to navigate to the next or prior image, while the image is still zoomed.

Playing Movies

To play back movies, navigate through the images by the methods described above until you find an image for which the screen shows the motion-picture film strip icon at the upper left. The screen will briefly display the legend, PLAY MOTION PICTURE, which will disappear after one or two seconds.

With the first frame of the motion picture displayed on the screen, press the up button (the top button in the five-button array) to start playback.

The movie will start to play. You can now use the five-button array as a set of VCR controls. The top button is Play/Pause; the right button is Fast Forward (or frame advance when paused); the bottom button is Stop; the left button is Rewind (or frame reverse when paused).

Also, you can raise or lower the volume of the audio by pressing the zoom lever on top of the camera to the right or left. You will see a little window open up on the screen with a volume display when you activate this control.

If you want to play your Motion JPEG movies on a computer or edit them with video-editing software, they will import nicely into software such as iMovie for the Macintosh, or into any other Mac or Windows program that can deal with video

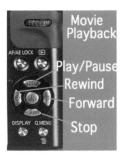 files with the extension .mov. This is the extension for Apple Computer's Quick-Time video software; QuickTime itself can be downloaded from Apple's web site. For some Windows-based video editing software, you may need to convert the LX5's movie files to the more commonly used .avi format before importing them into the software. You can do so with a program such as mp4cam2avi, which is easily found through an internet search. There also is useful software at aunsoft.com.

If you want to edit your AVCHD Lite movies, there is software available that will let you do this, though AVCHD is not as useful for editing as it is for playing directly on your HDTV.

To save a frame from a movie as a single image, play the movie to the rough location of the image you want, then press the up button, which acts as the Play/Pause button in this context. Use the left and right buttons to maneuver to the exact frame you want.

Once you are viewing the single frame you want, press the Menu/Set button to select it, then, when prompted, highlight Yes and press Menu/Set to confirm, and you will have a new still image at the end of the current group of recorded images.

Press the down button (Stop) to exit the motion picture Play-back mode. Note, though, that the saved still images will not be of the highest quality; each one will be of Standard quality and no larger than 2 MP in size.

Chapter 3: The Recording Modes

Up until now I have discussed the basics of how to set up the camera for quick shots, relying heavily on features such as Intelligent Auto mode, in which settings are controlled mostly by the camera's automation. Like other sophisticated digital cameras, though, the LX5 has a large and potentially bewildering range of options available for setting up the camera to take pictures and movies. One of the main goals of this book is to remove the "bewildering" factor while extracting the essential usefulness from the broad range of features available. To do this, I will turn my attention to two subjects; this chapter will discuss the recording modes for still pictures and Chapter 4 will explain the Recording menu options. First, the modes.

Whenever you set out to record still images, you need to select one of the available recording modes on the Mode dial: Intelligent Auto, Program, Aperture Priority, Shutter Priority, Manual, Scene, My Color, C1, or C2. (The only other entry available on the Mode dial is for Motion Pictures, which I will

discuss in Chapter 8.) So far, we have worked with the Intelligent Auto and Program modes. Now I will discuss the others, after a brief review of preliminary steps and some review of the first two recording modes.

Preliminary Steps Before Shooting Pictures

It can't hurt to recall the preliminary steps that you need to take before choosing any of the various shooting modes. They don't have to be done in this exact order, but this is not a bad order to follow:

1. Check to be sure you have selected the aspect ratio you want: either 1:1, 3:2, 4:3, or 16:9, with the slide switch on top of the lens barrel. I generally use 3:2 for everyday shooting, but you may prefer one of the others. If you intend to use software to edit and tweak your photos later, you can always change the aspect ratio later.

2. Check to be sure you have selected the focus method you want: either AF for autofocus, AF Macro for autofocus with close-ups, or MF for manual focus. Use the slide switch on the left side of the lens barrel.

3. Remove the lens cap.

4. Turn on the camera.

Now you're ready to select a recording mode. I'll go over them all below.

Intelligent Auto Mode

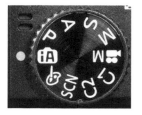

I've already talked about this shooting mode. This is the one you probably want if you just need to have the camera ready for a quick shot, maybe in an environment with fast-paced events when you won't have much time to fuss with settings.

To set this mode, turn the Mode dial, on top of the camera to the right of the flash shoe, to the camera icon with the letters "iA" inside it. (Be sure to distinguish this setting from the capital "A" with no icon, which sets a different mode, Aperture Priority.)

When you select Intelligent Auto mode, the camera makes quite a few decisions for you. It sets scene detection, image stabilization, quick autofocus, Intelligent Exposure, red-eye correction, backlight compensation, Intelligent Resolution, and Intelligent Zoom. I'll discuss all of those options later in connection with Recording menu settings, except for scene detection. With scene detection, the camera attempts to figure out if a particular scene type should be used for the current situation. It does not consider all of the Scene mode types, just a select few: Portrait, Scenery, Macro, Night Scenery, Night Portrait (if the flash is active), Sunset, and Baby. If it detects one of these, it displays an icon for that scene, and adjusts its settings accordingly.

Choosing Intelligent Auto mode imposes limitations, some of which you may not like, so let's discuss them. One of the limitations I don't like is that this mode limits your Picture Size

choices to just three or four, depending on what aspect ratio you have set, instead of the five or six that are available in Program mode. More importantly, in Intelligent Auto mode you can't select RAW for the Quality setting, which is set automatically to Fine or Standard, depending on the Picture Size. I'll discuss RAW later, but if you want to have the highest possible quality of images or intend to process them using one of the more sophisticated photo editing programs, like Adobe Photoshop, you won't like having to do without the RAW Quality setting.

There are many other limitations imposed by Intelligent Auto mode. Basically, when you choose this mode, the Recording menu is limited to four choices: Picture Size, Burst shooting, Color Effect, and Face Recognition. It may not be such a bad thing to do without a lot of menu choices, though, because, after all, the purpose of Intelligent Auto mode is for the camera to make quick, reasonably good choices for you so you can spring into action with the shutter button on a split second's notice. And, being able to turn on Burst shooting is quite useful, in that it gives you the opportunity to decide whether you will take multiple shots with one press of the shutter button.

One thing to note here is that the Color Effect setting is available on the Recording menu only when the camera is set to Intelligent Auto mode. This setting has just three options: Standard, Happy, and B/W, for Black and White. (Where the label "Happy" came from I can't say. I guess the "Let's make it simple for the user" department at Panasonic got a bit carried away.) The "Happy" setting is a watered-down version of the Film Mode menu option, discussed later in connection with the Recording menu.

Besides the settings mentioned above on the Recording menu and a few on the Setup and Motion Picture menus, as discussed in Chapter 2, there is one other item that you can adjust in Intelligent Auto mode: AF Tracking. When the camera

is set to Intelligent Auto, you will see a notice on the LCD that you can press the Focus button to activate AF Tracking.

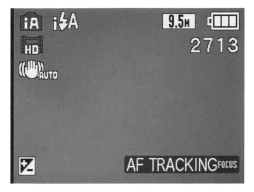

Here is how this works. If you press the Focus button (the up cursor button in the 5-button array), a small set of white focus-tracking brackets will appear in the center of the screen. Center those brackets over any subject you want to track, such as a child, pet, or other moving object. Then, as prompted by another message on the screen, press the AF/AE Lock button to lock the focus (and exposure) on that subject. At this point, the brackets will turn yellow, and the camera will do its best to keep that subject centered in the brackets, and will try to adjust the focus and exposure for that subject.

In summary, although the Intelligent Auto shooting mode lets the camera make most of the technical decisions, you still have a fair amount of involvement in taking photographs (and movies). Especially when you're just starting out to use the LX5, don't shy away from using Intelligent Auto as you explore the camera's capabilities. The automation in this mode is very sophisticated and will often produce excellent results; the drawback is that you don't have as much creative control as you might like. But for ordinary picture-taking opportunities, vacation photos, and quick shots when you don't have much time to decide on particular settings, Intelligent Auto is a wonderful tool to have at your fingertips.

Program Mode

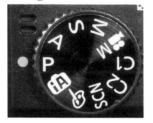

Choose this mode by turning the Mode dial to the P setting. This shooting mode lets you control many of the settings available, apart from manual exposure. (You still can override the camera's automatic exposure to a fair extent, though, by using exposure compensation and exposure bracketing, also known as Auto Bracket.) You don't have to make a lot of decisions if you don't want to, however, because the camera will make reasonable choices for you as defaults.

One way to look at Program mode is that it greatly expands the choices available to you through the Recording menu. You will be able to make choices involving picture quality, image stabilization, ISO sensitivity, metering method, and others. I won't discuss all of those choices here; if you want to explore that topic, go to the discussion of the Recording menu in Chapter 4 and check out all of the different selections that are available to you.

It is worth mentioning here that Program mode has the great advantage of letting you choose RAW quality for your still images. To do that, activate the Recording menu by pressing the Menu/Set button (the center button in the five-button array). Navigate down to the Quality setting, then press the right button to pop up the sub-menu with the five Quality settings: Fine, Standard, RAW plus Fine, RAW plus Standard, and RAW.

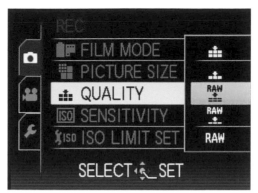

The Fine and Standard settings produce normal JPEG images. (JPEG stands for Joint Photographic Experts Group, an industry group that sets standards for photographic file formats.) With the RAW plus Fine and RAW plus Standard settings, the camera actually records two images as noted, so you will have both the RAW and the non-RAW image available. This choice can be useful if you won't have immediate access to software for editing the RAW images, and want to be able to use the lesser-quality images quickly.

Besides unlocking the many options in the Recording menu, choosing Program mode also provides you with access to many options in the Setup menu that are not available in Intelligent Auto Mode, such as various settings for the LCD screen display, including the histogram, manual focus assist, and highlight, which I will discuss later.

Are there any drawbacks to using Program mode? As with any choice of this sort, there are some tradeoffs. The most obvious issue is that you don't have complete control over the camera's settings. You can choose many options, such as Film Mode, Quality, Picture Size, and ISO, but you can't directly control the aperture or shutter speed, which are set according to the camera's programming. You can exercise a good deal of control through exposure compensation and Program Shift (see later discussion), but that's not quite the same as selecting a

particular aperture or shutter speed at the outset. If you need that degree of control, you'll need to select Aperture Priority, Shutter Priority, or Manual for your shooting mode.

There is one specific issue related to the lack of control over aperture and shutter speed when you're using Program mode. When that shooting mode is set, the Minimum Shutter Speed setting will be activated; you cannot turn it off. The slowest minimum shutter speed you can set in that situation is one second. So if you are trying to take a time exposure in a dark area (using a tripod, presumably), where the correct shutter speed would be, say, five seconds, the camera will not expose the picture properly. The minimum shutter speed setting of one second will be the longest exposure possible. If you expect to have exposures longer than one second, you need to select a shooting mode other than Program. (namely, Manual, Aperture Priority, Shutter Priority, or certain Scene types.)

Aperture Priority Mode

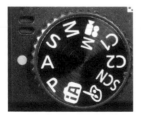

You set this shooting mode by turning the Mode dial to the capital A that stands alone, not the "iA" inside the camera icon. This mode is similar to Program mode in the functions that are available for you to control, but as the name implies, it also gives you, the photographer, more control over the camera's aperture.

Before discussing the nuts and bolts of the settings for this mode, let's talk about what aperture is and why you would want to control it. The camera's aperture is a measure of how

wide its opening is to let in light. The aperture's size is measured numerically in f-stops. For the LX5, the range of f-stops for still photos is from f/2.0 (wide open) to f/8.0 (most narrow). (The range is different for movies and for telephoto shooting, as discussed later.) The amount of light that is let into the camera to create an image on the camera's sensor is controlled by the combination of aperture (how wide open the lens is) and shutter speed (how long the shutter remains open to let in the light).

For some purposes, you may want to have control over how wide open the aperture is, but still let the camera choose the corresponding shutter speed. Here are a couple of examples involving depth of field. Depth of field is a measure of how well a camera is able to keep multiple objects or subjects in focus at different distances (focal lengths). For example, say you have three friends lined up so you can see all of them, but they are standing at different distances — five, seven, and nine feet (1.5, 2.1, and 2.7 meters)—from the camera. If the camera's depth of field is quite narrow at a particular focal length, such as five feet (1.5 meters), then, in this case, if you focus on the friend at that distance, the other two will be out of focus and blurry. But if the camera's depth of field when focused at five feet (1.5 meters) is broad, then it may be possible for all three friends to be in sharp focus in your photograph, even if the focus is set for the friend at five feet (1.5 meters).

What does all of that have to do with aperture? One of the principles of photography is that the wider open the camera's aperture is, the narrower its depth of field is at a given focal length. So in our example above, if you have the camera's aperture set to its widest opening, f/2.0, the depth of field will be narrow, and it will be possible to keep fewer items in focus at varying distances from the camera. If the aperture is set to the narrowest opening possible, f/8.0, the depth of field will be greater, and it will be possible to have more items in focus at varying distances.

In practical terms, if you want to have the sharpest picture possible, especially when you have subjects at varying distances from the lens and you want them to be in focus to the greatest extent possible, then you may want to control the aperture, and make sure it is set to the highest number (narrowest opening) possible.

On the other hand, there are occasions when photographers prize a narrow depth of field. This situation arises often in the case of outdoor portraits. For example, you may want to take a photo of a person standing outdoors with a background of trees and bushes, and possibly some other, more distracting objects, such as a swing set or a tool shed. If you can achieve a narrow depth of field, you can have the person's face in sharp focus, but leave the background quite blurry and indistinct. This effect is sometimes called "bokeh," a Japanese term describing an aesthetically pleasing blurriness of the background. You have undoubtedly seen images using this effect. In this situation, the blurriness of the background can be a great asset, reducing the distraction factor of unwanted objects and highlighting the sharply focused portrait of your subject.

So with our awareness of the virtues of selecting an aperture, on to the technical steps involved. Once you have moved the Mode dial to the A setting, the next step is quite simple. Use

the rear dial to change the aperture. Turn the dial to the right to get a narrower aperture (higher number) and turn it to the left to get a wider aperture (lower number). The number of the f-stop will display in the bottom center of the screen. The shutter speed will show up also, but not until you have pressed the shutter button halfway down, to let the camera evaluate the lighting conditions.

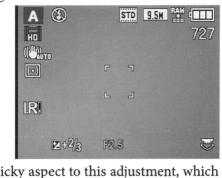

There's a tricky aspect to this adjustment, which is not all that clearly explained in the user's manual. I mentioned this earlier in connection with manual focus. The rear dial can be used to control at least one other function in this context, and you have to be somewhat careful to avoid slipping over into either of those functions. Here's what I mean. If you're controlling the aperture as described above, the aperture numbers will be displayed in yellow numerals on the screen. They will change as you turn the rear dial to the left or right. But if you then press in on the rear dial, the aperture numerals will turn white, and they will no longer change as you move the rear dial.

What happens here is, each time you press in on the rear dial, you trigger a different function—exposure compensation, aperture value, or manual focus if you have the focus switch set to MF. Once you have pressed in on the rear dial to activate exposure compensation, turning the rear dial will increase the brightness of the exposure (turn dial to the right) or decrease it (turn dial to the left), in the 1/3-EV increments that we discussed earlier. If manual focus is active, pressing the rear dial again will switch the dial's function to controlling manual fo-

cus. So, you may have to press the rear dial once or twice to make the aperture numbers turn yellow, showing that turning the rear dial now will control the aperture setting.

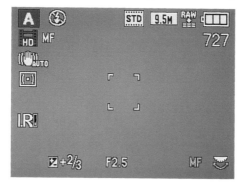

Here's another note on Aperture Priority mode that might not be immediately obvious and easily could lead to confusion: Not all apertures are available at all times. In particular, the widest-open aperture, f/2.0, is available only when the lens is zoomed out to its wide-angle setting (moved toward the W indicator). At higher zoom levels, the widest aperture available changes steadily, until, when the lens is fully zoomed in to the 90mm level, the widest aperture available is f/3.3.

To see an illustration of this point, here is a quick test. Zoom the lens out by moving the Zoom lever all the way to the left, toward the W. Then select Aperture Priority mode and select an aperture of 2.0 by turning the rear dial all the way to the left. Now zoom the lens in by moving the Zoom lever to the right, toward the T. After the zoom indicator is done showing up on the screen, you will see that the aperture has been changed to f/3.3, because that is the widest open the aperture can be at the maximum zoom level. (The aperture will change back to f/2.0 if you move the zoom back to the wide-angle setting; so you need to check your aperture after zooming out as well as after zooming in, to make sure you will not be surprised by an unexpected aperture setting.)

Finally, there's one more little twist involved in the setting of aperture on the LX5. The full range of shutter speeds, 8 seconds to 1/4000 second, is available only for apertures of f/4.0 and above. If you set the aperture anywhere from f/2.0 to f/3.5, the fastest shutter speed available is 1/2000 second. This limitation is not likely to cause you any problems, but you need to be aware of its existence.

Shutter Priority Mode

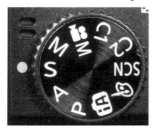

The next shooting mode is a complement to Aperture Priority mode. In Shutter Priority mode, you choose whatever shutter speed you want, and the camera will set the corresponding aperture in order to achieve a proper exposure of the image. In this case, the creative considerations are somewhat different than with Aperture Priority. The LX5 has a wide range of shutter speeds available in Shutter Priority mode (the range differs somewhat in some other modes). In this mode, you can set the shutter for a variety of intervals ranging from 8 full seconds to 1/4000 of a second. (As with aperture, the shutter speed settings are different for motion pictures.) The camera will pick an aperture from its full range of f/2.0 to f/8.0, unless you set the shutter speed faster than 1/2000 second, or the lens is zoomed in. For shutter speeds faster than 1/2000 second, the only apertures available are f/4.0 and higher.

If you are photographing fast action, such as a baseball swing or a hurdles event at a track meet, and you want to stop the action with a minimum of blur, you will want to select a fast shutter speed, such as 1/1000 of a second. At other times, for

creative purposes, you may want to select a slow shutter speed to achieve a certain effect, such as leaving the shutter open to capture a trail of automobiles' taillights at night. To illustrate, in the example below, the top image was shot with a shutter speed of 1/100 second, and the bottom image was shot at 1/6 second, to illustrate the effects of different shutter speeds on images of the flow of water from a large pipe into a canal.

The settings for Shutter Priority mode are, not surprisingly, quite similar to those for Aperture Priority mode. You select the mode by setting the Mode dial on top of the camera to the S indicator. Then you select the shutter speed by left-and-right motion of the rear dial. Turn the dial to the right for faster (shorter) shutter speeds, and to the left for slower (longer)

ones. The camera will then select the appropriate aperture to achieve a proper exposure, when you press the shutter button halfway down.

Once you've pushed the shutter button halfway down, you need to watch the colors of the shutter speed number and the f-stop number on the screen. If the numbers turn red, that means that proper exposure at that shutter speed is not possible at any available aperture, according to the camera's calculations. For example, if you set the shutter speed to 1/320 of a second in a fairly dark indoor setting, the shutter speed number and the aperture number (which will be f/2.0, the widest setting, if the zoom is set to wide angle) may turn red, indicating that proper exposure is not possible. One good thing in this situation is that the camera will still let you take the picture, despite having turned the numbers red to warn you. The camera is saying, in effect, "Look, you may not want to do this, but that's your business. If you want a dark picture for some reason, help yourself." (Note: This situation is less likely to take place when you're in Aperture Priority mode, because, unlike the situation with f-stops, there is a wide range of shutter speeds for the camera to choose from; a range from 8 seconds to 1/4000 second (or 1/2000 for wider apertures, as noted above). So no matter what aperture you select, there is likely to be a shutter speed available that will result in proper exposure.)

On the shutter speed display, you should be careful to distinguish between the fractions of a second and the times that are one second or longer. The LX5 has a good display in this regard, because it displays the fractions with a divider line, as in 1/2 and 1/125. One aspect of this display that can be somewhat confusing is that some of the times are displayed as a combination of fractions and decimals, such as 1/2.5 and 1/3.2. I find these numbers a bit hard to translate mentally into a time I can relate to. Here is a table that translates these numbers into a more understandable form:

1/1.3	0.77 or 10/13 second
1/1.6	0.625 or 5/8 second
1/2.5	0.4 or 2/5 second
1/3.2	0.31 or 5/16 second

Also, as with Aperture Priority mode, the rear dial serves two (or three) functions in Shutter Priority mode. If the shutter speed numbers are yellow, you are controlling the shutter speed, but if the shutter speed numbers turn white, then you will see yellow figures for the exposure compensation display (or the letters MF may turn yellow, if manual focus is in effect, meaning the rear dial now controls manual focus). You will have to press in on the rear dial once (or twice) more to get back to controlling the shutter speed with the rear dial.

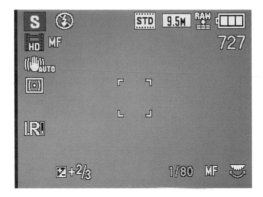

Manual Exposure Mode

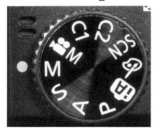

The LX5 has a fully manual mode for control of exposure, which is one of the great features of this camera. Not all compact cameras have a manual exposure mode, which is a boon for serious amateurs who want to exert full creative control over exposure decisions.

The technique for using this mode is not far removed from what we discussed in connection with the Aperture Priority and Shutter Priority modes. To control exposure manually, set the Mode dial to the M indicator. Now the rear dial will control both aperture and shutter speed. Earlier, we saw how the rear dial has two or three functions in the Aperture Priority and Shutter Priority modes: controlling either aperture or shutter speed, and also controlling exposure compensation, as well as manual focus if MF is set on the focus switch. In Manual Exposure mode, you shift back and forth between controlling aperture and controlling shutter speed by pressing in on the rear dial, and you then adjust the settings for the selected function by turning the rear dial. You no longer can control exposure compensation, because that would be of no use when you're already controlling the exposure manually. However, you still can control manual focus if that option has been selected with the focus switch.

To control the aperture, first press in on the rear dial (more than once if necessary). The aperture number (such as 2.8 or 3.5) will turn yellow, and can now be increased by turning the dial to the right, or lowered by turning it to the left. To shift to

65

controlling the shutter speed, press in on the dial again. The shutter speed number (such as 1/30 or 1/100) will turn yellow, and can now be changed to a faster speed by turning the rear dial to the right, or to a slower speed by turning it to the left.

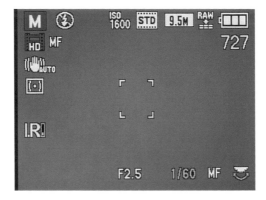

Two notes to remember: if you recall, with Aperture Priority mode, you cannot set the aperture to f/2.0 when the lens is fully zoomed in. The same situation is true with Manual mode; you cannot set the wide-open aperture of f/2.0 when the lens is zoomed all the way in to the 90mm equivalent setting. Also, as with Aperture Priority and Shutter Priority modes, as discussed above, you cannot set a shutter speed faster than 1/2000 second along with an aperture wider than f/4.0.

With Manual Exposure mode, the settings for aperture and shutter speed are independent of each other. When you change one, the other one stays unchanged until you change it manually. The camera is leaving the creative decision about exposure entirely up to you, even if the resulting photograph would be washed out by excessive exposure or under-exposed to the point of near-blackness.

However, the camera is not going to abandon you completely, so you won't have to use a separate light meter or other external aids to gauge the correct exposure settings. Even though you have selected Manual exposure control, the camera will

still provide help if you want it.

Once you are in Manual Exposure mode, either before or after you have started adjusting the aperture and shutter speed with the rear dial, press the shutter button halfway down until the camera beeps. The screen then shows a scale of tick marks ranging from -2 to +2 EV, with a zero at the mid-point and a little yellow indicator that moves along the scale. With this scale on the screen, you can adjust either aperture or shutter speed in turn until the yellow indicator settles over the zero point, indicating a standard exposure. Of course, you can adjust the settings however you want, leaving the indicator far to the right or left, as you please. But the camera is providing this display to show you what settings it would consider to yield a correct exposure given the lighting conditions in existence. The scale stays on the screen for as long as you are making adjustments with the rear dial, and for about ten seconds if you are not making adjustments. You can press the shutter button down to take the picture at any time.

Scene Mode

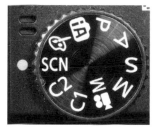

Scene mode is a rather different animal from the other shooting modes we have discussed. This mode does not have a single defining feature, such as permitting control over one or more aspects of exposure. Instead, when you select Scene mode, and then choose a particular scene type within that mode, you are in effect telling the camera what sort of environment the picture is being taken in and what kind of image you are looking for, and you're letting the camera make a group of decisions as

67

to what settings to use to produce that result.

I did not use Scene mode very much at first; however, after using it for a while, I came to appreciate its usefulness, particularly in certain situations. Let's take a look at how it works and you can decide for yourself whether you might take advantage of it on some occasions.

Turning the Mode dial to the SCN indicator places you in Scene mode, but unless you want to settle for whatever scene setting is already in place, you now need to make another choice, and pick one from the fairly impressive list of possibilities.

To make this further choice, you need to use the menu system. When you select Scene mode, the menu system itself changes. Ordinarily (unless you're in Playback mode), the menu system has only three branches: Record, Motion Picture, and Setup. Now that you're in Scene mode, there is a fourth branch of the menu system, named Scene. It takes over as the first choice at the top of the menu system once you have pushed the Menu/Set button (the center button in the five-button array). (The Scene menu may appear automatically once you select SCN on the Mode dial; that option is controlled by the Scene Menu setting on the Setup menu.)

Push the Menu/Set button, and you are faced with the Scene

menu. Next, press the right button, and the selector (a yellow outline) moves onto the first choice of scene types, which is Portrait. One very good thing about the Scene menu system is that each scene is labeled as you move the selector over it, so you are not left trying to puzzle out what each icon represents. If you want a bit more information, press the Display button (the furthest button down on the left of the camera's back, just to the right of the LCD screen) while in the Scene menu, and the display will give you a brief description of the Scene type that is shown in the menu.

Keep pushing the right button to move the selector over the other scene types; when you reach the right edge of the screen, the selector moves down to the left item in the next row down. That's all there is to do to select a scene type. But there are numerous choices, and you need to know something about each to know whether it's one you would want to select. In general, each scene type carries with it a variety of settings, including things like focus mode, flash status, range of shutter speeds, sensitivity to various colors, and others. With a few exceptions, including High Sensitivity, Hi-Speed Burst, and Flash Burst, you can set Quality to RAW, so you can take advantage of the special settings for the various Scene types and still enjoy the flexibility of RAW shooting. Let's look at the complete list of scene types, so you can make an informed choice.

Portrait: For rich skin tones. You are advised to stand fairly close to the subject and set the zoom to full telephoto, so as to blur the background if possible. The camera sets itself to a wide aperture if possible and initially sets the autofocus mode to Face Detection. The flash mode is initially set to Auto/Red-Eye Reduction.

Soft Skin: Similar to Portrait; detects skin tones in faces and adds a "soft effect" to those areas. Intelligent Exposure is set. Flash mode is initially set to Auto/Red-Eye Reduction.

Self-Portrait: This Scene type is intended for you to take a photo of yourself, such as by holding the camera at arm's length and pointing back at you. The user's manual recommends that you set the self-timer for two seconds. The camera automatically sets the zoom range to wide angle, which you should leave as is. The focus range will be from about 1 foot to 3.9 feet (30 cm to 1.2 m). Flash mode is initially set to Auto/Red-Eye Reduction.

Scenery: This style is intended for photographs of landscapes and vistas in the distance. The autofocus range is set from about 16 feet (4.9 meters) to infinity. The flash is set to off. (One interesting point about this Scene type is that, even if you open up the flash unit, it will be automatically set to be forced off, and will not fire. Ordinarily, there is no way for the user to force the built-in flash off when the unit is open, but the camera can do so automatically when set to the Scenery style and a few others.)

Panorama Assist: This mode is designed to help you take multiple pictures that you can later stitch into a panorama using the software that came with the camera or other editing software. When this mode is first selected, the camera shows you a screen for choosing the direction for your panorama: left to right, right to left, down to up, or up to down. Highlight one of these choices, then press Menu/Set. On the next screen, the camera displays a grid of horizontal and vertical guide lines to help you line up the first shot, so it is level and you can judge where its edge is. After you press the shutter button to take that shot, the screen will give you the choices of Next, Retake, and Exit. If the first picture was satisfactory, keep going by highlighting Next and pressing the Menu/Set button. For the next image, the camera will display a faint view of the previous image, so you can make sure the next image overlaps the first one. Repeat these steps for as many images as you need for your panorama; choose Exit after the final picture.

When you're taking your shots, stay in one position and try to keep the camera as level as possible (using a tripod can help, but is not absolutely necessary). What I sometimes do is wear the camera's strap around my neck and hold the camera out at arm's length so the strap tightens and helps keep the camera

71

steady. Try to overlap each image roughly 40 percent with the previous one, until you have taken enough pictures to make up your panorama. Also, try not to vary the exposure as you pan through the various parts of the scene and don't zoom the lens in or out. Once you have all the images, use a program such as PHOTOfunSTUDIO, Photoshop, Photoshop Elements, or others that are specifically designed for creating panoramas to stitch the various parts of the panorama into a single image.

Sports: This style is meant to stop the action of sports in bright daylight using fast shutter speeds at distances of 16 feet (4.9 meters) or more. The camera sets itself to use Intelligent ISO, with maximum ISO set to 1600. (I'll discuss ISO, or sensitivity to light, later. Briefly, with a higher-numbered ISO setting, the camera is more sensitive to light, and therefore can use a faster shutter speed. The tradeoff is the possibility of added "noise" or fuzziness of the image.) The flash can be used if you want to activate it.

Night Portrait: This style is designed for a portrait in low-light conditions, preferably with the camera on a tripod and possibly even using the self-timer to avoid shaking the camera. You should open the flash (or attach an external unit), and it will be set to slow sync red-eye reduction. The camera will be set to Intelligent Exposure. If possible, the subject should be asked not to move for about a second while the image is being exposed. The purpose of this mode is to expose the main subject with the flash, but to keep the shutter open long enough to also expose the background with the ambient light.

Night Scenery: This style is meant for night-time scenes with the camera on a tripod, and also using the self-timer to minimize camera shake. The shutter speed will be set for an exposure as long as 8 seconds, using only the available light. Because this style is for scenery and not portraits, the focus range will be from 16 feet (4.9 meters) to infinity. The flash will

be forced off, and will not fire.

Food: This scene is for those occasions when you're in a restaurant and are so impressed by the presentation of your meal that you want to photograph it, or for those people who are in the habit of documenting every meal they eat. Or you could use it for taking pictures for your cookbook. In any event, the idea here is to take a fairly close-up picture without flash, though the flash will be available if you want to use it. The autofocus range will be the same as for autofocus macro, or about two inches (5 cm) at wide angle, or two feet (61 cm) at telephoto, to infinity.

Party: For taking pictures in lighted interior settings, such as wedding receptions and other social events. It's recommended to use a tripod, and you can use flash if you want to. The recommended distance for shooting is about five feet (1.5 meters).

Candle Light: The name is self-explanatory, but oddly enough, this Scene type allows the flash to fire if you want it, which would seem to defeat the purpose. The manual does say it would be better if you didn't use flash, and I would think you would want to follow that advice. Focus range is the same as for autofocus macro, or about one-half an inch (1 cm) at wide angle, or one foot (30 cm) at telephoto, to infinity.

Baby 1 and Baby 2: These two settings both are geared for taking baby pictures in the same way. The only reason there are two different settings is because you can enter the birth dates and names of two children into the camera, and have the child's name and age displayed along with the picture. The attraction here is that the camera will keep track of what age the child is in each photo.

When you select one of these settings, the camera will present

you with a screen with options for name and age; you can leave either or both of these set to Off if you want, or enter the data. If you want to enter them, the camera gives you menus from which to choose year, month, day, and letters for the names.

Apart from the names and ages, the Baby 1 and Baby 2 scene styles set the camera to use a weaker-than-normal flash output, a focus range the same as for macro mode, Intelligent ISO (light sensitivity) activated, and ISO Limit (see later discussion) set to ISO 1600.

Pet: The Pet scene style is similar to Baby 1 and Baby 2 in that you can set your pet's name and age. The initial setting for the AF Assist lamp is Off. In this scene type, the camera turns AF Tracking on, with the idea that your pet may not be sitting still to have his or her portrait made.

Sunset: This scene style is designed to highlight the vivid reds of a sunset. The flash is forced off, and won't fire even if you open it up in dark conditions. Don't take the label "sunset" too literally; you can use this mode for sunrise also, and, as a matter of fact, for any scene in which you would like to emphasize the reddish or orange tones. For example, the photo on the next page was taken using Sunset mode in the early morning while the reddish beams of sunlight were lighting up some buildings with red tones of their own.

74

High Sensitivity: With this scene type, the camera sets the ISO high, in a range between ISO 1600 and ISO 12,800, making it possible for the camera to expose the picture correctly at a faster shutter speed than it could otherwise. The Quality setting is automatically placed at Standard and the Picture Size at 3 MP or less, depending on the aspect ratio setting, so the resulting pictures will not be suitable for big enlargements, possibly only 4 by 6 inch (10.2 by 15.2 cm) prints. The focus range is that of macro mode. This scene type is suitable for reducing motion blur when shooting in low light, such as indoors. Obviously, you will be sacrificing quality if you use this style, so it's best used only if there are no other viable options, unless image quality is not a particular concern for the pictures you'll be taking with this setting.

The image on the next page was taken at night with the LX5 in High Sensitivity mode, with no lighting except that from an adjacent room. The camera took this shot at ISO 3200, with an exposure of 1/13 second at f/3.0.

Hi-Speed Burst: This scene type sets the camera to fire rapid bursts of shots while you hold down the shutter button. When you first select this setting, the camera asks you to select either Speed Priority or Image Priority. With Speed Priority, the maximum burst speed is about 10 frames per second; with Image Priority, the shooting slows to about 6.5 frames per second, allowing somewhat better image quality. The camera will take pictures continuously up to a total of between about 15 and 100 images. The camera automatically sets the Quality to Standard, which means you'll be able to make good prints only up to a size of about 4 by 6 inches (10.2 by 15.2 cm). The focus range is set to the macro focus range. Once the focus, zoom, exposure, white balance, and ISO level are set for the first picture, all of those settings stay locked in for the rest of the pictures in the burst. The camera sets the ISO to a fairly high range so the shutter can fire rapidly and still expose the picture adequately. Also, the Picture Size is set to no more than 3 MP, depending on the aspect ratio.

The Hi-Speed Burst setting is a good thing to have in your bag of tricks if there's an occasion when you need to take a quick range of pictures of a changing scene, such as a breaking news event, when you need to get the camera set quickly and

don't have time to search for the right settings to get rapid-fire shooting. Of course, the tradeoff in image quality is a factor you need to consider, but if something happens quickly and you need a rapid sequence of shots, this scene type can be set quickly and is better than nothing.

Flash Burst: This Scene type sets the camera to take a burst of up to five pictures as fast as possible when you hold down the shutter button, with the built-in flash firing each time. (Your results may vary with an external flash; with the Panasonic DMW-FL220 flash, I got only three shots in this mode.) Apart from the firing of the flash and the more limited number of pictures taken, this style is similar to Hi-Speed Burst. In particular, the quality is limited to Standard, and the initial settings for the first picture (including focus, zoom, shutter speed, and ISO) are locked in for the subsequent pictures. Intelligent ISO is activated with an ISO limit of 3200. Because of the need for the flash to recycle, the burst is not quite as fast as for Hi-Speed Burst, but it is still fairly rapid.

Starry Sky: This setting is designed for one purpose: for you to set the camera on a tripod and take a picture of the stars in the night sky. The flash is forced off, image stabilization is turned off (because the camera will be on a tripod), and the ISO is set to its lowest value of 80. When you first select this scene type, the camera presents you with a screen to navigate through with the up and down buttons, to select either 15, 30, or 60 seconds for the length of the exposure. You make that selection, and then press the shutter button to start the exposure. The camera counts the seconds down on the screen. After the exposure is finished, the camera counts down the same amount of time all over again, because it takes that long to process the photograph inside the camera. After the second countdown, the picture appears for viewing. It's a good idea to use the self-timer to avoid touching the camera, which can induce some camera movement.

This is a good place to mention again something that is true of this Scene type in particular, and of other types as well. Don't let the name "Starry Sky" or "Sunset" lead you to use this setting only for pictures of one type of subject. It may be, for example, that "Starry Sky" is just what you need in other situations where a long exposure may yield good results. For example, I have used it to get shots of houses lit up at night, like the one below; it could be used to capture trails of headlights and taillights from automobiles, and undoubtedly could be useful in many other situations.

Fireworks: This scene setting is used to capture fireworks displays at night. It's recommended to have the camera on a tripod. The camera sets the shutter speed to either 2 seconds or 1/4 of a second, depending on the setting of the image stabilization function. If image stabilization is off, the camera chooses 2 seconds, presumably on the theory that the camera is on a tripod. If image stabilization is on, the camera chooses 1/4 second, unless it has sensed that there is very little camera shake, indicating the use of a tripod; in that case, it chooses 2 seconds. The ISO is set to 80.

Beach: This setting is designed to prevent the underexposure of subjects sitting on a beach, caused by the camera's being fooled by the brightness of the beach into closing down its aperture too much. The flash is forced on to brighten the subject so it is not overwhelmed by the surrounding brightness.

Snow: This setting is designed, according to Panasonic, to let you take pictures of snow that show it to be as white "as it actually looks." It's not clear exactly how this is accomplished, though the camera apparently boosts the gain slightly and uses the white balance setting to produce a warmer than usual image.

Aerial Photo: This setting is designed for taking pictures through an airplane window, when it may be difficult to focus on a subject such as clouds. The instructions are to aim at something with high contrast, press the shutter button halfway to lock in the focus, and then take the picture.

My Color Mode

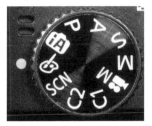

My Color mode occupies its own place on the Mode dial, so I will discuss it here in the context of the other shooting modes, even though it is a bit of a hybrid creature. It has some attributes of the Film Mode setting on the Recording menu, and some attributes of the Scene mode settings. In fact, in the predecessor to the LX5, the LX3, three of the choices that come under My Color on the LX5 (Pin Hole, Film Grain, and High Dynamic) actually were scene types that came under Scene mode on the LX3. One of the My Color settings, Dynamic (B&W), has the same name as a similar setting for the Film Mode menu option. Another My Color setting, Dynamic Art, is similar to the Dynamic setting for Film Mode.

When you turn the Mode dial to the icon of the artist's palette, representing My Color, you will see a yellow rectangle con-

taining the name of the selected setting; scroll up and down through those settings with the up and down cursor buttons, and select your choice with the Menu/Set button. There are eleven preset choices for specific effects and one choice for you to custom-make your own color settings. (If the Mode dial has already been set to the My Color mode, you get back to the yellow rectangles for selecting a setting by pressing the Menu/Set button, which takes you to a special My Color menu option, at the top of the menu icons on the left of the menu screen.)

These various My Color choices provide different "looks" for your images, in some cases quite dramatic alterations of the normal color, texture, and brightness. It's important to note that, because the My Color setting occupies its own slot on the Mode dial, whatever setting you make for My Color is only in effect when the Mode dial is set to that position. So, for example, if you switch the dial to Program or Aperture Priority mode, the My Color settings will no longer be in effect. If you later switch the dial back to My Color, though, whatever setting you previously made will once more take effect.

However, when you record a motion picture with the LX5, you don't need to move the Mode dial; you only need to press the red Movie button on top of the camera. So, when you record a movie, you need to be sure the Mode dial is set where you want it. For example, if you have just taken some still photos using an exotic setting from the My Color selections, that setting will still be in effect if you press the red button to record a

movie. So, if you want a more ordinary look for your movie, be sure to set the Mode dial back to Intelligent Auto, or Program, or some other mode, to avoid having the movie recorded using the My Color setting. On the other hand, being able to use My Color settings when shooting a movie can be a fine advantage when you want to add a particular atmospheric look to your motion pictures. I'll discuss movie settings in more detail in Chapter 8.

Here's a tip: One way to avoid the possibility of having an unwanted My Color setting creep into your movies is to leave the My Color setting on Custom, with no adjustments to any of the parameters, which will result in a plain image. Then, if you press the red Movie button while the Mode dial is set to My Color, there will be no unwanted color effect on your movies.

Note: Some My Color settings affect RAW images and some work only in JPEG. You will see that, when you set some My Color choices, RAW options on the Quality menu will be grayed out and unavailable. Specifically, you cannot use RAW quality with the My Color mode settings of High Dynamic, Dynamic Art, Dynamic (B&W), Pin Hole, or Film Grain.

Following are details about each of the eleven My Color choices. After each description I am including a photograph of the same fountain scene, taken using the setting discussed above the image, to give you an idea of how the various My Color settings compare. When I get to High Dynamic, I'll include some other images to discuss that feature further.

The first image on the next page is of the fountain scene as taken in Program mode using standard settings, to give you a reference point. After that come all of the My Color settings, in the order they appear on the camera's menu.

Normal (Program Mode).

Expressive. I would call this mode something like "super-vivid"; some people call it "pop art." When I aim the camera at my relatively mild-toned blond wooden desk, the Expressive style transforms that brownish hue to a screaming red and transforms a bland blue plastic covering for a printer with a garish, bright sky-blue color. If you like your colors with strong, wild saturation, this style is for you.

Retro. This style appears to me to be the opposite of Expressive; it paints the scene with subdued, somewhat yellowish tones, de-emphasizing the glaring qualities of Expressive. It evokes a gentle feeling of past times.

Pure. This effect shifts the hues to the cooler, more bluish end of the spectrum and increases the brightness to give a feeling of crisp, clean appearance, something like the look of light on a snowy day.

Elegant. This color style uses a dark and "amberish" look to achieve what Panasonic terms "stateliness." That sounds quite subjective to me, but the images produced by this style do have a pleasant look. Try it and see what you think.

83

Monochrome. This setting converts the image to black and white, but with what Panasonic terms a "whisper of color." I like this mode quite a bit, though I have to say that I would not likely use it often; I use Photoshop for post-processing, and it, along with other programs, like Lightroom, is very capable of producing excellent monochrome conversions. (With newer versions of Photoshop, use the command Image—Adjustments—Black & White.) I usually prefer to shoot images in RAW, and then convert them to various styles as appropriate.

High Dynamic. This setting is oriented less to altering the colors of the image and more to leveling out the shadows and highlights. As you can see from the name, it is akin to the "High Dynamic Range" or HDR processing that is often done with software, and sometimes, as here, through in-camera

processing.

The High Dynamic setting is useful when you're taking a picture that includes areas of both bright light and shadows. Ordinarily, a camera cannot process that sort of image and preserve the details in both areas. This setting alters the processing so more details are visible in the dark areas, and the bright areas are not so washed out and overexposed.

The images on the next page were shot at a historic site on a very bright day, but with part of the scene in shade. For the first shot, the LX5 was in Program mode. It's obvious that the camera was not able to record the entire scene, with its dramatic differences in brightness, without blowing out the highlights. The second photograph was taken using the High Dynamic setting, which resulted in a much more even rendering of the dynamic range of the scene as perceived by the human eye. It's still not as clearly rendered as it could be using HDR software, but this in-camera processing is certainly worthwhile for scenes like this.

Dynamic Art. If you find that the High Dynamic setting doesn't provide enough "punch" for your images, try Dynamic Art, seen below. It is similar to High Dynamic in that the camera processes the image to draw details out of shadows and to restore details to overly bright areas, but in this case the processing also tweaks the colors for more saturation, resulting in a richer mix of color.

Dynamic (B&W). Here is another variation on the High Dynamic setting, this time switching to a monochrome output, but still using the characteristic processing that levels out the brightness and contrast so the details are preserved in a high-key wash of light.

Silhouette. With the Silhouette selection, the camera reduces the brightness to achieve a darker appearance, while still preserving colors in the image. The idea is to render the main subject as a dark shadow against a brighter background.

Of course, the photographer needs to cooperate in this effort by choosing a subject and an environment that makes this sort of result possible; I'm not sure if the fountain image above

qualifies as a traditional silhouette, though it clearly is very different from the other images of the fountain taken with the other My Color settings.

Pin Hole. As with some of the other My Color selections, this one is not strictly an example of color processing. Rather, this setting tries to reproduce the effects that are achieved with an actual pin hole camera. A pinhole camera is one that does not use a glass lens, but just has a very small opening to let in light. The images that are produced with such a device are primitive in a way, because they lack sharpness, and, owing to the lack of a lens, suffer from vignetting at the corners. They can be quite appealing in their own way, though, and this setting lets you experiment with a very nice pin hole effect. It can be a pleasing way to highlight a single subject in the middle of the frame.

Film Grain. This setting uses visual "noise" in the image to good effect. The image is shot at a high ISO setting and processed in the camera to render in black and white, with the same grainy effect that can be obtained using high-ISO black-and-white film. This roughly textured appearance can be quite attractive for the right subject.

Custom. This setting gives you the opportunity to craft your own "My Color" setting, using the three parameters that are available for adjustment: color, brightness, and saturation. Highlight the Custom setting in the yellow rectangle on the screen, then press the right cursor button to produce the screen for the adjustments. Use the up and down cursor buttons to navigate through the choices, and use the left and right buttons to adjust each setting.

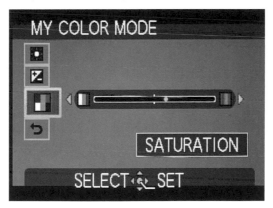

The first value, Color, adjusts the tint of the image, from red at the left of the scale to blue at the right. The second value, Brightness, increases brightness as you move the marker to the right on the scale, and decreases it with leftward motion. The final value, Saturation, increases the vividness of the colors to

89

the right of the scale, and drains the image of color moving left on the scale, until it becomes monochrome at the far left of the scale. The fourth option at the bottom of the adjustment screen lets you return all three values to their mid-point normal settings with one action. When adjustments to the three values in the Custom setting are in effect, small icons appear in the lower left corner of the LCD screen indicating which items have been adjusted.

Any adjustments made with the Custom setting will be in effect the next time you switch back to My Color with the Custom setting, even if you have turned the camera off and back on in the interim.

Chapter 4: The Recording Menu

Much of the power of the LX5 resides in the many options provided in the Recording menu, which gives the user control over the appearance of the images and the ways in which they are captured. Depending on your own preferences, you may not have to use this menu too much. You may prefer to use the various Scene mode settings, which choose many of the options for you, or you may prefer, at least on occasion, to use Intelligent Auto mode, in which the camera makes its own choices. However, it's nice to know that you can have this degree of control over many functions if you want it, and it is very useful to understand what types of items you can exercise control over.

The Recording menu is quite easy to use once you have played around with it a bit. As I discussed earlier, the menu options can change depending on the setting of the Mode dial on top of the camera. For example, if you're in Intelligent Auto mode, the Recording menu options are very limited, because that mode is for a user who wants the camera to make most of the

91

decisions without input. For the following discussion, I'm assuming you have the camera set to Program mode (Mode dial turned to the P setting), because in that setting you have access to all of the power of the Recording menu. (Though some menu options will be unavailable in certain situations.)

So turn the Mode dial on top of the camera to P for Program mode. You enter the menu system by pressing the center button in the five-button array on the back of the camera—the one labeled Menu/Set.

In the menu system, besides the Recording menu, there are the Motion Picture menu and the Setup menu. Also, when the camera is set to Scene mode or My Color mode, the Scene or My Color menu appears, both of which I discussed earlier. If the camera is in Playback mode, there are different menu options for controlling playback. I'll discuss the Motion Picture, Setup, and Playback menus later.

Once you press the center button, you are initially in the Recording menu. If you want to get into the Setup or Motion Picture menu, you need to press the left button in the five-button array. That will take you into the left column of the menu screen, where you can navigate up and down with the cursor buttons to highlight the icons for the Motion Picture menu (movie camera icon) or for the Setup menu (wrench icon).

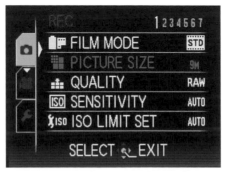

For now, we're staying in the Recording menu, symbolized by

the red still-camera icon at the top of the left column. If you navigated over to the left column with the icons for the three menus, press the right cursor button to move back over to the main part of the screen, with the Recording menu items.

You'll see a fairly long list of options, each occupying one line, with its name in capital letters, its icon on the left, and its current setting on the right. You have to scroll through several screens to see all of the options. If you find it tedious to scroll using the up and down cursor buttons, here's a tip for navigating any menu system on the LX5: You can use the Zoom lever on top of the camera to speed through the menus one full screen at a time. Also, depending on the menu option, you may be able to reach a menu item more quickly by reversing direction with the cursor buttons, and wrapping around to reach the option you want. (For example, if you're on the top line of the first screen of the menu, you can scroll up to reach the bottom option on the last screen of the menu.)

Some menu lines may have a dimmed, "grayed-out" appearance, meaning they cannot be selected under the present settings. For example, if Quality is set to RAW, you cannot set Picture Size, which is automatically set to the maximum value when RAW is selected, so the Picture Size line is grayed out, as shown in the image on the previous page.

Also, if you have set Quality to RAW, you cannot set Intelligent Exposure or Digital Zoom. If you want to follow along with the discussion of all of the options on the Recording menu, set Quality to Fine, which is the setting with an icon of an arrow pointing down onto two rows of bricks. To do so, scroll down using the bottom button until the Quality line is highlighted, then press the right button to pop up the sub-menu. Scroll up or down as needed to highlight the icon with the six bricks, and then press the Menu/Set button to select that option.

Okay, now you have access to every option on the Recording

menu. I'll start at the top, and discuss each option on the list.

Film Mode: This top item on the Recording menu gives you several options for setting the "Film" mode for your images. Just as various physical films used in cameras have considerably different characteristics, these settings yield differing results in terms of warmth, color cast, and other attributes.

There are a few points you need to bear in mind about these settings. First, they are not available in all recording modes. They are available only when the shooting mode is set to Program, Aperture Priority, Shutter Priority, Manual, or Custom. They also are available when you're recording a movie with the shooting mode set to one of the modes listed above. You cannot choose a Film Mode when you have set the camera to Intelligent Auto mode or any of the Scene types; in those cases, the camera makes the choice for you.

Four parameters are varied for these settings: contrast, sharpness, color saturation, and noise reduction. Even though each of these modes has basic settings of those four items, you can still make further adjustments and set the camera to memorize the new settings for each category. Use the up and down cursor buttons to scroll to any of the four parameters, then use the left and right buttons to change the value of that parameter up to two levels, either positive or negative. The camera will remember those settings even when it is turned off.

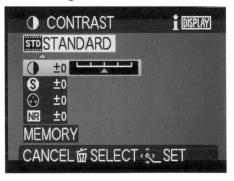

One important point to note here: For three of these parameters—contrast, sharpness, and noise reduction—there is no way to change them other than through this Film Mode setting; they cannot be adjusted directly, or in any other way. For the fourth parameter—color saturation—there is one other way to make an adjustment, namely, through the My Color shooting mode, using the Custom setting.

Here's one point that's not mentioned in the user's manual, though it makes sense if you think about it. When you set Film Mode to any of the monochrome settings, such as Standard BW, Dynamic BW, or Smooth BW, and the Quality is set to RAW, the picture you take will show up as black-and-white on the camera's LCD screen, but, when you import the image file into software that reads RAW files, the image will show up in color. This makes sense because the RAW format allows you to manipulate the "raw" data seen by the camera's sensor, which includes the color information. You can convert these images back to black-and-white on your computer by moving the saturation slider to zero in your RAW software or by using another method of conversion (such as the Image—Adjustments—Black & White command in Photoshop).

Also, it's worthwhile to spend a little time making sure you grasp the differences between the Film Mode settings and the My Color shooting mode. Here are a few pointers to help distinguish between them. My Color is a shooting mode, with its own slot on the Mode dial. When you select this mode on the dial, you are limiting some of your options, because some settings (including Film Mode) become unavailable. Also, the various My Color settings (Expressive, Retro, Elegant, Pure, Smooth, etc.) cannot be adjusted by the user, except for the Custom setting. The Film Mode settings, on the other hand (Standard, Dynamic, Nature, Smooth, etc.), all can be configured by the user to add further adjustments.

Next, it's important to note that the parameters that can be

adjusted by the photographer are largely different for the two settings. For the My Color mode Custom setting, you can adjust color (that is, the red or blue tint), brightness, and saturation; for all settings in Film Mode, you can adjust contrast, sharpness, saturation, and noise reduction. The only common adjustment is saturation.

Finally, although only color, brightness, and saturation are adjustable by the user in My Color mode, there is clearly considerably more processing going on inside the camera in this shooting mode, at least in certain settings, including High Dynamic, Pin Hole, and Film Grain, which alter the image in fairly significant ways beyond those three parameters.

The bottom line, in my opinion, is that there is no neat way to categorize the My Color and Film Mode settings, which amount to a mixed bag of some very useful photographic tools. You really need to work with them until you discover which ones are most useful to you. Personally, in My Color I tend to use High Dynamic, Film Grain, and Pin Hole, because of the distinctive looks they provide. I use Film Mode more often, though, because I prefer to shoot in Program, Aperture Priority, or Shutter Priority mode most of the time. I often just use the Standard setting and add effects, if needed, later through software; for street photography I often use the Dynamic (B&W) Film Mode setting. But there are many choices available, and I recommend that you explore them thoroughly.

Here are summaries of each of the Film Mode settings:

Standard: No change from the normal setting.

Dynamic: Increased saturation (intensity or vividness) and contrast of the colors in the image.

Nature: Brighter red, green, and blue.

Smooth: Lower contrast, for softer and clearer color.

Vibrant: Similar to Dynamic, but even greater increase in saturation and contrast.

Nostalgic: Decreased saturation and contrast, giving an antique or washed-out look.

Standard BW: Standard settings, but monochrome image.

Dynamic BW: Contrast is increased for black-and-white image. Note that, if you use RAW or RAW & JPEG quality with this setting, the RAW images will be in color with a greenish tint. This is just how this setting works; that coloration does not mean you did anything wrong or that the camera has a problem. You probably will want to use a JPEG image with this setting, though you can use the RAW image with a bit of post-processing.

Smooth BW: Lower contrast to soften the picture; black and white.

My Film 1: User-generated settings. (See below.)

My Film 2: Second set of user-generated settings.

Multi Film: Burst of up to three images using different film modes. (See discussion below.)

My Film 1 and 2: These two options are initially set to Standard. You can adjust all parameters (contrast, sharpness, saturation, and noise reduction) to whatever levels you want, to a total of plus or minus two levels from normal. The camera will remember those settings until you change them again, even after the power has been turned off and then on again.

Multi Film: This setting is intended to let you take up to three images at different Film Mode settings with one press of the shutter button. The Multi Film setting does not work if you are shooting RAW images; if you try to set it, the M Film icon will appear on the screen with an X through it. So if you want to take advantage of the Multi Film feature, set the Quality to Fine or Standard, but not to RAW or RAW plus Fine or Standard. (I suppose the theory here is that, if you're shooting in RAW mode, you can manipulate the colors and other qualities of the image with your post-processing software, so you don't really need to bracket your exposures in this way.)

Here's another point I found slightly confusing. The user's manual at page 126 says you can set Multi Film to take multiple pictures "up to a maximum of three films." That's true, but what's also true is that it can only be set to take either two or three images. When you think about it, it would no longer be a "multi" film setting if you could set it to take just one picture. When you get into the settings, remember that you have to set at least two of the Multi Film slots to take pictures using one Film Mode or another; it's only the third slot in Multi Film that has an "Off" setting.

If you're following along with your camera, I suggest setting the Quality to Fine (the icon with the six bricks under an arrow). Get into the Film Mode settings through the Record menu by pressing the center button in the five-button array, then press the right button repeatedly until you reach the Multi Film setting. (Or you can press the left button just once, and wrap around to the Multi Film setting.)

Using the down button, navigate to the top slot, called Multi Film1, then use the right arrow to set that slot to whatever Film Mode you want. (Note: If you have altered any of the Film Modes previously by changing their parameters, that mode will show up in orange, so you'll know it is not set to the factory settings.) As discussed above, you have to set this slot

98

and the next one to some Film Mode; you cannot turn it off. Repeat for slot 2, then go down to slot 3 and set it to a Film Mode or set it to Off if you want only two images taken, rather than all three. Press the center button enough times to exit completely from the menu system. Now the M Film indicator will appear at the top center of the LCD screen. When you press the shutter button, the camera will take two or three images at the Film Mode settings you selected.

Picture Size: This setting controls the number of megapixels (MP) in the images you record with the camera, up to and including its maximum of 10.1 MP. (The highest number shows up as simply 10 MP on the menu.)

The maximum MP setting is controlled by the aspect ratio that you have set. You can set the aspect ratio to one of four settings using the switch on top of the lens barrel: 1:1, 4:3, 3:2, or 16:9. If you set the aspect ratio to 4:3, the maximum MP setting is the full 10 MP. If you set the aspect ratio to 3:2, the camera achieves that image shape by cutting off some MP vertically but adding some horizontally, so the maximum setting for Picture Size is 9.5 MP. At the 16:9 setting, even more vertical MP are lost but horizontal ones are added, and the maximum Picture Size is 9 MP. At the 1:1 aspect ratio, pixels are lost in both directions, resulting in a maximum image size of 7.5 MP.

There are several points that you need to bear in mind about the MP settings. First, the higher the MP setting, the better the overall quality of the image, all other factors being equal. However, you can create a fuzzy and low-quality image with a high MP setting with no trouble at all; the MP setting does not guarantee a great image. But if all other factors are equal, a higher MP count should yield noticeably higher image quality. Also, when you have a large MP count in your image, you have some leeway for cropping it; you can select a portion of the image to enlarge to the full size of your print, and still retain

acceptable image quality.

On the other hand, images with high MP counts eat up your storage space more quickly than those with low MP counts. If you are running low on space on your SD card and still have a lot of images to capture, you may need to reduce your Picture Size setting so you can fit more images on the card.

Extra Optical Zoom

Another point to consider is how much zoom you need or want. You might not think that picture size is related to zoom, but with the LX5 it is. The camera has a feature called Extra Optical Zoom, designated as EZ in the user's manual illustrations. (The manual sometimes calls it Extended Optical Zoom, just to confuse things.) When you set the Picture Size to 3 MP, for example (with aspect ratio of 3:2), you will find that you can zoom in further than you can with the Picture Size set to its maximum. If you try this, you will see an EZ designation appear on the LCD screen to the left of the Zoom scale, as you move the zoom lever on top of the camera toward the T setting, for Telephoto. Depending on the Picture Size setting, the scale will extend to a zoom level of as much as 6.7X normal, or about an equivalent of 160mm, rather than the ordinary maximum zoom of 3.8X or about an equivalent of 90mm.

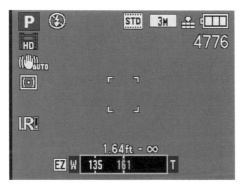

This feature needs further explanation. The lens of the LX5 has

an actual, physical focal length range of 5.1 millimeters (mm) to 19.2 mm, which you can see engraved on the end of the lens casing. At its full wide-angle (un-zoomed) setting, the lens's focal length is 5.1 mm. As with most digital cameras today, the camera's documentation converts this figure to the "35mm-equivalent," that is, to the focal length for the lens that would be the equivalent of this lens on a camera that uses 35mm film. In this case, that focal length is 24mm, which is still a very wide setting for a standard lens. The 35mm equivalent value for the fully zoomed setting of the LX5's lens is 90mm. So the 35mm equivalent zoom range for this lens is 24mm to 90mm.

Normally, the maximum zoom value for the LX5's lens is 90mm, or 3.8 times the unzoomed setting of 24mm. However, when you set the Picture Size to a value lower than the maximum 10MP, such as 3MP, the camera lets you zoom in further on the subject you are viewing using the Zoom lever. What is actually happening is the camera takes the normal area that the optical zoom "sees," and then blows it up to a larger size, which is possible because the lower MP setting means the camera is using a lower resolution and can present a larger zoomed image. Extra Optical Zoom has a maximum power of 6.7 times the normal lens's magnification.

To sum up the situation with Extra Optical Zoom, whenever you set the Picture Quality to a level below 9MP, you get a bit of additional zoom power because of the reduced resolution. In reality, you could achieve the same result by taking the picture at the normal zoom range with the Picture Quality set to the full 10MP or 9MP, and then cropping the image in your computer to enlarge just the part you want. But with Extra Optical Zoom, you do get the benefit of seeing a larger image on the LCD screen when you're composing the picture, and the benefit of having the camera perform its focus and exposure operations on the actual zoomed image that you want to capture, so the feature is not useless. You just need to decide whether it's of use to you in a particular situation.

Digital Zoom

One other note before we leave this subject: to add an extra dash of confusion, the LX5 has another feature called Digital Zoom, and still another called Intelligent Zoom. Digital Zoom is activated through the Recording menu by scrolling down through the various options until you reach Digital Zoom. You then push the right key to pop up the sub-menu, use the up or down key to select ON, and press the center button (Menu/Set) to activate the feature.

With Digital Zoom, unlike Extra Optical Zoom, you get what the user's manual calls "deterioration" of the image. As with all digital cameras, Digital Zoom is a way of further enlarging the pixels that are displayed so the image appears larger; there is no additional resolution available, so the image can quickly begin to appear blocky and of low quality. Experts often recommend staying away from this sort of zoom feature. As with Extra Optical Zoom, it might occasionally be of use to help you in viewing a distant subject. Digital Zoom has a maximum power of 15.1 times the normal lens's magnification. When you combine all of the zoom options, including Digital Zoom, there is a maximum total zoom power of about 36 times normal. Digital Zoom is not available in Intelligent Auto mode.

I'll discuss Intelligent Zoom later, as another one of the Recording Menu options.

Quality

The next setting on the Recording menu is Quality. I have already discussed the Quality setting briefly, in connection with basic picture taking. I'll mention the main information again here, in order to provide a description of all of the features on the Recording menu.

It's important to distinguish the Quality setting from the Picture Size setting. As I discussed above, Picture Size concerns the image's resolution, or the number of megapixels in the image. Quality has to do with how the image's digital information is compressed for storage on the SD card and, later, on the computer's hard drive. There are three levels of quality available: RAW, Fine, and Standard. RAW is in a category by itself, and I'll spend some time discussing how to work with files of that type. Fine and Standard are two levels of compression for computer image files which use the JPEG standard. Images saved with Fine quality are subjected to less compression than those saved with Standard quality. In other words, Standard-quality images have their digital data "compressed" or "squeezed" down to a smaller size to allow more of the files to be stored on an SD card or computer drive, with a corresponding loss of image quality. The more compression an image is subjected to, the less clear detail it will contain. So unless you are running out of space on your storage medium, you probably want to leave the Quality setting at Fine to ensure the best quality. (Of course, you may prefer to shoot in the RAW format for maximum quality.)

With the LX5, besides choosing one of the individual Quality settings (RAW, Fine, or Standard), you also have the option of setting the camera to record images in RAW *plus* either Fine or Standard. If you choose that option, the camera will record each image in two files—one RAW, and the other a JPEG file in either Fine or Standard quality, depending on your selection. If you then play the image back in the camera, you will see only one image, but if you copy the files to your computer, you will find two image files; one with a .jpg extension and one with an .rw2 extension. The RAW file will be much larger than the JPEG one. In a few examples I just looked at on my computer, the RAW files were all about 11 MB and the corresponding JPEG files were between about 2.7 and 4 MB.

Why would you choose the option of recording images in

RAW and JPEG at the same time? Say you're taking pictures of a one-time event such as a wedding or graduation. You may want to preserve them in RAW for the highest quality, but also have them available for quick review on a computer that might not have software that reads RAW files, or you might want to be able to send them to friends quickly without translating them from RAW into a JPEG format that most people can easily view on their computers. Here, again, this is an option that's open to you if space on your SD card is not a major consideration. If you have a high-capacity card, or multiple cards available, you may want to take advantage of both ways to record images.

Sensitivity

The next setting on the Recording menu is Sensitivity, which lets you set the ISO to Auto ISO, Intelligent ISO, or a specific numerical value. This topic calls for some background discussion of ISO. These initials stand for International Standards Organization. When I first started in film photography a few decades ago, this standard was called ASA, for American Standards Association. The ISO acronym reflects the more international nature of the modern photographic industry.

Originally the ISO/ASA standard designated the "speed," or light sensitivity, of film. So, for example, a "slow" film might be rated ISO 64, or even ISO 25, meaning it takes a considerable amount of exposure to light to create a usable image on the film. Slow films yield higher-quality, less-grainy images than faster films. There are "fast" films available, some black-and-white and some color, with ISO ratings of 400, or even higher, that are designed to yield usable images in lower light. Such films can often be used indoors without flash, for example.

With digital technology, the industry has retained the ISO concept, but it applies not just to film, but to the light sensitivity of the camera's sensor, because there is no film involved in

a digital camera. The ISO ratings for digital cameras are supposed to be essentially equivalent to the ISO ratings for films. So if your camera is set to ISO 100, there will have to be a good deal of light to expose the image properly, but if the camera is set to ISO 1600, a reasonably well exposed (but "noisier" or "fuzzier") image can be made in very low light.

The upshot is that, generally speaking, you want to shoot your images with the camera set to the lowest ISO possible that will allow the image to be exposed properly. (One exception to this rule is if you want, for creative purposes, the grainy look that comes from shooting at a high ISO value.) For example, if you are shooting indoors in low light, you may need to set the ISO to a high value (say, ISO 800) so you can expose the image with a reasonably fast shutter speed. If the camera were set to a lower ISO, it would need to use a slower shutter speed to take in enough light for a proper exposure, and the resulting image would likely be blurry and possibly unusable.

To summarize: Shoot with low ISO settings (around 100) when possible; shoot with high ISO settings (say 400 or higher, up to 1600 or even 3200) when necessary in dimmer light to allow a fast shutter speed to stop action and avoid blurriness, or when desired to achieve a creative effect with graininess.

With that background, here are the details on the Sensitivity setting. The possible numerical values are 80, 100, 200, 400, 800, 1600, 3200, 6400, and 12800, unless you change the ISO Increments setting, discussed below. You need to note one very important caveat, though: If you set the ISO to a number higher than 3200, the camera automatically reduces the resolution of the images that will be recorded to 3.5 MP, 3 MP, or 2.5 MP, depending on the aspect ratio that is in effect. Also, with those high ISO settings, you cannot set the Quality to RAW. So, although those very high ISO settings are available, they come with a major tradeoff in terms of image size and quality. (And that's in addition to whatever loss in quality re-

sults from the noise that is introduced by the use of the high ISO value.)

When you set a numerical value for Sensitivity, you cannot then set ISO Limit (discussed below). When you set Sensitivity to Auto, the camera automatically adjusts ISO to the maximum value set with ISO Limit, if any has been set, based on the brightness of the scene. When you use the Intelligent ISO setting, the camera adjusts the ISO based on the movement of the subject as well as the brightness, so you can use a higher shutter speed to stop the motion. Note that you can use the right cursor button, marked ISO, to get immediate access to the Sensitivity setting without having to use the menu system.

When would you want to use the Sensitivity setting? One example is if you want the highest quality for your image, and you aren't worried about camera movement, either because you are using a tripod so a slow shutter speed won't result in blur, or it's bright enough to use a fast shutter speed. Then you could set the ISO to its lowest possible setting of 80 to achieve high quality. On the other hand, if you definitely want a grainy, noisy look, you can set the Sensitivity to 1600 or even higher to introduce noise into the image. You also might want a high ISO setting in order to use a fast shutter speed in low light. In many cases, though, you can just leave the setting at Auto and let the camera adjust the ISO as needed.

ISO Limit Set

This option lets you set an upper limit for how high the camera will set the ISO, when you have set Sensitivity to either Auto ISO or Intelligent ISO, as discussed above. The choices for this setting are Auto, 200, 400, 800, 1600, and 3200. When the Sensitivity is set to Auto ISO and ISO Limit is set to Auto, then the camera will set the ISO in a range up to 400 when flash is not used, and up to 1000 when flash is used. When the Sensitivity is set to Intelligent ISO and ISO Limit is set to Auto, then the

camera will set the ISO in a range up to 1600 when flash is not used, and up to 1000 when flash is used.

ISO Increments

Using this option, you can expand the range of values available for the setting of ISO. Normally, ISO is set only at the numerical values noted above; if you select the increment of 1/3 EV instead of the normal 1 EV, then several interpolated values for ISO are added, such as 125, 250, 500, 640, and 5000. You can then set these values from the Sensitivity menu item.

White Balance

One issue that arises in all photography is that film, or a digital camera's sensor, reacts differently to colors than the human eye does. When you or I see a scene in daylight or indoors under various types of artificial lighting, we generally do not notice a difference in the hues of the things we see depending on the light source. However, the camera's film or sensor does not have this auto-correcting ability. The camera "sees" colors differently depending on the "color temperature" of the light that illuminates the object or scene in question. The color temperature of light is a numerical value that is expressed in a unit known as kelvins (K). A light source with a lower kelvin rating produces a "warmer" or more reddish light. A light source with a higher kelvin rating produces a "cooler" or more bluish light. For example, candlelight is rated at about 1,800 K; indoor tungsten light (ordinary light bulb) is rated at about 3,000 K; outdoor sunlight and electronic flash are rated at about 5,500 K; and outdoor shade is rated at about 7,000 K.

What does this mean in practice? If you are using a film camera, you may need a colored filter in front of the lens to "correct" for the color temperature of the light source. Any given color film is rated to expose colors correctly at a particular

color temperature (or, to put it another way, with a particular light source). So if you are using color film rated for daylight use, you can use it outdoors without a filter. But if you happen to be using that film indoors, you will need a color filter to correct the color temperature; otherwise, the resulting picture will look excessively reddish because of the imbalance between the film and the color temperature of the light source. With a modern digital camera, you do not need to worry about filters, because the camera can adjust its electronic circuitry to correct the "white balance," which is the term used in the context of digital photography for balancing color temperature.

The LX5, like many digital cameras, has a setting for Auto White Balance, which lets the camera choose the proper color correction to account for any given light source. You get access to this setting through the Recording menu. Once you reach the White Balance line, press the right cursor button to pop up the sub-menu. You then have the following choices for the White Balance setting, most of them represented by icons: Auto White Balance (AWB); Outdoors, clear sky (sun icon); Outdoors, cloudy sky (cloud); Outdoors, shade (building); Flash only (lightning bolt with WB); Incandescent light (light bulb); Preset white balance 1 (number 1); Preset white balance 2 (number 2); Preset color temperature (the word "Set" with the letter K). (The last three options are not shown on the screen below; you need to scroll down to reach them.)

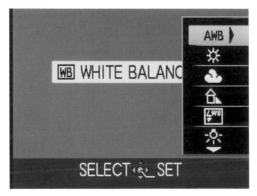

Most of the above settings are self-explanatory. You may want to experiment, though, and see if the named settings (outdoor sun, outdoor shade, etc.) produce the results you want. If not, you'll be better off setting the white balance manually.

To set white balance manually, select the White Balance option in the Recording menu, then press the right key to pop up the sub-menu and scroll to select Preset number 1 or 2. Then press the right key, and a rectangle will appear in the middle of the LCD screen. Aim the camera at a sheet of white paper under the light source you will be using, and fill the rectangle with the image of the white paper. Then press the center button (not the shutter button) to lock in that white balance setting. Now, until you change that setting, whenever you select that Preset (1 or 2, as the case may be), it will be set for the white balance you have just set. This system can be very useful if you often use a particular light source, and want to have the camera set to the appropriate white balance for that source.

To set the color temperature directly by number, choose the Set K option from the White Balance menu. Then press the right key to pop up a screen with the value 2500K showing. You then can use the up and down arrows to adjust that value, anywhere from 2500K up to 10000K in increments of 100K.

But we're not done yet—there's one more level we can take this white balance adjustment to. If you really want to tweak the white balance setting to the nth degree, after you have selected your desired white balance setting and made any further selections, such as the numerical color temperature, or setting the balance with a white sheet of paper, before pressing the center button, press the right button one more time, and you will be presented with a screen for fine adjustments. You will see a pair of axes that intersect at a zero point, marked by a yellow dot. The four ends of the axes are labeled G, B, M, and A, for Green, Blue, Magenta, and Amber.

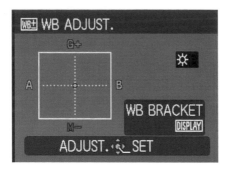

You can now use all four directional buttons to move the yellow dot away from the center toward any of the axes, to adjust these four values until you have the color balance exactly how you want it. The camera will remember this value whenever you select the white balance setting that you fine-tuned. A little wrench shows up on the LCD screen beside the white balance setting when you have fine-tuned the setting using this screen.

One final note: If you're shooting in RAW Quality, you don't have to worry about white balance at all, because, once you import the RAW file into your software, you can change the white balance however you want. This is one of the marvels of RAW. If you had the camera's white balance setting at Incandescent while shooting under a bright sun, you can just change the white balance setting to Daylight in the RAW software, and no one need ever know about the error of your shooting.

White Balance Bracket

There is still one more aspect of white balance that needs to be discussed. Later on, I'll discuss exposure bracketing, also known as Auto Bracket, a feature by which the LX5 automatically takes three pictures at varying exposure settings, so you can have three options to choose from. You can do something similar with white balance—set the camera to take three images at once with different white balances, to give you a better chance of having one image with the perfect

color balance. I'm discussing this option here rather than in the section on Auto Bracket, because this option is accessed from the white balance setting screen.

Here is how to set up white balance bracketing. In the Recording menu, select white balance, then select a main setting, such as Daylight or Incandescent. Press the right button to access the fine adjustment screen, and press Display to activate white balance bracketing.

You can then use the up or right cursor button to set up an interval for the three images to be taken. When you press one of these buttons you will see three small, yellow dots appear on the horizontal or vertical axis, indicating the interval on the green to magenta or blue to yellow axis. Press the Menu/Set button twice to lock in the settings and exit the menu system. You will see the white balance bracket icon on the LCD screen. (The icon looks like a stack of rectangles with the letters WB on top.) Press the shutter release, and three images will be recorded with one shutter actuation, with slight variations in the white balance, according to your settings. This function does not work with RAW images, and does not work in Intelligent Auto or Motion Picture mode.

Face Recognition

This function is related to Face Detection, which I'll talk about later, in the discussion of autofocus modes. I'm not going to

spend a lot of time on Face Recognition, other than to go over the basics of its operation, in case you want to try it out. You can select this item on the Recording menu, and the camera will let you take up to three pictures each of three different people, to "register" their faces in the camera's memory. Then, when you take a picture of a scene that includes one of those faces (assuming the camera recognizes it), the camera will direct its focus and exposure to that face.

AF (Autofocus) Mode

This setting on the Recording menu lets you select among five different autofocus methods: Face Detection, AF Tracking, 23-Area, and 1-Area. Here is how they work:

Face Detection: When you select this setting, the camera does not display any focusing brackets or rectangles until it detects a human face. If it does, it outlines the general area of the face with a yellow rectangle. Then, when you press the shutter button halfway down, the rectangle turns green when the camera has focused on the face. If the camera detects more than one face, it displays white rectangles. Any faces that are the same distance away from the camera as the face within the yellow rectangle will also be in focus, but the focus will be controlled by the face in the yellow rectangle.

As you might expect, Face Detection is not a perfect system. If conditions do not permit the camera to properly detect a face or faces, it is best to switch to another autofocus mode to avoid confusion. Face Detection cannot be used in Motion Picture recording or in the following varieties of Scene mode: Panorama Assist, Night Scenery, Food, Starry Sky, and Aerial Photo. Face Detection is automatically activated in Intelligent Auto mode. It is the initial setting for the following Scene types: Portrait, Soft Skin, Self Portrait, Night Portrait, Party, Candle Light, and Baby.

112

AF Tracking: This next setting for AF Mode allows the camera to maintain its focus on a moving subject. As with other AF modes, set this one using the Recording menu. Scroll down to AF Mode, press the right button to bring up the submenu, and then select the second icon, which is a group of offset focus frames, designed to look like a moving focus frame. With this mode set, place the camera's focus frame on the moving subject and press the AF/AE Lock button, above and to the left of the array of five buttons on the back of the camera. The camera will then do its best to keep the moving target in focus. It will display yellow brackets that should stay close to the subject on the LCD screen. When you are ready, press the shutter button to take the picture. If you want to cancel AF Tracking, press the AF/AE Lock button again.

If the camera is not able to maintain focus on the moving subject, the focus frame will turn red and then disappear. AF Tracking will not work when you're recording a movie; 1-Area mode will be used instead. AF Tracking also cannot be used in the following Scene mode types: Panorama Assist, Starry Sky, and Fireworks. However, it is available in Intelligent Auto mode by pressing the Focus button, and it is initially turned on for the Pet scene type, though you can switch to another focus method if you want.

When would you use AF Tracking? The idea here is to reduce the time it takes for you to be able to take a picture of a moving subject. If you are trying to snap a picture of your restless four-year-old or your fidgety Jack Russell Terrier, AF Tracking can give you a head start, so the camera's focus is close to being correct, and the focusing mechanism has less to do to achieve correct focus when you suddenly see the perfect moment to press the shutter button.

23-Area: This method of focusing causes the camera to focus on up to 23 smaller focus areas within the overall autofo-

cus area, which is the same area as that of the current aspect ratio setting. You cannot select which of the 23 areas the camera focuses on; it selects however many areas it detects that are at the same distance from the camera and can be focused on. When you use the 23-Area focusing method, once you push the shutter button down halfway, the camera will display green rectangles to show you which of the multiple focus areas it has selected to focus on.

The 23-Area method can be useful if your subject is not in the center of the screen and you don't want to be bothered moving the focus point around. With this method, the camera provides a broad range of focus areas, and, if it finds a subject to focus on within the area that has been defined for it, it establishes the focus on that subject.

1-Area: This method causes the camera to focus on the center area of the screen. The camera uses a single, small focusing rectangle that you can move around the screen as you wish, in one of two ways. If you have just scrolled to AF Mode on the menu, you can press the right key while the 1-Area selection is highlighted, to move directly to setting the location of the autofocus rectangle using the direction buttons.

Or, if you are not in the menu system, you can press the Focus

button (the up cursor button), and then use the cursor buttons to move the focus rectangle as you wish. Then press the center button to fix the rectangle in place. If you want to move the focus area back to the default selection in the middle of the screen, press the Focus button to return control to the focus brackets, then press the Display button at the bottom left of the area with buttons on the back of the camera. The focus area will also move back to its starting position when the camera is switched to Intelligent Auto mode, enters sleep mode, or is turned off.

In addition, whenever the focus rectangle is activated, as indicated by the presence of yellow triangles on each side of the rectangle, you can change the size of the rectangle by turning the rear dial to one of four positions. You can reset the size (as well as the position) of the rectangle to normal using the Display button. The size will be reset to default when you turn off the camera, and your chosen size cannot be saved as a custom setting.

The 1-Area method is a very good one to use for general shooting, because it lets you quickly move the focus area to just where you want it. I prefer using this method to letting the camera choose from among 23 areas with no input from me.

Pre AF

This next function on the Recording menu has three possible settings: Off, Q-AF, for Quick Autofocus, and C-AF, for Continuous Autofocus. They are set in the normal way, scrolling down to the line for PRE-AF, then using the right key to pop up the sub-menu. If you set the camera to Q-AF, the camera will focus on the subject whenever the camera has settled down and is quite still, with only minor movement or shake. You do not need to press the shutter button halfway down to achieve focus; the camera focuses on its own. If you select C-AF, the camera focuses continuously without your pressing

the shutter button halfway down, and does not wait for movement to settle down.

The advantage of these modes is that you will have a slight improvement in focusing time, because the camera does not wait until you press the shutter button to start the focusing process. The disadvantage is that the battery will run down faster than usual, especially in C-AF mode. So unless you believe that a split second for focusing time is critical, I would stay away from these settings, and leave this menu option set to Off. The camera will still focus automatically when you press the shutter button halfway down; it just will take a little bit longer.

AF/AE Lock

This setting lets you change the function of the AF/AE Lock button, which is located to the upper left of the array of five buttons on the back of the camera. You can use this menu item to set that button to lock both autofocus and auto-exposure settings, or just one or the other. The camera will indicate on the LCD display, just below the image stabilization icon, which of the two values are locked, once you press the AF/AE Lock button and the values are locked in. It is not possible to lock exposure using the AF/AE button in Manual shooting mode (unless Sensitivity is set to Auto) or in Scene mode, even though the display will still show the AE indicator if the button is set to lock exposure.

Metering Mode

The next option on the Recording menu lets you choose what method the camera uses to meter the light and determine the proper exposure. The LX5 gives you a choice of three methods: Multiple, Center-weighted, and Spot. If you choose Multiple, the camera evaluates the brightness at multiple spots in the image that is shown on the LCD screen, and calculates an

exposure that takes into account all of the various values. With Center-weighted, the camera gives greater emphasis to the brightness of the subject(s) in the center of the screen, while still taking into account the brightness of other areas in the image. With Spot, the camera evaluates only the brightness of the subject(s) in the small spot-metering area.

The user's manual recommends using Multiple mode, presumably on the theory that it produces a reasonable choice for exposure, based on evaluating the overall brightness of everything seen on the LCD screen. However, if you want to make sure that one particular item in the scene is properly exposed, you may want to use the Spot method, and aim the spot metering area at that object or person, then lock in the exposure.

Choosing your metering method is less complicated than some other choices. Just enter the Recording menu and scroll down to the line for Metering Mode, then press the right arrow to activate the sub-menu with the three choices. The first icon, a rectangle with a pair of parentheses and a dot inside, represents Multiple mode; the second, a rectangle with a pair of parentheses inside, represents Center-weighted; and the third, a rectangle with just a dot inside, represents Spot.

With Multiple or Center-weighted, metering is quite simple: point the camera at the subject(s) you want and let the camera compute the exposure. If you choose Spot as your metering technique, the process can be more involved. Presumably, you

will have a fairly small area in mind as the most important area for having the correct exposure; perhaps it is a small object you are photographing for an online auction. The LCD screen will display a small + sign in the center of the focusing brackets, and you need to be sure that the + is over the most important object. If that object is not in the center of the screen, then you may need to use the AE Lock control, which is operated by the small button just to the right of the LCD on the back of the camera. If you want that button to lock only the exposure, as discussed above, you can set that limitation through the Recording menu, on the AF/AE Lock line. Just select AE Lock. Of course, the chances are pretty good that if you want to expose one object correctly you will also want to focus on that object, so it's often going to be okay to leave the AF/AE lock button set to lock both autofocus and auto-exposure.

Aim the camera so the + in the middle of the screen touches the object to be exposed correctly, then press the AE Lock button. The LCD will show that AE-L (or AE-L and AF-L) has been engaged. You can now move the camera back to compose the picture as you want it, perhaps with the correctly exposed object off to one side. The exposure setting will not change as you re-compose the image. Press the shutter button, and the image is exposed as you wanted it. The AE-Lock stays in effect until you cancel it by pressing the AE-Lock button again.

Note that there is a sparsely-documented feature of the camera that lets you move the little + around the camera's screen so that you can place it right over the area of the picture that you want properly exposed. This will work only if, in addition to using the Spot metering mode, you are also using the 1-Area autofocus method. In that case, whenever you move the focusing target, the Spot-metering target moves along with it, so the target serves two purposes at once.

Some more notes on Metering Mode: This setting is not available in the Intelligent Auto or Scene modes. The LCD screen indicates which metering mode is active through an icon near the top left of the screen, below the recording mode and image stabilization icons. When Multiple metering is selected and the autofocus mode is set to Face Detection, the camera will attempt to expose a person's face correctly, assuming a face has been detected.

Intelligent Exposure

The Intelligent Exposure, or I.Exposure, setting causes the camera to adjust the exposure automatically to compensate for a situation in which there is a large difference in brightness between the background and the subject of the picture. It is not available when the Quality is set to RAW, so you need to set Quality to Standard or Fine to use this feature. It also is not available in the Intelligent Auto or Scene modes. This feature can be set to Off, Low, or High, depending on how dramatic an effect you wish to achieve. When it is turned on to either level, its icon (an i with a dark and white circle) appears on the screen in black and white. When the feature is actually being triggered by the lighting conditions, the icon turns yellow.

The function of this option is to boost the ISO setting slightly, in the shadowed areas of the image only, when there is so much contrast in the scene as to cause the loss of details in shadows. The ISO will be raised enough to bring out more de-

tails in the shadowed areas. Its particular value lies in the fact that it can selectively alter the ISO setting for only the part of the image where that alteration is called for.

Multiple Exposure

This function is more in the category of trick or creative photography than control of normal image-making. In a nutshell, it lets you create double or triple exposures in the camera. The steps to take are a bit unusual, because you actually carry out the picture-taking while in the Recording menu system.

Enter the Recording menu and scroll down to Multi. Expo, then press the right button, which takes you to a screen with the word Start highlighted. Press the center button (Menu/Set) to select Start. The screen then has the word End displayed; you can press the center button to end the process if you have had second thoughts.

If you are going to proceed, then compose and take the first picture. At this point the screen will display the image you just took along with the choices Next, Retake, and Exit. If you're not satisfied with the first image, scroll to Retake and select that option with the center button, then retake the first image. If you're ready to proceed to taking a superimposed image, leave Next highlighted and press the shutter button halfway down, or, if you prefer, press the Menu/Set button. This action produces the interesting effect of leaving the first image on the screen and making the screen live at the same time to take a new image. Compose the second shot as you want it, while viewing the first one, then press the shutter button fully to record that image. You can then repeat this process to add a third image, retake the second image, or exit the whole process. When you are done, you will have a single image that combines the two or three superimposed images you recorded.

120

Before you take the images using the Multiple Exposure procedure, the menu gives you the option of setting Auto Gain on or off. If you leave it on, the camera adjusts the exposure based on the number of pictures taken; if you turn it off, the camera adjusts the exposure for the final superimposed image. In my experience, the On setting produces results with clearer images of the multiple scenes; Off produces fainter images.

For the image below, I shot in RAW + JPEG and used the RAW file for editing. I boosted the brightness, contrast, and saturation somewhat in the Adobe Camera Raw software before importing it into Photoshop for final editing.

Minimum Shutter Speed

The setting for Minimum Shutter Speed lets you set the slowest shutter speed the camera will use, in a range from 1/250 second to one full second. You can use this setting when you want to avoid the camera shake that is likely to result from a slow shutter speed, such as 1/4 second. When you select any setting other than the default, which is AUTO, the camera displays the indicator MIN along with the minimum shutter speed in the lower right corner of the LCD screen. With the AUTO setting, the camera will use any shutter speed up to one full second, if the camera is steady or the Stabilizer is turned off. If camera shake is an issue, the camera will not use speeds

121

slower than about ¼ second. If the camera cannot achieve a proper exposure using a specific setting, the MIN indicator flashes in red when you press the shutter button halfway, meaning there is not enough light available. The camera will still take the picture if you continue to press the shutter button fully down; it has warned you, but will follow your instructions. In effect, this setting is a low-light alarm that you can ignore if you want to. I always leave this setting on AUTO.

Note that this setting only has any effect when you are shooting in Program mode, either by setting the Mode dial to P, or by setting it to C1 or C2, with a custom setting that includes Program mode. This makes sense, because there are likely to be times when you would be hampered by having a minimum shutter speed of one second, the slowest available with this setting. For example, if you're taking a long exposure in a dark area, or shooting infrared photos (see Chapter 9), you may need an exposure of several seconds. If you're in a situation like that, you have to remember not to set the camera to Program mode. You can choose Aperture Priority, Shutter Priority, Manual, or Scene mode. Note, though, that in Aperture Priority or Shutter Priority mode, the slowest shutter speed available is 8 seconds, whereas you can set it to a full 60 seconds in Manual mode. Also, as discussed earlier, some of the Scene types include long exposure times.

Burst

Burst mode has only two settings: On or Off. Off means no burst of shots is selected. On (represented by the icon showing multiple image rectangles) means the camera will continue taking pictures while you hold down the shutter button, but only within rather restrictive limits. This is one area in which the LX5 unfortunately fails to keep pace with its predecessor, the LX3, which offered an Unlimited Burst mode, although with reduced image quality. However, note that the LX5 has a

very strong movie recording capability, and you can save a still image (with reduced size and quality) from a motion picture by pressing the Menu/Set button during paused playback. So, if you ever really need to take continuous photos for an extended period, consider recording the scene as a movie and selecting individual shots later.

Here are some guidelines. Shooting RAW or Fine images in Program mode with no flash, you will get no more than three shots in your burst. Shooting Standard images, you will get no more than five shots. You cannot use the flash with this mode. However, there is some good news: You can use Burst mode in almost any shooting mode for still images.

Another way to turn on continuous shooting is to rely on the settings in Scene mode for Hi-speed Burst and Flash Burst, discussed earlier. The Flash Burst setting is the only way to get any burst of shots with the built-in flash operating. Also, using Scene mode ensures that the optimum settings are used to achieve the greatest possible burst with or without the flash. The assumption is that if you choose this mode, you have made a decision that quantity and speed of shooting are considerably more important than the quality of the shots, and the camera's burst settings in Scene mode will make the necessary adjustments to achieve quantity and speed.

There are other limitations to Burst mode. First, the focus, exposure, and white balance are locked in when the first picture is taken. When the self-timer is set, the burst is limited to three shots. Also, you have to remember to cancel Burst shooting yourself. If you do not, the camera will leave Burst set, even after the camera is turned off and then on again.

Intelligent Resolution

The Intelligent Resolution, or I.Resolution, option can be set

123

to Off, Low, Standard, or High. This setting increases the apparent resolution in images by providing additional sharpening through in-camera digital manipulation. It does seem to improve image quality somewhat in certain situations. I recommend that you try shooting with it turned on and off to see if it provides actual benefits for your shots.

Intelligent Zoom

The Intelligent Zoom, or i.zoom option is related to the I.Resolution setting, discussed above. When i.zoom is turned on, the camera takes advantage of the I.Resolution processing to improve the appearance of the image, so you can zoom to a higher level of magnification without image deterioration, using either normal optical zoom or Extra Optical Zoom. For example, without the i.zoom setting, the limit for the optical zoom is 3.8X; with i.zoom turned on, the maximum is 5X. The question of image quality in this situation is a matter of judgment; as with I.Resolution, I recommend that you try this setting to see if you are satisfied with the quality of the images. If so, you can then use an effective zoom range up to 120mm, rather than the 90mm of the optical zoom alone.

Digital Zoom

I discussed the Digital Zoom feature earlier in connection with Picture Size and Extra Optical Zoom. Before I discuss it again, note a few restrictions: Digital Zoom is not available if you have the camera set to Intelligent Auto mode or if you have Intelligent ISO turned on. Also, it is not available if you have Quality set to RAW. To recap its use briefly, you access Digital Zoom through the Recording Menu and turn it either on or off. Remember, this is really an artificial sort of zoom that does not give you any added "real" magnification; it just enlarges the existing image, making it fuzzy and blocky if you use too much of it. It's best avoided, except possibly for helping

you view a distant object while composing your shot.

Step Zoom

This is a useful feature that was not available on the Lumix LX3. When this function is turned on through the Recording Menu, you can zoom the lens to specific focal lengths. Starting from the wide-angle setting of 24mm, you can zoom to settings of 28mm, 35mm, 50mm, 70mm, and 90mm, the full extent of the optical zoom. (If the aspect ratio is set to 1:1, the zoom settings are somewhat different.) If you have activated Intelligent Zoom, Extra Optical Zoom, or Digital Zoom, the available focal lengths increase accordingly. To move to a particular zoom increment, give a short nudge to the Zoom lever, and the zoom indicator will move to the next numbered setting and stop. This option can be of particular use if you happen to have an external optical viewfinder with a particular focal length setting, and want to set the camera's focal length to correspond to the viewfinder's frame lines.

The one problem with using this feature is that you cannot zoom to any focal length other than the specified ones. Therefore, you can't fine-tune your focal length to frame a subject; you can only zoom to one of the available settings. There is a trade-off between having complete control over your zoom range and having a repeatable, precise value for your zoom. It's good to be able to have this choice, though, for particular situations in which it is useful.

Stabilizer

The LX5 is equipped with an image stabilization system, which works to minimize the effect of camera shake on the image. There are four available settings: Off, Auto, Mode 1, and Mode 2. With Auto, the camera's circuitry determines the best of the two modes to use, depending on conditions. With Mode 1, the

125

camera continuously compensates for camera shake while in Recording mode. With Mode 2, the camera does not compensate for shake until the shutter button is pressed.

The camera automatically uses Mode 2 in the Self Portrait style of Scene mode, and automatically turns all stabilization off in Starry Sky mode (because you'll be using a tripod). Stabilization cannot be turned off in Intelligent Auto mode. It cannot be set to Auto or Mode 2 in Motion Picture mode. The status of the stabilization setting is displayed by an icon of a hand surrounded by wavy lines on the upper left of the LCD screen; the mode is indicated by either Auto, 1, 2, or Off.

You get access to the Stabilizer menu through the Recording menu, pressing the right key to pop up the sub-menu with the four options. Mode 1 will use up the battery faster, because it continuously counters any camera shake, while Mode 2 waits until the shutter is pressed. Neither mode will do much good if there is a lot of camera shake present, or if you are operating under conditions that magnify camera movement, such as using a long focal length with no tripod and a slow shutter speed.

I leave the setting at Auto, which causes the camera to use Mode 1 when zoomed in to telephoto and Mode 2 at wide-angle. This setting makes sense, because there is more likely to be noticeable camera shake at the telephoto focal length, and it can be helpful to see the effects of stabilization on the LCD while you're composing the image in that situation. At the wide-angle setting, stabilization is not so much of an issue, and it is probably better to preserve battery life by leaving the stabilization to take place when the shutter button is pressed.

Autofocus Assist Lamp

The autofocus (AF) assist lamp is a reddish light on the front of the camera, near the lens below the hot shoe and the Mode

dial. The lamp illuminates when the ambient lighting is dim, to help the autofocus mechanism achieve proper focus by providing enough light to define the shape of the subject. Ordinarily, this option is left turned on for normal shooting, because the light only activates when it is needed because of low-light conditions. However, you have the option of setting it to the off position so that it will never turn on. You might want to do this if you are trying to shoot your pictures without being detected, or without disturbing a subject such as a sleeping animal.

In Intelligent Auto mode, you cannot turn off the AF assist lamp. In some of the Scene types, such as Scenery and Night Scenery, the AF assist lamp cannot be turned on. The lamp does not illuminate when you are using manual focus (unless you press the Focus button to give you an autofocus assist during the manual focusing process).

Flash

The Flash item on the Recording menu is available for adjustment only if the built-in flash is popped up or a compatible external flash unit is attached to the hot shoe. The available settings vary somewhat according to the shooting mode. In most modes, the available settings for Flash are Auto Flash, Auto Flash with Red-Eye Reduction, Forced Flash On, and

Slow Sync with Red-Eye Reduction.

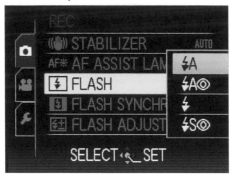

Note that the list does not include Forced Flash Off, because you can choose that option by stowing the flash unit back inside the camera. In Intelligent Auto mode, the flash is set to Auto Flash, and you have no control over that setting, although the camera will vary the automatic flash setting as needed.

There's one other option that ordinarily does not appear on the menu: Forced Flash On with Red-eye Reduction. That option only appears in two contexts: when you are in Scene mode, with the scene type of Party or Candle Light. Otherwise, that option is not available for you to choose.

If you place into the hot shoe a flash unit that speaks the LX5's language, and turn it on, then the Flash menu item gives you at least five options, including Forced Flash Off. You could turn off the external flash unit using its own power switch, but for some reason the camera is programmed to let you force the external flash off through software, even though you can't turn off the built-in flash unit in this way. You have to stuff the built-in flash unit back down into the camera to force it off.

Later, I'll discuss when to use the various Flash options.

Flash Synchro

This setting is one you may not have a lot of use for, unless you encounter the particular situation it is designed for. Flash Synchro has two settings—1st and 2nd. Although the user's manual does not use this terminology, the 1st and 2nd are references to 1st-curtain sync and 2nd-curtain (also known as rear-curtain) sync. The normal setting is 1st, which causes the flash to fire early in the process when the shutter opens to expose the image. If you set it to 2nd, the flash fires later, just before the shutter closes.

The reason for having the 2nd-curtain sync setting available is that it can help you avoid having a strange-looking result in some unusual situations. This issue arises when you are taking a relatively long exposure, say one second, of a subject with taillights, such as a car or motorcycle at night, that is moving across your field of view. With 1st-curtain sync, the flash will fire early in the process, freezing the vehicle in a clear image. However, as the shutter remains open while the vehicle keeps going, the camera will capture the moving taillights in a stream that appears to be extending in front of the vehicle. If, instead, you use 2nd-curtain sync, the initial part of the exposure will capture the lights in a trail that appears behind the vehicle, while the vehicle itself is not frozen by the flash until later in the exposure. Therefore, with 2nd-curtain sync in this particular situation, the final image is likely to look more natural than with 1st-curtain sync.

To sum up the situation with 1st and 2nd Flash Synchro settings, a good general rule is to always use the 1st setting unless you are sure you have a real need for the 2nd setting. Using the 2nd setting makes it harder to compose and set up the shot, because you have to anticipate where the main subject will be when the flash finally fires late in the exposure process.

When the setting is 2nd, the indication "2nd" appears next to the flash icon when the flash is on.

The Flash Synchro setting is not available in Intelligent Auto mode, Motion Picture mode, or with any of the Scene types.

Flash Adjustment

This is a nice capability to have. The Flash Adjustment menu item lets you lower or raise the intensity of the flash, which can be useful in situations in which the subject is very small, or reflectivity is unusually high or low.

Navigate to this item, press the right button to pop up the submenu, and you are presented with the flash intensity screen.

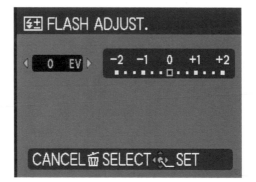

Use the right and left cursor buttons to increase or decrease the EV of the flash up to 2 full levels in either direction. This setting stays in place even when the camera is turned off and then back on. So you need to be careful to reset the flash output adjustment to zero (unchanged) when you are done with it. The LCD screen will help you remember that it's set on, by displaying an icon showing the amount of positive or negative flash output value, in the upper left of the screen, just to the right of the image stabilization icon. The flash output adjustment is not available in Intelligent Auto mode or when using the Flash Burst setting in Scene mode.

The Flash Adjustment option works fine with external flash units that are attached to the LX5's hot shoe, if they operate automatically in TTL (through-the-lens) mode and communicate properly with the camera. With such external flash units, you can raise or lower the output of the flash in exactly the same way as with the built-in flash unit. The two units that I have tested this operation with are Panasonic's own flash for the LX5, the DMW-FL220, and the Metz Mecablitz 36 AF-4. There undoubtedly are other external flash units that will also operate in this way.

Red-eye Removal

This setting on the Recording menu is not to be confused with Red-eye Reduction, which is an aspect of how the flash fires. "Red-eye" is the unpleasant phenomenon that crops up when a flash picture is taken of a person, and the light illuminates his or her retinas, causing an eerie red glow to appear in the eyes. One way the LX5 (like many cameras) deals with this problem is with the Red-eye Reduction setting for the flash, which causes the flash to fire twice: once to make the person's eyes contract, reducing the chance for the light to bounce off the retinas, and then a second time to take the picture.

The LX5 has a second line of defense against red-eye, called Red-eye Removal. When you select this option, then, whenever the flash is fired and Red-eye Reduction is activated, the camera also uses a digital red-eye correction method, to actually remove from the image the red areas that appear to be near a person's eyes. This option operates only when the Face Detection setting is turned on.

Personally, I would not use this option, because I process my images using Photoshop or other software, and it's easy to fix red-eye at that stage. But this option could be convenient if you take lots of photos at a gathering and want to share them quickly, without a lot of processing.

131

Optional Viewfinder

This function can be set to either Off or On, depending on whether or not you have an optional external viewfinder attached to the camera. The LX5, like many compact digital cameras (as opposed to DSLRs), does not have a built-in viewfinder, but forces you to rely exclusively on its LCD screen to compose pictures. This system works quite well in normal light conditions, but in bright outdoor light or very dim light it can become difficult to see the screen. In addition, some photographers like to be able to hold the camera up to their eye rather than hold it out to see the LCD screen. Therefore, as we will discuss in the section on accessories, Panasonic offers an optional external viewfinder that attaches to the camera's hot shoe and lets you compose photographs without the use of the LCD screen. If you attach an external viewfinder (from Panasonic or another maker), you may want to turn off the LCD display to conserve battery power.

The On setting of this option lets you turn the LCD screen off. Actually, it adds the turned-off-screen option to the cycle of options you get when you press the Display button on the back of the camera. With Opt. Viewfinder set to On, pressing the Display button in Recording mode cycles through the following options: full display information; focus brackets only; focus brackets and gridlines; display off. With Opt. Viewfinder set to Off, you get the same options, minus the display off option. When the display is turned off through this setting, the green status light to the left of the Focus button on the camera's back lights up to let you know that the display is off by choice, and that the camera is still powered up and functioning. Also, although the LCD does not display the image that the camera sees, the screen does display a green dot to confirm focus, as well as the icon that shows the status of the flash unit.

At this writing, Panasonic offers two different kinds of optional viewfinder—an optical viewfinder, the DMW-VF1, and

an electronic model, DMW-LVF1. This menu option is only needed when using the optical viewfinder; when the electronic one is attached, its controls can turn off the LCD display. I discuss the viewfinders in Appendix A.

Conversion

This setting is needed only if you attach an optional wide-angle conversion lens, such as Panasonic's DMW-LWA52, to the normal lens of the camera, using an adapter such as the DMW-LA6. If you attach the conversion lens, turn this option on so the lens stays at the wide-angle setting and the camera optimizes the image for the use of the conversion lens.

Auto Bracket

Auto Bracket is a function that lets you take three exposures with one press of the shutter button, at three different exposures, thereby giving you an added chance of getting a good, usable image. If you're shooting with RAW Quality, exposure is not so much of an issue, because you can adjust it later with your software, but it's always a good idea to start with an exposure that's as accurate as possible.

Also, you can use this feature to take three differently exposed shots that you can then merge into a single High Dynamic Range (HDR) image, in which the three images combine to cover a wider range of lights and darks than any single image could. This merging can be accomplished using software such as Photoshop (use the command File-Automate-Merge to HDR) or a more specialized program such as PhotoAcute or PhotoMatix. For HDR shooting, I suggest you set the interval between the exposures to the full 3 EV. Of course, you should use a tripod so all three images will include the same area of the subject and can be easily merged in the software.

Here is how to use the Auto Bracket feature. Once you enter the Auto Bracket screen, you adjust the size of the EV interval between exposures with the right and left cursor buttons. You spread the interval further apart with the right button, and narrow it with the left button. The maximum spread between exposures is 3 EV levels. The first picture taken is always at the metered level, or 0 change in EV; the second is at the lower EV (darker), and the third is at the higher EV (brighter).

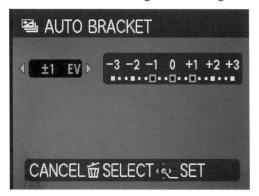

The Auto Bracket procedure cannot be used with flash (either built-in or external); the flash will be forced off and cannot be activated. Auto Bracket is not available with Intelligent Auto mode or when shooting movies, nor with several of the Scene mode categories. Auto Bracket cannot be set in Manual or Shutter Priority mode if the shutter speed is set to be longer than one second. Auto Bracket is canceled when the camera is turned off.

Aspect Bracket

Aspect Bracket is similar to Auto Bracket, in that it lets you take multiple images with one press of the shutter button, but in this case the result is images with different aspect ratios. You don't have to select anything other than the function itself, because there are only four aspect ratios available: 1:1, 4:3, 3:2, and 16:9, and the camera automatically records your image

using all four of these settings.

To activate the Aspect Bracket procedure, select this menu option and then press the right cursor button to reach the Aspect Bracket screen. Then press the right or left button to change the setting for Aspect Bracket from Off to On, or vice-versa, then press the Menu/Set button to exit.

Now you will see a screen with four different colored rectangles outlining the frames for the four aspect ratios. When you press the shutter button, you will take the same image in all four of those aspect ratios.

One thing that can be a bit confusing about Aspect Bracket is that you will hear only one shutter activation, so it will sound as if only one picture is being taken, but the camera actually records four images at the same time with the single shutter sound.

Aspect Bracket cannot be used at the same time as Auto Bracket, and Aspect Bracket is not available when you are shooting with RAW quality. (This can be confusing, because the camera will let you set both Aspect Bracket and RAW, but only one image will be recorded when you press the shutter button.) Aspect Bracket, like Auto Bracket, is canceled when the camera is turned off.

Clock Set

The final option on the LX5's Recording menu is Clock Set, which functions in the same way as the same item on the Setup menu. This option is also included in the Recording menu, presumably for convenience in case you find that the time and date settings need to be adjusted.

Chapter 5: Other Controls

Not all of the settings that affect the recording process are located on the Recording menu. Several important functions are controlled by physical buttons and switches on the camera. I have already discussed some of these, but in order to make sure all of the information about these controls is included in one place, I'll go through each physical control, some in greater detail than others.

Aspect Ratio Switch

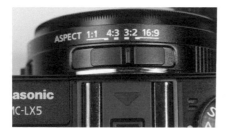

This switch on top of the lens barrel has four settings: 1:1, 4:3, 3:2, and 16:9, representing the ratio of the width of an image to its vertical height. This setting does not affect just the shape of the image; it also determines how many megapixels an image can contain. When the aspect ratio is set to 4:3, the maximum resolution of 10 MP is available; when the aspect ratio is set to 3:2, the greatest possible resolution is 9.5 MP; at 16:9, the greatest possible is 9. At the 1:1 ratio, the largest resolution available is 7.5 MP. If you want your image to use

the entire area of the LCD screen, choose 3:2, which is the aspect ratio of the screen. With 4:3, there will be black bars at the sides of the screen as you compose your shot; with 16:9, there will be black bars at the top and bottom of the screen.

Autofocus Switch

The Autofocus switch is located on the left side of the lens barrel as you hold the camera in shooting position. Its three selections are Autofocus, Autofocus Macro, and Manual Focus. I have previously discussed Autofocus and Manual Focus. The third setting, Autofocus Macro,

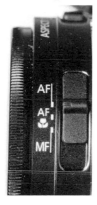

needs some additional discussion. When you move the switch on the lens to select this mode, the focusing range changes to a macro range. So, instead of the normal focusing range of 1.64 feet (50 cm) to infinity at wide angle, the lens can focus down to as close as 0.4 inch (1 cm). It is a good idea to set the flash to Off when using macro mode, because the flash would not be useful at such a close range. I'll discuss macro shooting in more detail later.

Flash Switch

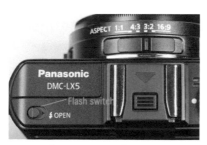

The flash switch is on top of the camera at the far left. It has only one function—to unlatch the flash mechanism so it can pop up and be available in case conditions call for its use. If you, the user, do not manually pop the flash unit up using this switch, it will not be available, because the camera cannot pop the unit up au-

137

tomatically.

Mode Dial

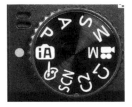

The Mode dial is on top of the camera to the right of the hot shoe when the camera is in shooting position. This dial moves you between the various modes of shooting: Intelligent Auto, Program, Aperture Priority, Shutter Priority, Manual, Creative Motion Picture Mode, Custom 1, Custom 2, Scene, and My Color. If you happen to leave it in a position that does not select one of those settings, the camera will display a message advising you that the dial is not in a proper position.

Shutter Button

This control is quite familiar by now. You press it down halfway to check focus and exposure, and press it the rest of the way to record the image. You can also press it to wake the camera up from sleep mode. The shutter button has a somewhat different use when you are making multiple exposures using that option on the Recording menu. After the initial exposure is made, you can move to the next one by pressing the shutter button halfway down (or by pressing the Menu/Set button).

Also, you should note that, although you ordinarily record motion pictures by pressing the red Movie button, when the camera is set to Creative Motion Picture mode, you have the additional option of using the shutter button to start and stop a movie. (In other shooting modes, of course, if you press the shutter button you will take a still picture, but in Creative Motion Picture mode, you will start a movie recording.)

138

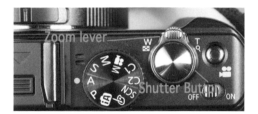

Zoom Lever

The Zoom lever is a ring with a ridged handle that encircles the shutter button. The lever's basic function is to change the lens's focal length to wide-angle, by pushing it to the left, toward the W indicator, or to telephoto, by pushing it to the right, toward the T indicator. The lever also has other functions. When you are viewing pictures in Play mode, the lever enlarges the image on the LCD screen when pushed to the right, and selects different numbers of thumbnail images to view when pushed to the left. In addition, when you are playing a motion picture taken by the camera, the Zoom lever can be used to raise and lower the audio volume. Also, you can use this lever to speed through the menus a full page at a time.

Power Switch

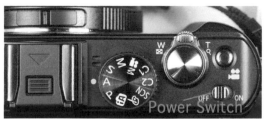

The power switch is on the far right of the camera's top. Slide it right for On and left for Off. When you do either of these actions, the little green status light to the right of the LCD and to the left of the 5-button array blinks briefly.

If you leave the camera unattended for a period of time, it automatically powers off, if the sleep mode option is set through the Setup menu. I'll discuss the Setup menu later, but this option can be set to be off altogether so the camera never turns off just to save power, or to turn the camera off after two, five, or ten minutes of inactivity. You can cancel the sleep mode shutdown by pressing the shutter button halfway.

Play Button

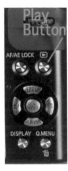

This button is located below the rear dial at the upper right of the top of the camera's back, marked by a small green triangle. You press this button to put the camera into Playback mode. Press it again to exit back into Recording mode. When the camera is in Playback mode, the menu options change; see the discussion of Playback mode options in Chapter 6. If you don't like having to remove the lens cap before turning the camera on, you can hold down the Play button while moving the power switch to the On position; this procedure starts the camera in Playback mode, and you won't get an error message if the lens cap is still on, as you do when starting the camera in Recording mode.

Rear Dial

This ridged dial at the upper right of the back of the camera, just below the power switch, has quite a few functions, of which I have discussed several. It is used to adjust focus when the camera is in manual focus mode. It is used to adjust shutter speed and/or exposure when the camera is in Aperture Priority, Shutter Priority, or Manual Exposure mode. But it has other duties as well, described below.

140

Exposure Compensation with Rear Dial

One of the most important functions of the rear dial is to adjust exposure compensation. You start by pressing in on this dial, using it as a button. At that point the exposure compensation icon, which was white, will turn yellow to indicate that you can now adjust that value using the dial.

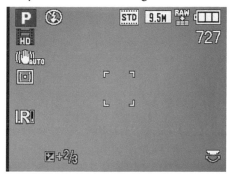

(If the camera is in Aperture Priority, Shutter Priority, or Manual mode, or if manual focus is active, pressing the rear dial will activate one or more of those settings in turn. If so, keep pressing the rear dial until the exposure compensation icon turns yellow.) Turning the rear dial right and left now will raise and lower the level of exposure compensation.

Program Shift with Rear Dial

Here is a function of the rear dial that may not be obvious. Program Shift is available only when you're taking pictures in Program mode. This function lets you take the camera's automatic settings for aperture and shutter speed and reset them to a different combination that yields the same exposure. That is, you can "shift" both settings the same amount in opposite directions. For example, if the camera computes the correct settings as f/2.0 at 1/100 second, you can shift those settings to any equivalent pair, such as f/2.2 at 1/80 second, f/2.5 at 1/60 second, f/2.8 at 1/50 second, or f/3.2 at 1/40 second.

141

Why would you want to do this? You might want a slightly faster shutter speed to stop action better, or a wider aperture to blur the background more, or you might have some other creative reason. Of course, if you really are interested in setting a particular shutter speed or aperture, you probably are better off using Aperture Priority mode or Shutter Priority mode. However, having the Program Shift capability available is a good thing for a situation in which you're taking pictures rapidly using Program mode, and you want a quick way to tweak the settings somewhat.

Here's how to use Program Shift. When you're about ready to take the picture, press the shutter button down halfway to calculate the exposure. You will see a yellow rectangle that outlines the values for shutter speed and aperture at the bottom center of the LCD screen. Within about ten seconds, turn the rear dial left or right to shift the values. You will see the new values within the rectangle, and the Program Shift icon (a rectangle with a P and a diagonal two-headed arrow) will appear at the bottom of the LCD screen to indicate that Program Shift is in effect.

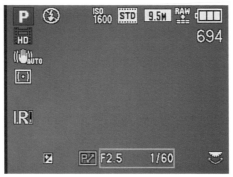

If that icon turns red, the exposure settings are not adequate for a proper exposure. To cancel Program Shift, use the rear dial to change the settings until the Program Shift icon disappears. Also, turning off the camera will cancel Program Shift.

Quick Menu/Trash Button

Quick Menu Function

The next control on our tour of the camera's landscape is the Q.Menu (Quick Menu)/Trash button, located at the bottom right of the camera's back, below the array of five buttons. When you press the Q.Menu button while in shooting mode, a mini-version of the camera's menu system opens up at the top of the screen, like a Windows or Macintosh computer program's main menu system.

You navigate right and left with the cursor buttons across the menus until you find the category you want, then navigate within that category with the up and down buttons until you reach the selection you want. Finally, press the Menu/Set button to make your choice of the highlighted item. Note that the selections wrap around in all directions, so if you navigate all the way to the right of the menu headings and keep going, you will reach the selections on the left. Similarly, if you navigate all the way to the bottom of a menu category and keep going, you will wrap around to the top. To exit from the Quick Menu, press the Q.Menu button again.

The available menu options vary according to what mode the camera is in; not surprisingly, the Quick Menu offers the largest variety of choices when the camera is in Program, Aperture Priority, Shutter Priority, or Manual mode. It offers the smallest variety in My Color mode and Intelligent Auto mode, though it still offers several choices. There are a moderate number of choices in Scene mode and Creative Motion Picture mode.

In my experience, the Quick Menu is a very useful alternative to the Recording menu. This system is, in fact, quite quick, and lets you make certain settings very efficiently that otherwise would require a longer time, in part because you can see all of the available options at the same time on the screen as soon as you press the Q.Menu button.

For example, I find that the Quick Menu is the best way to get access to the Burst mode to set up continuous shooting. Access to the feature is very fast this way, and, even better, when you later press the Q.Menu button again to go back to cancel Burst mode, the Burst option is still highlighted, and it takes just one quick movement of the cursor button and one quick press of the Menu/Set button to cancel Burst mode.

One final note: Two options on the Quick Menu, white balance and AF area, have additional adjustments available. For any setting on the white balance menu, you can press the Display button to get access to additional fine-tuning of the setting along the Green, Blue, Magenta, and Amber axes, just as you can when selecting white balance from the Recording menu. For AF area, only one of the options, 1-Area, has an additional adjustment. When you select 1-Area on the Quick Menu, you can then press the Display button, which activates the AF box so you can move it around the screen using the cursor buttons. Also, you can resize the box using the rear dial, just as if you had selected AF area from the Recording menu.

Trash Function

When the camera is set to Playback mode, the Q.Menu/Trash button takes on the identity of the trash can. Press the button and you are presented with several options on the LCD screen: Delete Single Yes/No; Delete Multi; and Delete All.

Use the cursor buttons to navigate to your choice. If you select Delete Single Yes, then the camera will delete the image that is currently displayed on the screen (unless it is protected).

If you select Delete Multi, then the camera presents you with a display of recent pictures, up to six at a time per screen. You then move through them with the cursor buttons, and press the Display button to mark any picture you want to be included in the group for deletion. You can press Display a second time to unmark a picture for deletion. When you are finished marking pictures for deletion, press Menu/Set to start the deletion process; the camera will ask you to confirm, and one more press of Menu/Set will carry out the deletion of all of the marked images. Delete All, of course, deletes all images, unless you have marked some as Favorites and choose to delete all except Favorites (indicated by stars). You can interrupt a deletion process with the Menu/Set button, though some images may have been deleted before you press the button.

AF/AE Lock Button

The AF/AE Lock button is located at the upper left of the

145

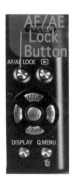

camera's back, next to the Playback button. As I discussed earlier, through the Recording menu you can set whether this button locks both autofocus and auto-exposure, or just one or the other. Then, you can just press this button to lock whichever settings have been selected through the menu. Press it again to unlock. You cannot lock exposure with the button when the camera is set to Manual Exposure mode, unless ISO is set to Auto. You cannot lock exposure in Scene mode.

Also, when you have set the AF Mode to AF Tracking through the Recording menu, the AF/AE Lock button has another function. In this context, as prompted on the screen, you center the tracking focus brackets over your moving subject, and press this button. At that point, the brackets will turn yellow, and the camera will do its best to keep them centered over the subject as it (or the camera) moves. If you want to cancel the current tracking, just press AF/AE Lock again.

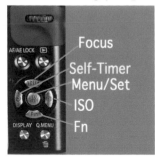

Five-Button Array

What I call the five-button array is the set of five buttons on the back of the camera, arranged in a pattern that looks a bit like the leaves of a clover, set on a circular platform. I generally refer to the outer buttons as cursor buttons, and to the center button as the Menu/Set button.

The cursor buttons act as cursor keys do on a computer keyboard, letting you navigate up and down and left and right through the various menu options. However, the buttons' functions do not stop there. Each of the four directional cursor buttons performs at least one additional function, as indi-

cated by the icon on the button. Let's go through those functions, starting at the top and moving clockwise.

Top Button: Focus

The top button doubles as the Focus button. As I discussed earlier, this button is used to move the focusing frame around the screen, so you can focus on an object that is not in the center of the screen. To do so, aim the camera, press the Focus button, then use the cursor keys to move the frame where you want it. Then press the center button (Menu/Set) to set the location. To return the frame to the center of the screen, press the Focus button again, then press the Display button on the lower left of the camera back's controls.

The Focus button has one other function that I mentioned briefly earlier. With manual focus, the standard procedure is to use the rear dial to adjust the focus until it looks sharp on the screen. However, even with the camera set to manual focus, if you press the Focus button the camera will attempt to focus automatically. If you are faced with a tricky focusing situation, such as a subject that has important points to focus on at various distances, using the Focus button to pre-focus the subject can give you a starting point, from which you can take over with the rear dial to fine-tune the focus as you want it.

In the Playback context, the top button is used to start playing a motion picture when the initial frame of the motion picture is displayed on the screen. That button also serves as a play/pause button once the movie has started playing. Finally, when a still image is displayed on the screen, if you press the top button (Focus button), the camera will enlarge the image, using the point where focus was set as the center point. (This procedure will not work in some situations, such as when the picture was not focused, or manual focus was used.)

Right Button: ISO

The right button does double duty as the ISO button. Press this button, and you are presented with a vertical menu of the choices for the ISO setting, including Auto ISO, Intelligent ISO, and the available numerical values. This vertical menu wraps around from bottom to top. You can scroll through the values using the up, down, and right buttons, and make your selection with the Menu/Set button. When playing movies and slide shows, this button acts as a VCR control to move through the images.

Down Button: Fn

The "down" button in our clockwise group bears the label "Fn." To me, this is the "function" button, though some people prefer to call it the Fn button without drawing conclusions about its meaning. In any event, this button provides a very useful service—it gives you, the photographer, the option of selecting any one of a number of camera settings with one press of this button, without having to go through the menu system.

The default (factory) setting for the Fn button is to give you quick access to the Film Mode settings, but there are several other choices available. You also can set the Fn key to give you access to any one of several other menu operations from the Recording menu: Quality; Metering Mode; White Balance; AF Mode; I.Exposure; Guide Line; Recording Area (Motion Picture); Remaining Display; Flash; Auto Bracket; and Aspect Bracket. Just go into the Setup Menu, select Fn Button Set, and then make your choice from the list that appears. You cannot set the Fn button's action while the camera is in Intelligent Auto mode.

When the camera is in Playback mode, pressing the down button marks (or un-marks) images as Favorites, if you have

turned on the Favorites option in the Playback menu. When you are playing a slide show or a movie, the down button acts as a Stop button on a VCR to stop the playback completely. When you use the Video Divide function from the Playback menu, the down button is used to "cut" a movie at your chosen dividing point.

Left Button: Self-Timer

The last button on our clockwise tour of the cursor buttons, the left button, operates the camera's self-timer. The self-timer is very easy to use on the LX5. Just press this button, then select a time from the menu that appears. For many modes, the selections will be Off, 10 seconds, or 2 seconds. Select the one you want with the up and down buttons. The LCD screen will then have an icon on it showing the self-timer with the chosen number of seconds beside it.

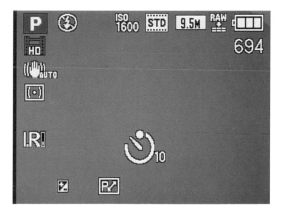

Now you can wait as long as you want before actually taking the picture (unless the camera times out by entering sleep mode or you take certain other actions, such as changing the shooting mode). Compose the picture, then press the shutter button. The AF Assist lamp, which does double duty as the self-timer lamp, will blink and the camera will beep, until the shutter is tripped at the end of the specified time. The beeps

149

and blinks speed up for the last second as a warning, when the timer is set to ten seconds. For the two-second operation, the camera just beeps and blinks four times rapidly. You can cancel the shot while the self-timer is running by pressing the center button (Menu/Set).

It's not a bad idea also to set the camera to take a burst of pictures, so you'll have several choices after the self-timer has done its work. You need to use the Quick Menu or the Recording menu to do that, because the self-timer does not work with the Hi-speed Burst setting of Scene mode. It also doesn't work when recording movies, and you cannot set it to 10 seconds in the Self Portrait setting of Scene mode.

In Playback mode, this button acts as a VCR control to move through the images when you are playing movies or slide shows.

Center Button: Menu/Set

The last button to discuss is the button in the center of the five-button array, labeled Menu/Set. You use this button to enter and exit the menu system, and to make or confirm selections of menu items or other settings. In addition, when you are playing a motion picture and have paused it, you can press the Menu/Set button to select a still image to be saved from the motion picture recording.

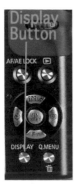

Display Button

The Display button is a round button at the bottom left of the camera's back, below the five-button array. It has several functions, depending on the context. If you have the LX5 set for still recording in any mode other than Intelligent Auto, here is the progression you get from re-

peated presses of the Display button: (1) full display, showing information including battery life, Picture Size, Quality, Film Mode, flash status, ISO (if set to a specific value), motion picture quality and format, Stabilizer status, recording mode, metering mode, and number of pictures that can be shot with the remaining storage, as well as the histogram (discussed later), if that option is turned on through the Setup menu; (2) blank display except for the focus area (if in 1-Area AF or AF Tracking mode); and (3) focus area (if in 1-Area AF or AF Tracking mode), grid lines for composition, and histogram, if that option is on. If you have set the Optional Viewfinder menu item turned on in the Recording menu, then a blank LCD is added as a fourth screen in the cycle.

If the camera is set to Intelligent Auto mode or Creative Motion Picture Mode, the display button produces the screens listed above, but the histogram does not appear, even if it was turned on in the Setup menu.

If the camera is set for Playback, repeated presses of the Display button produce the following screens: (1) recorded image with time, date, image number, and basic information including Picture Size and Quality; (2) the same information, with the addition of the shutter speed, aperture, focal length, ISO, white balance, flash status, and recording mode, as well as the histogram if that option is turned on through the Setup menu; and (3) just the recorded image, with no other information.

If you are playing back a motion picture, the display is similar, except for some added information that applies to that mode, including a brief display showing that the Zoom lever controls the audio volume.

The Display button also has several other functions: You can press it to move the focus area back to the center of the screen after you have moved it off center after pressing the Focus button or through the Recording menu system for moving the

focus. Also, as I'll discuss in Chapter 6, the Display button is used to select or de-select pictures you are marking for deletion after pressing the Trash button and selecting Delete Multi. During a slide show, the Display button toggles the display of image numbers and slide show controls on and off. In Title Edit mode, the button toggles between displays of various types of characters. The button also displays information about the settings that have been saved to the C2 Custom Memory Set storage areas, and it displays information about each of the scene types when you are viewing them in the Scene menu. Finally, if you need a reminder of the current date and time, with the camera in Recording mode, press the Display button enough times to cycle back to the screen with the most recording information, and the date and time will appear on the lower left of the screen for about 5 seconds.

Chapter 6: Playback

If you're like me, you take the images you've created and import them into your computer, where you manipulate them with software, then post them on the web, print them out, e-mail them, or do whatever else the occasion calls for. In other words, I don't spend a lot of time viewing the pictures in the camera. But that doesn't mean it's not a good thing to know about. Depending on your needs, there may be plenty of times when you take a picture and then need to examine it closely in the camera. Also, the camera can serve as a viewing device like an iPod or other gadget that is designed, at least in part, for storing and viewing photos, and you can connect it to a TV set (HD or standard) to view a slide show or just one or two images or movies. So it's worth taking a good look at the advanced playback functions of the LX5.

I'll start with a brief rundown of the basic playback techniques. To quickly review a recently taken still picture, press the Playback button—the one below the small green triangle, at the top right of the camera's back. Then scroll through your images with the left and right cursor buttons in the five-button array or by turning the rear dial to the right and left.

153

That's playback reduced to the very basics, and that's really enough to let you view your still images and show them to others with no problems. But there are considerably more options to choose from, so let's explore the nuts and bolts.

The Playback Menus

Yes, if you spotted the "s" at the end of "Menus" in the above heading, you are observant. But no, that was not a mistake. There is only one Recording menu (as well as one Motion Picture and one Setup menu), but there are two Playback menus. This situation could lead to some confusion, so let's sort through it clearly.

As you know, when the camera is in Recording mode and you press the Menu/Set button, you enter the menu system. Once in that system, you can navigate to either the Recording menu or the Setup menu, or, if you have selected Scene mode from the Mode dial, you can also enter the Scene menu to select a particular type of scene. And, you can also select the Motion Picture menu.

But if the camera is in Playback mode when you press Menu/Set, you encounter a slightly different situation. Here you can navigate to the Playback Mode menu, the Playback menu, or the Setup menu.

The first option, the Playback Mode menu, is akin to the Mode dial on the top of the camera. In other words, this menu selects the Playback mode (Normal Play, Slide Show, Mode Play, etc.), just as the Mode dial selects the Recording mode. There was no room for another Mode dial, and its existence probably would have been confusing, so the Playback mode selection is done through this separate branch of the menu system.

The second option on the menu system is the actual Playback

menu, which is similar to the Recording menu, letting you set various options for how playback works.

Let's look at these two menus one at a time.

The Playback Mode Menu

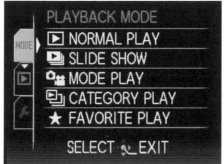

The first option once you enter the menu system when the camera is in Playback mode offers four or five choices, depending on the settings in effect: Normal Play, Slide Show, Mode Play, Category Play, and Favorite Play. The last choice, Favorite Play, appears on the Playback Mode menu only if you have turned on Favorites in the Playback menu, and it is available for selection only if you also have marked some images as Favorites, as discussed later. You use the Playback Mode menu like any other menu; just highlight the choice you want, such as Normal Play, and press the Menu/Set button.

Here are the details for each of the five choices:

Normal Play

Normal playback is fairly straightforward. With this mode selected, you scroll through the images individually using the left and right cursor buttons or by moving the rear dial left and right. Whenever an image is displayed on the screen, you can press the Trash button to initiate the deletion process, and choose to delete either a single image, multiple ones, or all im-

ages. If you want to mark some images as Favorites, which will be useful for the Favorites Playback mode and which can single out some images to avoid deletion, you first have to make sure the Favorites function is activated by selecting Favorite in the Playback menu (not the Playback Mode menu) and setting that option to On. Then, when you are displaying an image in Normal Playback mode, press the down button (Fn button) to mark (or un-mark) it as a Favorite. A star will then be displayed on the screen for that image.

Slide Show

The second option on the Playback Mode menu is Slide Show. Navigate to this option, then press Menu/Set, and you are presented with the choices All, Picture Only, Video Only, Category Selection, and Favorite. The last two are dependent on whether you have pictures that are marked as Favorites or that fall into Categories, as discussed later.

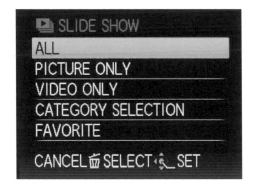

[Play] All

If you choose All, you are taken to a menu with the choices Start, Effect, and Setup.

You can choose Start to begin the slide show, or you can go to Effect or Setup first and make some selections. Setup lets you choose a duration of 1, 2, 3, or 5 seconds for each still image, but you can only set the duration if Effect is set to Off. If you select any effect, the camera will automatically set the duration to 2 seconds per still image.

You can also choose to set Sound to Off, Auto, Music, or Audio. With Off, no sound is played. With the Auto setting, the camera's music is played for still images, and the motion pictures have their own audio played. The Music setting plays music as background for all images and movies, and the Audio setting plays only the movies' audio tracks.

Also, you can set Repeat On or Off. Note that you can set a duration even when there are videos included along with still images; the duration value will apply for the still pictures, but not for the videos, which will play at their normal, full length.

For effects, you have the following choice of styles: Natural, Slow, Swing, Urban, or turning effects off altogether. If you choose Urban, the camera not only plays "urban" music, it uses a somewhat more dramatic visual style, with a variety of transitions, including converting some color images to black and white. So choose Urban only if you're a free-spirited type who doesn't mind a slide show with altered slides. If you choose Category Selection for your choice of images and videos to play, then the camera gives you another choice of effect: Auto,

in which the camera chooses an appropriate effect according to the category of each given image or video.

Once the slide show has begun, you can control it using the five-button array as a set of playback controls, the same as with playing back motion pictures. The up button controls play/pause; the left and right buttons move back or forward one slide when the show has been paused; and the down button is like a stop button; pressing it ends the slide show. A small display showing these controls stays on the screen during the show, along with image numbers, unless you press the Display button to switch to a screen showing the images only.

[Play] Picture Only/Video Only

These selections for playing the slide show are self-explanatory; instead of playing all images and videos, you can play either just still images, or just videos. The only difference between the options for these two choices is that, as you might expect, you cannot select an effect or a duration setting for a slide show of only videos; the slide show will just play all of the videos on the memory card, one after the other. You can use the Effect setting to choose whether to play the videos with their audio tracks or with the sound turned off.

Category Selection

Besides having the slide show play all of the pictures and/or videos available, you can select the items to be played in the show by category. You don't get to place your pictures and videos in categories of your own making; the camera has a predefined list of nine groups that it considers "categories," and it plays all of the images or videos in whichever single category you select. Note that some of the categories overlap with others—that is, an image might be in more than one category. Here are the categories:

All images and videos that used Face Recognition; if you select this option, the camera will prompt you to select a particular person whose face was recognized.

All images and videos from the following Scene types: Portrait, Soft Skin, Self Portrait, Night Portrait, and Baby 1 and 2

All images and videos from the following Scene types: Scenery, Sunset, Aerial Photo

All images and videos from the following Scene types: Night Portrait, Night Scenery, Starry Sky

All images and videos from the following Scene types: Sports, Party, Candle Light, Fireworks, Beach, Snow, Aerial Photo

All images from the following Scene types: Baby 1 and 2

All images from the following Scene type: Pet

All images from the following Scene type: Food

All images with a Travel Date

Favorite

The third and final option for selecting the images to play in a slide show is to play all of the images that you have marked as Favorites. In order to use this option, you have to have first turned the Favorite setting on in the Playback menu (not the Playback Mode menu). Then, when you play the images normally, you press the down button to mark an image as a Favorite.

Other Playback Modes

This next part could be confusing, so I'll try to explain carefully. I have just finished talking about the Slide Show mode of playback, which includes within its own options the choices of playing the slides by Category or by Favorites. We now move on to the other three modes of play that are not Slide Show. Those other modes—Mode Play, Category Play, and Favorites Play—happen to include playing all images by Category or by Favorites. The difference is that, in these modes, the images do not advance by themselves, there is no music playing along with them, and there are no transitions between them, as is the case with a slide show.

Mode Play

This selection has three choices: Picture, AVCHD Lite, and Motion JPEG. You can choose any one of these three file types to be played. That is, you can have the camera play back all of your still images, or all of your movies of either the AVCHD format or the Motion JPEG format. (If you want to play back all movies of either format, your best option is to use Category Play, discussed next.)

Category Play

In the Category Play mode, you can select any one of the nine categories listed earlier, plus one more: all Motion Pictures. (There is no category for Motion Pictures in the Slide Show selection, because you can select Video Only as a slide show playback option, so there is no need to have that option for a Category selection.)

If you choose Category Play and then select one of the ten listed categories, you will be viewing a subset of your images that fits this category. You can move through them with the

left and right cursor buttons, and you can delete them using the normal delete procedure, using the Trash button. You can change the amount of information displayed using the Display button. For videos, of course, you need to press the Play (top cursor) button to get them to play. One little difference here from other modes is that, to exit the playback, you need to switch the camera back into Recording mode by pressing the shutter button halfway or by pressing the Playback button.

Favorite Play

In this last Playback mode, the camera will play back any pictures you have marked as Favorites. As noted earlier, you have to have turned on the Favorites function in the Playback menu, and then you have to have marked at least one picture as a Favorite. As with the Category Play mode, to exit playback you need to switch the camera to Recording mode.

The Playback Menu

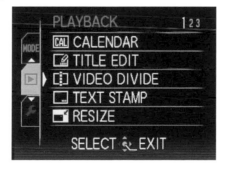

Okay. Now I am going to talk about the *other* playback menu. We just finished talking about the Playback Mode menu; this one is just the Playback Menu. If you recall, this one is similar to the Recording Menu, because it offers a collection of options for how Playback works. To reach this menu, you first have to put the camera into Playback mode by pressing the Playback button under the green triangle to the upper right of the array of five buttons. Then press the Menu/Set button,

which takes you into the menu system. Make sure the cursor is in the far left column of the menu display, then press the down button to highlight the green triangle, which represents the Playback menu. Next, press the right button to enter the list of menu options, and scroll down to the one you want. I'll talk about each one in order, from top to bottom. Note that not all options may be available in a given Playback mode, depending on what images or videos are present in storage. They are all available for Normal and Mode playback, but some may not be available for Category Play or Favorite Play. (You can't enter the Playback menu system while in Slide Show Play.)

Calendar

The first Playback menu option for Normal play is Calendar. This option displays a calendar for the current month (assuming, of course, that the date is set accurately). For any date on which an image was recorded, the camera displays a small thumbnail image to the left of the calendar. You can scroll to any of those dates using the cursor buttons or the rear dial, and select that date using the Menu/Set button. When you do, the camera displays the pictures and videos from that date. You then can scroll through these thumbnail images using the rear dial or cursor buttons. When a video's thumbnail is highlighted, an icon of a movie camera displays at the top left of the screen, next to the date. Press the Menu/Set button to select a highlighted image or video and display it on the full screen.

Title Edit

This is the second operation available through the Playback menu. It allows you to enter normal text, numerals, punctuation, and a fairly wide range of symbols and accented characters for a given image or group of images through a system of selecting characters from several rows. I won't go into all the details of using this system, because it's easy enough to figure

out by working through it yourself. One point to be aware of is that you can toggle between three displays of capital letters, lower case letters, and numerals and symbols using the Display key. The maximum length for your caption or other information is thirty characters. You can use the Multi option to enter the same text for up to 50 images. You cannot enter titles for motion pictures, protected pictures (see discussion below), or RAW images.

Once you have entered the title or caption for a particular image, it does not show up unless you use the Text Stamp function, discussed below. The title is then attached to the image, and it will print out along with the image. There is no way to delete the title other than going back into the Title Edit function and using the Delete key from the table of characters, then deleting each character until the title disappears.

Video Divide

The Video Divide function can be quite useful; it gives you a rudimentary editing or trimming function for videos using your camera. Using this procedure, you can, within limits, pause a video at any point and then cut it at that point, resulting in two sections of video rather than one. You can then, if you want, delete an unwanted segment.

Here is how to accomplish this: Choose the Video Divide function from the Playback menu. Then, press the right but-

ton to go to the playback screen. if the video you want to divide is not already displayed, scroll through your images using the left and right cursor buttons until you locate it. (Oddly, the camera displays all your images here, including stills, so you may have to scroll through many non-videos until you reach the video you want.) Once you have the desired movie on the screen, press the Menu/Set button to start it playing. When it reaches the point where you want to divide it, press the up cursor button, which pauses the video. At this point, while the video is paused, you can move through it a frame at a time using the left and right cursor buttons, until you find the exact point where you want to divide it.

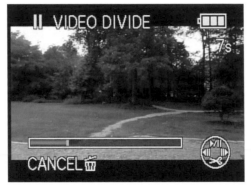

Once you have reached that point, press the down cursor button to make the cut. (You will see an icon of a pair of scissors in the little display of controls at the bottom of the screen.) Now you have two new videos, divided at the point you chose. As I noted above, this is a rudimentary form of editing. It can't be used to trim a movie too close to its beginning or end, or to trim a very short movie at all. But it's better than nothing, and gives you some ability to trim away unwanted footage without having to edit the video on your computer.

Text Stamp

The Text Stamp function takes information associated with a

given image and attaches it to the image in a visible form. For example, if you have entered a title or caption using the Title Edit function discussed above, it does not become visible until you use this Text Stamp function to "stamp" it onto the image. Once you have done this, the text or other characters in the title will print out if you send the picture to a printer. Besides the information entered with the Title Edit function, the Text Stamp function gives you the choice of making the following other information visible: year, month, and day; year, month, day, and time; age of subject (if set); travel date (if set); location (if set). Also, you can apply this function to information from pictures taken with Scene types Baby 1 or 2 and Pet, if you have entered a name for your baby or pet, and to pictures that have names registered with the Face Recognition function.

Using Text Stamp reduces the image size of higher-resolution images to the range of 2.5 – 3.0 MP. The function cannot be used at all with RAW images. Picture quality may deteriorate once the function is applied, but it saves the text-stamped image to a new, smaller file, so you will still have the original. I have never found this function useful, but if you have an application that could use it, it is available and ready to assist you.

Resize

This function from the Playback menu can be useful if you don't have access to software that can resize an image, and you need to generate a smaller file that you can attach to an e-mail message or upload to a web site. You activate the Resize function using the standard procedure with the cursor buttons, then select whether to resize a single image or multiple ones. Then, using the left and right cursor buttons, navigate to the image you want to resize, if it's not already displayed on the screen. You can use this function only on JPEG still images, not on RAW files or movies.

Once the image to be resized is on the screen, press the Menu/

Set button to start the resizing process. Then, as prompted on the screen, use the left and right cursor buttons to select what size to reduce the image to, down as far as 0.3 MP, depending on the aspect ratio of the image. Then press Menu/Set to carry out the resizing process.

As with the Text Stamp function, resizing does not overwrite the existing image; it saves a copy of it at a smaller size, so the original will still be available. The new image will be found at the end of the current set of recorded pictures. RAW images, protected images, and motion pictures cannot be resized, nor can still pictures with audio recordings attached, or pictures stamped with Text Stamp.

Cropping

This function is similar to Resize, except that, instead of just resizing the image, the camera lets you crop it to show just part of the original image. To do this, select Cropping from the Playback menu and navigate with the left and right cursor buttons to the image to be cropped, if it isn't already displayed. Then use the Zoom lever to enlarge the image, and use the cursor buttons to view the part of the image to be retained. When the enlarged portion is displayed as you want, press Menu/Set to lock in the cropping, and select Yes when the camera asks if you want to save the new picture(s). Again, as with Resize, the new image will be saved at the end of the current set of recorded images, and it will have a smaller size than the original image, because it will be cropped to include less information (fewer pixels) than the original image. The Cropping function cannot be used with RAW images, motion pictures, or pictures stamped with Text Stamp.

Leveling

This is an interesting function; it allows you to make minor

corrections in the rotation of an image. For instance, if you have a straight object in your image that is slightly off-kilter, you can apply a small amount of clockwise or counter-clockwise rotation to correct the tilt. When you select this function, the camera displays a framework of horizontal and vertical grid lines to help you make fine adjustments. You then carry out the rotation with the left and right cursor buttons. As with other functions of this sort, the camera saves a new image with the new appearance.

Also, as with most of the modifications made through the Playback menu, there are several limitations. First, the correction is limited to two degrees positive or negative rotation. Second, the process achieves the rotation effect in part by zooming in and cropping the image slightly, so a part of the image is lost and the size of the file and the resolution will decrease somewhat. Finally, as with the Resize and Cropping functions, this operation cannot be carried out with RAW images, motion pictures, or pictures stamped with Text Stamp.

Rotate Display

This option does not modify your images. It can be set to either Off or On, and affects the way the camera displays images for which you held the camera in a vertical position when you recorded them. That is, images for which the top of the camera was rotated to be facing to the right or left when you took the

picture. If you leave this option turned off, then those images will be displayed to look the way they were viewed when they were taken; that is, you will have to rotate the camera back to a vertical position to see such images properly. If you turn this option on, then the camera automatically displays those images in a vertical orientation when the camera is held horizontally. To do this it has to shrink the image so the entire vertical image will fit within the horizontal screen.

The Rotate Display function does not work when you are viewing multiple images on the screen; or when you have pressed the Zoom lever to the left (toward the W setting) to view images 12 or 30 at a time, or by date from the calendar.

Favorite

I have mentioned this function a couple of times before, because you have the option of viewing just your Favorite pictures under some of the Playback modes. Here is how to select images as Favorites. You select the Favorite option from the Playback menu, and turn it on. Then, when you are viewing pictures on the LCD screen, you can press the down button to mark the image as a Favorite. If you are viewing with the information display turned on, you will see a star, the symbol for Favorite, in the lower right corner of the screen with a down-pointing triangle next to it, indicating that pressing the down button will select (or de-select) the displayed image as a Favorite.

When you select an image as a Favorite, a star appears in its upper left corner. If you de-select the image as a Favorite, the star disappears. You cannot select RAW images as Favorites.

Print Set

The next option on the Playback menu, Print Set, lets you set your images for Digital Print Order Format (DPOF) printing. DPOF is a process that was developed by the digital photography industry to allow users of digital cameras to specify, on the camera's own memory card, which pictures to print and other details, then take the card to a commercial printing shop to have them printed according to those specifications.

With the LX5, you select this option from the Playback menu, and then select Single or Multi. If you select Multi, the camera gives you a display of six images at a time on the screen. Using the four cursor buttons, you navigate through the images. When you arrive at one you want to have printed, you press the Menu/Set button, and you then see a box with the word "Count" followed by a number and up and down arrows. You use the up and down cursor buttons to raise (or, later, lower, if you change your mind) the number of copies of that image you want to have printed. In addition, if you press the Display button, the word "Date" is added to the small image for that picture, and the date will be printed on that picture. You can follow the above procedure for a single image by selecting "Single" when you first enter the DPOF option.

If you want to use the DPOF system to print photos recorded on the camera's built-in memory, you need to copy them to a memory card and then take that card to the printing store, after setting the DPOF options. (See the Copy function, discussed later in connection with the Playback menu.)

The DPOF settings cannot be set for RAW images. Once you have set one or more images to print using this menu option,

you can use the Cancel option from the Print Set menu to go back and cancel the printing setup.

Protect

The next Playback menu option is Protect, which is used to lock selected images against deletion. The process is essentially the same as that for the Favorite function; you enter the Playback menu system, select the Protect option, then select Multi or Single. You then mark the images you want to protect, using the Menu/Set key. When a picture is protected in this way, a key icon appears on the left side of the image.

The Protect function works for all types of images, including RAW files and motion pictures. Note, however, that all images, including protected ones, will be deleted if the memory card (or camera's built-in memory) is re-formatted.

Face Recognition Edit

This Playback menu option is of use only if you have previously registered one or more persons' faces in the camera for face recognition. If you have, use this option to select the picture in question, then follow the prompts to replace or delete the information for the person or persons you select. Once

deleted, this information cannot be recovered.

Copy

The final option on the Playback menu, the Copy function, lets you copy images from the camera's built-in memory to an SD storage card, and vice-versa. After you select Copy from the Playback menu, press the right cursor button to pop up the little sub-menu, which provides two options, represented by two pairs of icons connected by a directional arrow. One icon has the label "In," showing that it represents the camera's built-in memory; the other icon is labeled "SD," representing an SD card inserted into the camera. One pair of icons has an arrow going from the In icon to the SD icon, and the other pair has the arrow going from the SD icon to the In icon.

If you select the first icon, the camera will prompt you with a message asking you to confirm whether you want to copy the images from the built-in memory to the memory card. If you choose Yes to confirm, the process starts, if there are images to copy.

If you select the second pair of icons, the camera displays an image, and asks if you wish to copy it to the camera's built-in memory. If you select Yes, the camera copies that single image to the built-in memory. You can then move on to other images, or cancel out of the process with the Trash button.

Remember that the built-in memory has a capacity of only about 40 MB, so it does not hold very many high-quality images.

Chapter 7: The Setup Menu

I have discussed the options available to you in the Recording and Playback menu systems (including options in the Scene and My Color branches of the menu system). The next menu system to discuss is the Setup Menu. As a reminder, you enter the menu system by pressing the Menu/Set button (the center button in the five-button array on the lower half of the camera's back). The available menus change depending on whether you're in Recording mode, Playback mode, or Scene mode. However, no matter what other menus may be available, you can always enter into the Setup menu.

After pressing Menu/Set, press the left cursor button to get into the left column of menu choices, then use the down button as many times as needed (up to three) to navigate to the wrench icon, indicating the Setup menu. Once the wrench is highlighted, press the right button to get back to the list of menu choices, which will now contain the Setup choices, discussed below. (All of these choices are available unless the camera is set to Intelligent Auto mode, in which case only a limited number of options are available on the Setup menu.)

Clock Set

With the Clock Set option highlighted, press the right button to go to the settings screen and follow the arrows. Use the up and down arrows to adjust an item, then move to the next item with the right button. When the settings are done, press Menu/Set to exit and save. You can cancel with the Trash button.

World Time

This is a handy function when you're traveling to another time zone. Highlight World Time, and then press the right button to access the next screen. If you haven't used this menu item before, you'll be prompted to select your Home area. If so, just use the left and right buttons to scroll through the world map and use the Menu/Set button to choose your Home area.

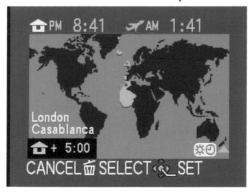

Then use the up button to highlight Destination, and use the left and right buttons to scroll through the world map to select the time zone you will be traveling to. The map will show you the time difference from your home time. Press Menu/Set to select this zone for the camera's internal clock. Then, any images taken will reflect the correct time in the new time zone. When you return from your trip, go back into the World Time item and select Home to cancel the changed time zone setting.

Travel Date

This function lets you set a range of dates when you will be taking a trip, so you can record which day of the trip each image was taken. Then, when you return from your trip, if you use the Text Stamp function to "stamp" the recorded data on the images, the images will show they were taken on Day 1, Day 2, etc., of the trip. The entries are self-explanatory; just follow the arrows and the camera's prompts.

Beep

This menu option lets you adjust several sound items. First is the volume of the beeps the camera makes when you press a button, such as when navigating through the menu system. You can set the beeps to Off, Normal, or Loud. It's nice to be able to turn the beeps off if you're going to be in an environment where such noises are not welcome.

Second is the tone of the beeps. Check out the three possibilities and see which one you like best.

Third is the volume of the shutter operation sound. Again, it's good to be able to mute the shutter sound.

Finally, you can choose from three shutter sounds.

Volume

With this option, you adjust the volume of the camera's speaker for playing back motion pictures and images recorded with audio files. This setting does not affect the sound level for beeps and shutter operations, which is controlled separately, as noted above. When you're playing a motion picture, you can use the Zoom lever on top of the camera to adjust the volume.

Custom Set Memory

This is a useful function for anyone who wants to have a quick way to set several shooting parameters without having to remember them or go into menus and fiddle with switches to set them. The camera lets you record four different sets of settings, each of which can be recalled immediately by setting the Mode dial. You can consider this function a way to create four of your own custom-tailored Scene types for use whenever you want them.

Here is how this works. First, you need to have the camera set to Recording mode rather than Playback mode, so if it's in Playback mode, press the shutter button halfway or press the Playback button to exit back to Recording mode. Then, set the Mode dial on top of the camera to the shooting mode you want to select: Program, Aperture Priority, Shutter Priority, Manual, Creative Motion Picture, My Color, or Scene. (You can't use Intelligent Auto mode in a Custom setting.) Next, make any other adjustments that you want to have stored for quick recall such as Film Mode, ISO, autofocus method, exposure metering method, white balance, and the like. You can set most of the items on the Recording Menu and the Setup Menu for inclusion in the custom settings.

Once you have all of the settings as you want them, leave them

175

that way and enter the Setup menu. Navigate to Custom Set Memory and press the right button, which gives you choices of C1, C2-1, C2-2, and C2-3. For your most important group of settings, choose C1, because that group of settings is the easiest to recall quickly.

When you go to use your saved settings, just turn the Mode dial to C1 or C2. If you choose C1, you're done; the camera is now set as you had it set when you entered the C1 information. If you choose any of the other three groups of settings (C2-1, C2-2, or C2-3), you will also need to select the second part of the number (1, 2, or 3) from a short menu. Once you have selected the custom mode you want, you are still free to change the camera's settings, but those changes will not be saved into the Custom Set Memory unless you enter the Setup menu again and save the changes there with the Custom Set Memory option.

If you want to see what settings you have saved for any of the three C2 Custom Memory slots, the camera will display them for you. Turn the Mode dial to C2 and the camera will show you the menu for selecting one of the sub-settings for C2; either C2-1, C2-2, or C2-3. At the bottom of that screen you will see a small letter i, for "information," next to the label for the Display button. If you push the Display button, you will get information consisting of two screens that show the settings that the camera currently has saved for whichever of the three Custom settings is highlighted on the menu. (There is no such information display for the C1 settings.)

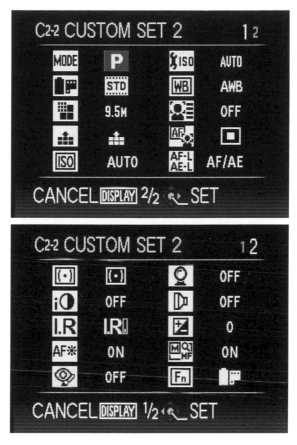

Following is the list of the 20 items that are saved in each of the three C2 slots. Note that the items will change somewhat according to what recording mode is selected. For example, if Creative Motion Picture is the selected recording mode for the Custom Memory slot, then the saved values include only Recording Quality, and not Picture Size.

Shooting mode
Film Mode
Picture Size
Recording Quality

177

ISO
ISO Limit Set
White Balance
Face Recognition
Autofocus Area
AF/AE Lock
Autofocus Mode
Intelligent Exposure
Intelligent Resolution
AF Assist Lamp
Red-eye Removal
Optional Viewfinder
Conversion
Exposure Compensation
Lens Resume/MF Resume
Fn Button Set

There are some limitations with this system. You cannot set certain parameters from the Setup Menu, but they are ones you wouldn't need to include in a set of custom shooting parameters, such as Clock Set, Travel Date, and Reset. You cannot set certain items that require physically moving a switch, such as aspect ratio and manual focus. Note that the camera saves only the items listed above; you can't save settings like a specific shutter speed or aperture, or the size and location of the focus bracket. But apart from those limitations, Custom Set Memory is a powerful capability, and anyone who has or develops a favorite group of settings would be well advised to experiment with this option and take advantage of its power.

Also, don't shy away from using this feature even if there are only one or two settings that you want to change. For example, if you're comfortable with standard values for the most part, such as Program shooting mode and Standard Film Mode, but you like to dial in, say -1.5 EV of exposure compensation, go ahead and use one of the four slots of the Custom Memory Set

feature for that setting. In other words, you don't have to have a long list of exotic parameters to justify using this option.

Fn Button Set

I discussed this option earlier, in describing the functions of the various buttons on the camera. The Fn button, which is the down, or bottom button of the five-button array on the back of the camera, is initially set to Film Mode, which lets you press this button while in Recording mode to quickly change the "look" for your images to Standard, Dynamic, Smooth, etc. Using the Fn Button Set menu option on the Setup menu, you can set this button to carry out any one of several other functions from the Recording menu instead. The available functions besides Film Mode are: Quality, Metering Mode, White Balance, AF Mode, I.Exposure, Guide Line, Recording Area, Remaining Display, and Flash. For example, if you often have a need to change your ISO setting, you might want to assign that operation to the Fn button for ease of access.

Don't forget that many of these items also can be quickly adjusted using the Quick Menu system by just pressing the Q.Menu button and then navigating through the easy-access menu that appears. So you should pick whatever item you really expect to need the most often to assign to the Fn button.

LCD Mode

This setting affects the brightness of the LCD display. It has three settings: Off, Auto Power LCD (Icon with letter A and asterisk), and Power LCD (Icon with asterisk only). The Off setting does not turn off the LCD display; instead, it means that the Power LCD setting is off, and the LCD display is at its normal brightness. The Auto Power LCD setting means that the screen's brightness will adjust according to the ambient lighting conditions. If you choose the Power LCD mode,

the screen becomes extra-bright to compensate for sunlight or other lighting conditions that make it hard to see the screen. This mode dims back to normal after 30 seconds; you can press any button to make the screen turn bright again. An indicator appears at the left of the LCD display, toward the bottom, if Power LCD or Auto Power LCD mode is active. That indicator is an asterisk (*) for Power LCD and an asterisk with an A (A*) for Auto Power LCD.

You should note that using either Power LCD or Auto Power LCD mode decreases the battery's endurance, because of the use of extra power to make the screen brighter. If you find it hard to see the screen in bright sunlight and don't want to use an external viewfinder, you might want to try the Power LCD approach to see if the added brightness gives you enough visibility to compose your shots properly.

Display Size

This option lets you set the size of some icons and menu screens larger, for greater visibility.

Guide Line

This option gives you some control over the grid lines that are displayed on the LCD screen to assist you with composition of your pictures when you cycle through the various screens with the Display button. Once you select Guide Line from the Setup menu, you get to a screen with two options: Recording Information and Pattern. If you set Recording Information on, when the grid lines are displayed, along with the grid lines there will be information about the shooting mode, ISO setting, and other data. Otherwise, you will see only the grid lines, unless you have the histogram turned on, in which case you will see the grid lines and the histogram (see below).

The pattern of the grid lines is controlled by your selection for the Pattern option. There are two fixed patterns to choose from: a grid that forms nine equal rectangles on the screen, or a pattern with sixteen equal rectangles as well as two diagonal lines that intersect at the exact center of the screen. The second pattern is useful to find the center point of the image. Finally, there is a third option that displays just two intersecting lines, one horizontal and one vertical, and lets you set their positions using the cursor buttons. This option can be useful if you need to compose your shot with an off-center subject.

When the camera is in Intelligent Auto mode, the grid lines cannot be changed from the standard nine-block pattern.

Histogram

This option, which controls whether the histogram displays on the screen, has only two choices: On or Off. If you turn the histogram on, it will display on the right side of the LCD screen in both Recording mode and Playback mode for every image. The histogram does not display in Intelligent Auto or Motion Picture mode, or when the HDMI cable is connected.

A histogram is a graph representing the distribution of dark and bright areas in the image that is being displayed on the screen. The darkest blacks are represented by vertical bars on the left, and the brightest whites by vertical bars on the right, with continuous gradations in between.

If an image has a histogram in which the pattern looks like a tall ski slope coming from the left of the screen down to ground level in the middle of the screen, that means there is an excessive amount of black and dark areas (tall bars on the left side of the histogram), and very few bright and white areas (no tall bars on the right). The first image on the next page illustrates this situation.

A ski slope moving from the middle of the screen up to the top of the right side of the screen would mean just the opposite; too many bright and white areas, as in the histogram and image below.

A histogram that is "just right" would be one that starts low on the left, gradually rises to a medium peak in the middle of the screen, then moves gradually back down to ground level at the right. That pattern indicates a good balance of whites, blacks, and medium tones. An example of this type of histogram is shown below.

The histogram is an approximation, and should not be relied

on too heavily. It gives you some feedback as to how evenly exposed your image is likely to be. (Or, for playback, how well exposed it was.) If the histogram is displayed in orange, that means that the recording and playback versions of the histogram will not match for this image, because the flash was used, or in a few other situations.

Recording Area

This option can be set either Off or On. If you turn it on, the camera's screen is shaded at the edges, leaving a clear view of the area that will be viewed and recorded if you record a motion picture using the current settings. Motion pictures are recorded with aspect ratios that differ from the settings that are in effect for still images, so turning this optional guide on can give you an idea of what to expect, before you start recording a movie.

Remaining Display

This feature lets you choose whether the camera's display shows how many still images can be taken with current settings, or how much time is available for video recording.

Highlight

This feature produces a flashing area of black and white on areas of the image that are over-saturated with white, indicating they may be too bright. The flashing effect takes place only when you are viewing the pictures in Auto Review or Playback mode. That is, you will see the Highlight warning only when the image appears briefly on the screen after it has been recorded (Auto Review) or when you play the pictures in Playback mode. The purpose of this feature is to alert you that your picture may be washed out (overexposed) in some areas, so that you may want to reduce the exposure for the next shot.

Lens Resume

This setting has two sub-options: zoom resume and manual focus resume, either of which can be turned on or off. If you turn on zoom resume, then, after you turn the camera off and back on, the lens will return to its last zoom position. If you leave this setting turned off, the lens will zoom out to its widest angle when the power is turned back on.

If you turn manual focus resume on, then the camera will return to its previous manual focus position after the power has been turned off and back on, or after the camera has been switched off of manual focus and back, or has been switched to Playback mode and then back to Recording mode. If you leave this setting turned off, the manual focus will go to the infinity setting when the power is turned back on or one of the other conditions occurs.

Manual Focus (MF) Assist

I discussed this feature briefly earlier, in talking about how to use manual focus. This function lets you decide whether and how the screen display is magnified when you're using manual focus. With the MF Assist option highlighted, press the right cursor button to pop up the little sub-menu that lets you choose among the three available options: Off, MF1, and MF2. If you choose Off, there is no magnification; MF1 is the setting for magnification of the center of the screen; MF2 is the setting for magnification of the whole screen.

You may want to experiment with manual focus using each of these three options, then settle on the one that works best for you, and leave that setting in place. I tend to prefer MF2, which magnifies the whole screen and seems a bit easier to use, but one of the others may work better for you.

Economy

This menu option gives you two ways to save battery power: sleep mode and Auto LCD Off. Sleep mode turns the camera off after a specified period of not using any of the camera's controls. The period can be set to two, five, or ten minutes, or the option can be turned off, in which case the camera never turns off automatically (unless it runs out of battery power). When Auto LCD is turned on, Sleep mode is fixed to two minutes; in Intelligent Auto mode, Sleep mode is fixed to five minutes. To cancel Sleep mode, press the shutter button halfway, and the camera will come back to life.

Auto LCD Off, which can be set to fifteen or thirty seconds, turns off the LCD after the specified time. This option can also be turned off altogether, so the screen never goes dark. If the screen is blanked through this feature, the small green status light to the left of the Focus button turns on to let you know the camera is still on and operating, even though the screen is dark. You can press any button to turn the screen back on.

Play on LCD

This option is of use only if you have installed Panasonic's optional electronic viewfinder, Model No. DMW-LVF1. When you attach this viewfinder and turn it on, the LCD goes blank, because you will be viewing through the viewfinder. If you turn on the Play on LCD option through the Setup menu, then, when you enter Playback mode, the LCD will automatically turn back on. In my experience, this command has not been necessary, because the LCD turns back on in Playback mode no matter how this option is set.

Auto Review

This option gives you control over how your pictures are re-

viewed immediately after they have been recorded by the camera. The possible settings are Off, 1 second, 2 seconds, and Hold. These are fairly self-explanatory; after the shutter button is pressed, the image appears on the screen (or not) according to how this option is set. If you set it to Hold, the image stays on the screen until you press a button.

One note: The user's manual says that Hold keeps the picture on the screen until you press "any button." That may be true, but if you press some buttons, such as the Self-timer or Burst buttons, you will be activating a new operation, so you're better off relying on the Menu/Set button for this purpose.

Note that Auto Review is automatically activated, regardless of the setting on the Setup menu, in certain shooting modes, including Auto Bracket, Aspect Bracket, Multi Film, Hi-Speed Burst, and Flash Burst.

Auto Review does not work when recording motion pictures.

Start Mode

This function can be set to either Record mode (camera icon) or Playback mode (playback triangle icon). This setting controls which mode the camera will be set to immediately after the power switch is turned on. One reason you might want to set the camera to start up in Playback mode is that you can then turn it on without first removing the lens cap; if you start it up in Record mode without removing the lens cap, you will see an error message and will have to remove the lens cap before proceeding. So, if you know you will be viewing pictures or just using Playback or Setup menu options, you may want to set this option to start the camera up in Playback mode. It won't hurt to do this, because you can then just tap lightly on the shutter button to go right into Recording mode.

Note, though, that you don't really need to use this menu option if you just want to start up in Playback mode occasionally; just hold down the Play button while turning on the camera, and it will start up in Playback mode.

Number Reset

This function lets you reset the folder and image number for the next image to be recorded in the camera. If you don't use this option, then the numbers of your images will keep increasing until they reach 999, even if you change to a different memory card. If you want each new memory card to start with images that are numbered from 1 up, use the Number Reset function each time you start a new card, or a new project for which you would like to have freshly numbered images. I prefer not to reset the numbers, because I find it easier to keep track of my images if the numbers keep getting larger; I would find it confusing to have images with duplicate numbers on my various SD cards.

Reset

This function resets all Recording mode settings to their original states, and also resets all Setup menu settings to their original states. This is a convenient way to get the camera back to its default mode, so you can start with fresh settings before you experiment with new ones. The camera prompts you twice, asking if you want to reset all Recording menu settings, and then all Setup menu parameters.

USB Mode

If you are going to connect the camera directly to a computer or printer, you need to go into this menu item and select the appropriate setting: Select on Connection, PictBridge (for connecting to a printer), or PC. If you choose Select on Connec-

tion, you don't select the setting until after you have plugged the USB cable into the device to which you are connecting the camera. The LX5 connects to a computer using the rapid USB 2.0 connection standard, assuming your computer has a USB port of that speed. (If not, the camera will still connect at the slower speed of the computer's older USB port.)

TV Aspect

This menu option is available only when you are connecting the camera to a TV by means of the audio-visual cable. The only two choices are 16:9, for widescreen, or 4:3, for fullscreen.

HDMI Mode

This menu option, which is intended to match the camera's output to the capabilities of an HDTV, is available only when you are connecting the camera to an HDTV by means of an optional HDMI cable. The choices for this connection are Auto, 1080i, 720p, and 480p. The Auto setting should work, but if it doesn't, you can try one of the other settings to match the setting of your TV.

VIERA Link

This menu option is for use when you are connecting the LX5 to a Panasonic VIERA HDTV using a mini-HDMI cable. If you set this option to Off, then the operations of the camera are controlled by the camera's own controls. If you set it to On, then the VIERA TV's remote control can also control the operations of the camera, so you can play slide shows or review individual images and movies.

Scene Menu

This option has two possible settings: Off or Auto. If you choose Auto, whenever you turn the Mode dial on top of the camera to the SCN setting to select Scene mode, the LCD display will immediately display the menu of Scene modes with one of them highlighted, so you can scroll through them and choose. For example, it may start with Portrait highlighted, so you can press the Menu/Set button to select Portrait, or you can scroll through the other choices to find the one you want. This method saves you the step of entering the menu system and selecting the Scene menu.

If, instead, you turn the Scene Menu setting to Off, when you turn the Mode dial and select Scene mode, the screen displays the live view image with the camera set to whatever Scene type happens to be the last one used; if you want to select a different Scene type, you need to press Menu/Set and navigate to the Scene menu to make a different selection.

I like the Auto setting, because chances are I will want a different Scene type than the last one I used when I turn the Mode dial to SCN. But if you often choose the same Scene type, you may prefer to leave this setting off, and go back to the same Scene type each time you select SCN on the Mode dial. It's not hard to enter the menu system and choose a different Scene type, if you need to.

Menu Resume

This menu item can be set either on or off. When it is turned on, whenever you enter the menu system, the camera displays the last menu item you had selected. When it is turned off, the camera always starts back at the top of the first screen of the menu system, which may be the Recording menu, Playback menu, or Scene menu, depending on what mode the camera

189

is in (Recording, Playback, or Scene mode). If there is a particular menu item you need to adjust often, this option can be of considerable use, because you can just press the Menu/ Set button, and the item will appear, ready for you to make your setting. For example, if you are in a situation where you need to change the metering mode frequently, turn on Menu Resume. Then, whenever you need to get back to the metering mode setting, just press Menu/Set, and the item will be there at your fingertips. (Of course, you also could set the Fn button to bring up this option, or you could use the Quick Menu, but this is one other approach to consider.)

User's Name Recording

This menu item lets you enter your name (or any other name), so that, if this option is turned on, that name will be recorded along with the image, giving you a record of who took the picture. The name cannot be seen on the images in the camera; you have to use Panasonic's supplied PHOTOfunSTUDIO software to make sure the name was recorded correctly.

Version Display

This menu item has no settings; when you select it, it displays the version of the camera's firmware that is currently installed. As I write this, my LX5 has version 1.0 of the firmware installed.

Firmware is a term for something that is somewhat like both software and hardware; it is the programming for the camera's

circuitry that is electronically recorded into the camera, either at the factory, or through your computer if you upgrade the firmware with an update provided by Panasonic. A new version of the firmware can fix bugs and can even provide new features, so it's well worthwhile checking the Panasonic web site periodically for updates. Instructions for installing an update are provided on the web site. Essentially, the process usually involves downloading a file to your computer, saving that file to an SD card formatted for the camera, then placing that card in the camera so the firmware can be installed.

Format

This is one of the more important menu options. Choose this process only when you want or need to completely wipe all of the data from a memory storage card. When you select the Format option, the camera will ask you if you want to delete all of the data on the card. If you reply by selecting Yes, it will proceed to do so, and the result will be a card that is empty of images, and is properly formatted to store new images from the camera. It's a good idea to use this command with any new memory card you use in the camera for the first time.

If you want to format the camera's built-in memory, you have to remove any card from the camera, so the built-in memory is the only possible memory to be formatted.

Language

This option gives you the choice of language for the display of commands and information on the LCD screen. The only choices on my U.S. version of the camera are English and Spanish. Presumably, models sold in Europe and elsewhere have more choices. If your camera happens to be set to a language that you don't read, you can find the language option by going into the Setup menu (look for the wrench icon), and

then scrolling to this option, which is marked by a little icon showing a man's head with a word balloon. It also is the next-to-last option on the Setup menu.

Demo Mode

This last option on the Setup menu lets the camera perform two demos. The first is a demonstration of the camera's optical stabilization system, giving a graphic demonstration of how much that system can counteract the effects of camera shake. You can press the Menu/Set button during the demo to change the display to showing the results of having the stabilizer turned on or off.

The other demo is a self-running demo that shows off a few of the camera's features as a slide show, with some sample images.

Chapter 8: Motion Pictures

Until recently, most compact digital cameras had only quite basic video capabilities. They could record video sequences, but could not alter the exposure or focus in some cases; in other cases, they could only record in standard-definition formats with moderate quality, or only for a few minutes.

The LX5 is part of a newer generation of video-capable compact cameras that are beginning to exhibit some features that rival those of dedicated camcorders. The LX5 is not sufficiently sophisticated to serve as the main camera for professional film-making, but its features in some areas are remarkably advanced. In fact, they are so sophisticated that video-making on the LX5 needs its own chapter just to cover the essentials. So let's get started.

Basics of LX5 Videography

In one sense, the fundamentals of making videos with the LX5 can be reduced to four words: "Push the red button." Having a dedicated motion picture recording button does make things very easy for the user of this camera, because anytime you see a reason to take some video footage, you can just press that easily accessible button while aiming at your subject, and you will get some results that are very likely to be quite usable. So, if you're more of a still photographer and not particularly interested in movie-making, you don't need to read any further. Be aware that the red button exists, and if flying saucers start to land in your neighbor's back yard, the button will be there for you.

But for those LX5 users who would like to delve further into their camera's motion picture capabilities, there is considerably more information to discuss.

Choosing the Shooting Mode

One aspect of motion picture recording with the LX5 that is somewhat confusing is what to do about choosing a shooting mode. For still photography with this camera, when you choose a shooting mode by turning the Mode dial on top of the camera, that is the mode that you will shoot your pictures in. That is not quite how it works with movie recording. In the motion picture arena, where you set the Mode dial has some effect on your shooting, but not as direct an effect as for still photos.

Here is the situation. If you look at the Mode dial on top of the camera, you will see the various shooting modes for still photography: Intelligent Auto, Program, Aperture Priority, Shutter Priority, Manual, Custom 1, Custom 2, Scene, and My Color. There is also one entry on the dial for movies, repre-

sented by the letter M with a movie camera icon: Creative Motion Picture mode. However, because of the red Movie button, you do not have to set the Mode dial to Creative Motion Picture mode to record a movie (though you certainly can, as I'll discuss shortly). In fact, you can have the Mode dial set to any of its settings and still record a movie. But, the results may not be what you might expect based on the name of the shooting mode.

For example, if the mode dial is set to M for Manual Exposure mode, if you press the red button you will not be shooting a movie in Manual Exposure mode. In fact, you'll be shooting a movie with the camera adjusting the exposure automatically by setting the aperture and shutter speed. This is the same result you'll get with any of the four PASM shooting modes on the Mode dial (Program, Aperture Priority, Shutter Priority, and Manual).

Here is where the situation gets slightly complicated. As I just noted, when you set the Mode dial to some of the major still-shooting modes, such as A, S, or M, the camera does not follow that mode's behavior for setting exposure when you press the red movie button. But the camera does use some (but not all) of the other settings that have been made in that shooting mode. For example, if you have the camera set to Aperture Priority mode on the Mode dial, when you press the red button to make a movie, the camera does not let you set the aperture; instead, it chooses both aperture and shutter speed. However, the camera does use some of the settings that have been chosen through the Recording menu while the camera was in Aperture Priority mode, such as white balance, metering mode, and ISO. However, the autofocus mode will be set to 1-Area; you cannot use 23-Area or AF Tracking when recording movies. And, of course, several options from the Recording menu make no sense when recording movies, and therefore have no effect when you press the red button, including Flash, Burst, Auto Bracket, and Aspect Bracket.

You also can set the Mode dial to Intelligent Auto mode, and the camera will take over even more of the settings for your movies, or you can set it to Scene mode and for movies it will use the basic settings for the type of scene you select, in many cases. For certain scene types, though, the camera will use its own versions of scene types, as follows: For the two Baby scene types, the camera will use the Portrait type. For Night Portrait, Night Scenery, and Starry Sky, the camera will use what Panasonic calls the "Low Light mode." And, for Panorama Assist, Sports, Pet, Hi-Speed Burst, Flash Burst, and Fireworks, it will use its "Normal Motion Picture" mode.

If you want to have more control over the camera's exposure settings while shooting your movie, that's the role of the movie-oriented setting on the Mode dial, Creative Motion Picture.

When you turn the Mode dial to that setting, the screen will display a menu of four exposure modes: Program, Aperture Priority, Shutter Priority, and Manual Exposure.

EXPOSURE MODE
P PROGRAM AE
A
S
M

SELECT ☜ SET

You have to select one of those four modes, which will then be in effect when you press the red button to record a movie.

196

These modes work in essentially the same way as their still-photography counterparts, but they are distinctly separate, video-oriented shooting modes.

If you select Program, the camera chooses shutter speed and aperture.

If you choose Aperture Priority, you use the rear dial to select the aperture, and the camera will then adjust its shutter speed for the correct exposure, if possible. The range of aperture values you can select from is considerably greater at the narrow end of the spectrum than for still images. The LX5 has a special range of video-oriented aperture values: f/2.0 to f/11 at the wide-angle zoom setting, and f/3.3 to f/18 at the zoomed-in setting. (The range of f numbers available for still shooting is f/2.0 to f/8.0 at wide-angle, and f/3.3 to f/8.0 when zoomed in.)

If you choose Shutter Priority, you set the shutter speed. Because of the nature of video footage, which is recorded (in the United States) at about 30 frames per second, the slowest shutter speed you can normally choose is 1/30 second (but see the note below under Manual mode, for an exception). You can choose from a wide range of faster shutter speeds, though; in fact, for motion pictures in Creative Motion Picture mode, the camera has a special range of shutter speeds for video recording: 1/30 second to 1/20,000 second!

If you choose Manual, you set both shutter speed and aperture, in the same way as for still photography. Of course, as with shooting stills, the camera will not make any changes until you change one or both of the values, so, if the lighting changes, the exposure may be incorrect. There is one more benefit in terms of creative options if you shoot your video in this Manual mode: If you also have the focus switch (on the lens barrel) set to manual focus, you can then set the shutter speed as slow as 1/8 second. This shutter speed setting results in a video frame rate of 8 frames per second, considerably slower than the normal (U.S.) frame rate of 30 frames per second. It lets you record usable footage in conditions of very low light and can result in interesting effects, such as ghost-like streakiness of your image if you pan the camera. You would not want to use this slow shutter speed for taking video of a sporting event, but if you're making a science-fiction or horror movie, this feature could present some very promising possibilities.

Note, also, that you are completely free to change either shutter speed or aperture, or both, during your shot. So, for example, if you're shooting a movie in Shutter Priority or Manual Exposure mode, you can gradually increase the shutter speed to a faster and faster value to make the picture fade gradually to black. In fact, I just did this, and was somewhat amazed to see the shutter speed value on the LCD eventually rise to 1/20,000 second! This seems quite amazing in a camera whose fastest shutter speed for still photos is 1/4000 second. But it

worked, and produced a nice fadeout. The only problem was that the motions of the rear dial could be heard on the audio track. (Audio recording is not a strong point in the LX5's video-making characteristics.)

With the Program, Aperture Priority, and Shutter Priority video modes, you can adjust exposure compensation, just as with still photography, by pressing in on the rear dial and then turning it left or right. Also, when the camera is set to Creative Motion Picture mode, you can use the shutter button to start and stop video recording. In all other modes, pressing the shutter button will take a still picture, but in this one situation, you can use either the red Movie button or the shutter button to control movie-making. The only advantage I can think of for using the shutter button instead of the red button is that you can control that button using the cable release with its special adapter, as described in Appendix A. (You can't use the self-timer in Creative Motion Picture mode.)

Finally, you can use manual focus when shooting movies, but there will be no enlarged focus area or distance scale displayed on the LCD to assist you in achieving sharp focus.

The Motion Picture Menu

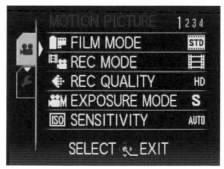

Now you have chosen a shooting mode for making your movies. Next, we will explore the one menu system we have not yet discussed in any detail—the Motion Picture menu. This menu

is available whenever the camera is in shooting mode. The camera does not have to be in Creative Motion Picture mode, because, as we have seen, you can press the red button at any time to record a movie. The Motion Picture menu changes according to what shooting mode has been set with the Mode dial on top of the camera. It's also important to note that many of the items that appear on the Motion Picture menu when the Mode dial is set to Creative Motion Picture are similar to, or the same as, items that also appear on the Recording menu for still photos. This situation can be a little confusing to sort out. I find that the best way to approach the matter is to discuss each of the items on the Motion Picture menu, including those that have already been discussed in connection with the Recording menu, even if the discussion is very brief. Along the way, I'll note what modes the various items are applicable to.

With that introduction, following is the list of all items that can appear on the Motion Picture menu. Each item is accompanied by the list of Mode dial positions in which it appears, abbreviated as follows: IA – Intelligent Auto; P – Program; A – Aperture Priority; S – Shutter Priority; M – Manual; CMP – Creative Motion Picture; C1 – Custom 1; C2- Custom 2; SCN- Scene; MC – My Color.

Film Mode (CMP)

This setting lets you choose the "look" of your footage. It works the same as it does for still photos. The choices are Standard, Dynamic, Nature, Smooth, Vibrant, Nostalgic, Standard (B&W), Dynamic (B&W), Smooth (B&W), My Film 1, My Film 2. The only difference from the still-shooting settings is that the Multi Film setting is not available, because that setting is for taking multiple shots with different settings, and has no applicability in the video context.

Recording Mode (IA, P, A, S, M, CMP, C1, C2, SCN, MC)

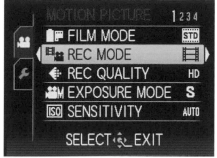

This setting gives you the basic choice of video format for any movies you make: AVCHD Lite or Motion JPEG. If you want the highest-quality HD (high definition) footage to display directly on an HDTV, choose AVCHD Lite. However, unless you are experienced in editing such footage, you may find it more difficult to work with on a computer than Motion JPEG, which produces the relatively familiar .mov files that are used by Apple QuickTime software. In addition, if you want to produce smaller, lower-quality footage for e-mailing or web use, select Motion JPEG, which gives you the option of producing files that are easier to send via e-mail than AVCHD files.

Recording Quality (IA, P, A, S, M, CMP, C1, C2, SCN, MC)

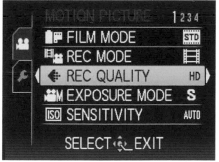

The choices here depend on what you select for Recording Mode, above. If you choose AVCHD, the choices for Recording Quality are SH, H, and L, for super-high, high, and low

quality. All of these formats produce videos of the same size: 1280 X 720 pixels in the 16:9 widescreen aspect ratio (regardless of how the aspect ratio switch on the lens barrel is set). The difference is in the bit rate of the video recording, or how much data is recorded for the footage. The higher the bit rate, the higher the quality of the images, but the more storage space required and therefore the less recording time on your memory card.

If you choose Motion JPEG for the Recording Mode, the Quality choices are the following, in descending order of quality: HD (1280 X 720 pixels, 16:9 aspect ratio); WVGA (848 X 480 pixels, 16:9 aspect ratio); VGA (640 X 480 pixels, 4:3 aspect ratio); QVGA (320 X 240 pixels, 4:3 aspect ratio). The WVGA setting is not available when the Mode dial is set to Intelligent Auto.

Exposure Mode (CMP)

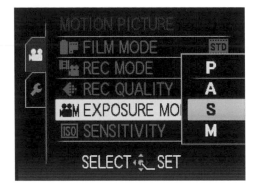

This option lets you select one of the four special video-oriented exposure modes that are available in Creative Motion Picture mode: Program, Aperture Priority, Shutter Priority, or Manual. You can select one of these modes when you first turn the Mode dial to the CMP setting, or you can use this menu option if you later want to switch modes while you're still in the CMP shooting mode.

202

Sensitivity (CMP)

This setting lets you set the ISO for your video footage. The menu option works the same way as for still shooting, except that the only choices are Auto, 400, 800, 1600, 3200, and 6400, unless you change the ISO Increments setting on this menu, discussed below. There are no higher or lower settings, and there is no Intelligent ISO setting.

ISO Limit Set (CMP)

As with the Sensitivity setting, this one works in the same way as its still-photography counterpart, but it has fewer possible values, the same ones as for the Sensitivity setting.

ISO Increments (CMP)

As with the Recording menu version of this setting, this option lets you set the ISO increment to 1/3 EV instead of 1 EV, resulting in several interpolated values: 500, 640, 1000, 1250, 2000, 2500, 4000, and 5000.

White Balance (CMP)

This setting works just as the White Balance setting does for still photography.

AF Mode (CMP)

The Autofocus mode setting for motion pictures is limited to two choices: Face Detection or 1-Area AF. If you choose the latter, you can move the focus rectangle around the screen with the cursor buttons and resize it with the rear dial, just as with still image recording.

Continuous AF (P, A, S, M, CMP, C1, C2, SCN, MC)

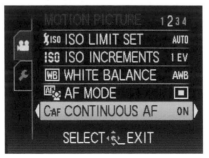

This setting is somewhat similar to the Pre-AF setting on the Recording menu, but it is oriented to the video features of the LX5. It has only two settings: On and Off. If you turn it on, the camera will attempt to keep its focus on the subject you first focus on. If you turn it off, focus will remain fixed where you first set it. This setting is fixed off for the Starry Sky and Fireworks scene types. When you are shooting a motion picture, you can re-focus at any time by pressing the Focus button.

AF/AE Lock (CMP)

This setting works in the same way as the similar setting on the Recording menu.

Metering Mode (CMP)

This menu option gives you access to the same three metering methods found on the Recording menu: Multiple, Center-weighted, and Spot.

Intelligent Exposure (CMP)

This setting works the same as the similar setting on the Recording menu.

Intelligent Resolution (CMP)

This setting also works the same as its still-photo counterpart.

Intelligent Zoom (CMP)

This setting is another one that is no different from the version on the Recording menu.

Digital Zoom (CMP)

Another setting that's the same as that on the Recording menu.

Stabilizer (CMP)

This setting differs from the similar one on the Recording menu. The version for still photos has three settings: Off, Mode 1, and Mode 2. The version on the Motion Picture menu has only the Off and Mode 1 settings, which makes sense, because Mode 1 means the Stabilizer works constantly, and Mode 2 means it works only when the shutter button is pressed. Mode 2 would not make sense in the motion picture context.

AF Assist Lamp (CMP)

This setting is the same as for still photography—off or on.

Conversion (CMP)

This setting is no different from the same one on the Recording menu. Set it to On if the wide-angle conversion lens is attached.

Wind Cut (P, A, S, M, CMP, C1, C2, SCN, MC)

This last setting on the Motion Picture menu is one of the few that appear only on that menu. It has two settings: Off or On. If it is turned on, the camera attempts to cut the noise from wind while recording a video sequence. This processing may have an adverse effect on the quality of the audio, though. Again, audio recording is not a strong suit of the LX5.

Recording Time

One other point about video-making with the LX5 is not related to the menu system: the length of recording time available. Although the version of the camera sold in Europe is limited to recording just under 30 minutes of video in one stretch, the version of the LX5 camera that is sold in the United States is capable of an amazing amount of continuous recording time—slightly more than 13 hours in the AVCHD Lite format! That figure is not for the total amount that can fit on a single SD card; it's for the total time you can record video in one uninterrupted shot! That amount of recording requires a 64 GB SDXC card, which are now available (though at a rather high price at present—more than $300.00).

Although I don't expect to have a great need for recording great lengths of video continuously, the need can arise, as I found when I recorded my daughter's high school play using two camcorders that each held only one hour's worth of tape; the juggling act to keep the recording going without any gaps was fairly hair-raising.

As an experiment, I loaded the LX5 with a 64GB SDXC card and plugged in the AC adapter (along with the required DC Coupler; see Appendix B). I set the camera on a tripod aimed at a TV set and set the recording format to AVCHD Lite and the quality to SH, the highest possible. With this setup, the

206

camera recorded a baseball game. The total recording time was about 2 hours and 48 minutes by the time the game ended. The camera was still going strong when I turned it off. I played back the recording, and it showed no problems—that is, no gaps, pauses, or stutters. The quality was not great, apparently because of some interference when recording directly from a TV screen. The audio was quite acceptable.

The results of this test showed me that the LX5 (U.S. version) is very capable of recording multiple hours of high-quality video and audio, as long as you have an AC adapter (with DC Coupler) and an SDXC card (or an SDHC card for shorter durations). I can imagine various situations in which the camera's ability to make super-long recordings could come in handy; besides school plays, there could be business conferences, speeches, and other long-lasting events that you might want to capture in HD quality video.

Dealing with Purple Lines

One issue that may cause you considerable consternation when you first encounter it is the purple lines that can appear on your video images under certain circumstances. As you can see from the image below, which is a still taken from a video shot with the LX5 in a room with bright lights, these lines can be very intrusive and annoying.

If you see these lines in your videos, it does not mean there is anything defective about your camera; it is a known issue that occurs when you are filming with a CCD sensor like that on the LX5 toward bright lights or with wide-open apertures. Try to avoid these conditions. One fix suggested by users on dpreview.com is to use Creative Motion Picture mode with the Manual or Shutter Priority setting and set your shutter speed to 1/30 second. You still need to avoid aiming the camera directly at bright lights or the sun, but using the 1/30 second shutter speed may help minimize the problem.

Recommendations for Recording Video

Now that I have covered the essentials of how to record video footage with the LX5, here are some recommendations for how to approach that process. I have to say that I feel somewhat overwhelmed at the wealth of features and capabilities of this camera in the movie-making arena, and it may be that some readers feel the same way. I don't pretend to have definitive answers to how best to use the LX5 for making movies. The existence of such sophisticated video recording features in such a small digital camera is a fairly new phenomenon, and I expect many amateur and even some professional filmmakers will develop an amazing range of applications for those features. For now, I will just offer some general guidelines for how to use the LX5's motion picture functions.

In my opinion, for everyday use, such as for taking video clips of a vacation trip or a birthday party, it's probably a good idea to stick with the Intelligent Auto setting on the Mode dial, and, on the Motion Picture menu, set Recording Mode to Motion JPEG and Recording Quality to HD. In that way, you'll likely have excellent-quality videos, well exposed, and ready to show on an HDTV (or standard TV) or to edit in your favorite video-editing software.

If you happen to be in a situation that clearly fits one of the Scene modes, like a day at the beach, or an afternoon on the ski slopes, you might want to switch the Mode dial to Scene mode and select the appropriate scene type, to take advantage of the camera's programming for that environment.

If your inner Kathryn Bigelow or Quentin Tarantino is struggling to emerge, by all means turn the Mode dial to Creative Motion Picture and start experimenting with manual exposure using incredibly fast or quite slow shutter speeds, hours-long shots, custom Film Mode settings, pull-focus shots using manual focus, and maybe throw in some creative uses of white balance settings to boot.

If you aren't ready to deal with a whole host of manual settings, but still would like to add some flashy coloring to your movie scenes, consider shooting in My Color mode, choosing a style like Expressive or Retro. Or, choose Custom and create your own look.

My point is that the possibilities for creativity with the LX5's movie-making apparatus are, if not unlimited, at least mind-boggling. So consider the options, and don't hesitate to press the red button when inspiration strikes.

Chapter 9: Other Topics

Macro (Closeup) Shooting

Macro photography is the art or science of taking photographs when the subject is shown at actual size (1:1 ratio between size of subject and size of image) or slightly magnified (greater than 1:1 ratio). So if you photograph a flower using macro techniques, the image of the flower will be about the same size as the actual flower. You can get wonderful detail in your images using macro photography, and you may discover things about the subject that you had not noticed before taking the photograph.

The LX5, like many modern digital cameras, has a special capability for shooting in macro mode. To use this mode, you have only one basic setting to change: Move the autofocus switch on the left side of the lens barrel to its middle position,

for Macro Autofocus, with the tulip icon, indicating macro.

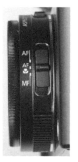

With the autofocus switch in Macro position, the camera can focus as close as 0.4 inch (1 cm) from the subject, when the Zoom lever is pushed all the way to the wide-angle setting. With the lens zoomed in for its full optical zoom, the camera can focus as close as about 1 ft (30 cm) in Macro mode. If the camera is not set to Macro mode, then the closest focusing point is about 1.64 ft (50 cm) at the widest angle, and about 3.28 ft (1 meter) with the lens zoomed in fully.

You don't have to use the Macro setting to take macro shots; if you use manual focus by moving the focus switch to its lowest position (MF), you can also focus on objects very close to the lens. You do, however, lose the benefit of automatic focus, and it can be tricky finding the correct focus manually.

When using the Macro setting, you should use a tripod, because the depth of field is very narrow and you need to keep the camera steady to take a usable photograph. It's also a good idea to use the self-timer or a cable release (see Appendix A). If you do so, you will not be touching the camera when the shutter is activated, so the chance of camera shake is minimized. You should also leave the built-in flash retracted, so it can't fire. Flash from the built-in unit at such a close range would be of no use. If you need the extra lighting of a flash unit, you should consider using a special unit designed for close-up photography, such as a ring flash that is designed to provide even lighting surrounding the lens.

I don't know of a ring flash made to fit on the LX5, but there are flash units that can be used or adapted for this purpose. I have heard that the Metz 15 MS-1 Ringlight works well, though I have not tried it myself. There are also other creative solutions to the problem of providing even lighting for closeup

photography. For an excellent discussion of this and related issues, see *Closeup Shooting* by Cyrill Harnischmacher (English translation published by Rocky Nook 2007).

One question you may have is: If the camera can focus down to one centimeter and out to infinity in Macro mode, why not just leave it set in Macro mode? The answer is that in Macro mode, the focusing system is set to favor short distances, and it is not as responsive in focusing on farther objects. So in Macro mode you may notice that it takes more time than usual to focus on subjects at farther distances. If you don't need the fastest possible focusing, you can just leave the camera set to AF Macro at all times, if you want the whole range of focusing distances to be available.

Using RAW Quality

I've discussed RAW a couple of times. RAW is a Quality setting in the LX5's Recording menu. It applies only to still images, not to motion pictures. When you set the Quality to RAW, the camera records the image without as much in-camera processing as it performs for JPEG images; essentially, the camera takes in the "raw" data and records it, leaving you with a wide range of options for altering it through software.

There are both pros and cons to using RAW in this camera. First, the cons. A RAW file takes up a lot of space on your memory card, and, if you copy it to your computer, a lot of space on your hard drive. Second, there are various functions of the LX5 that don't work when you're using RAW. The user's manual does not list all of these in one place, but as far as I could determine, these are the functions that don't work with RAW Quality images: Intelligent Exposure, Intelligent Auto mode, Digital Zoom, Aspect Bracket, White Balance Bracket, Multi Film, Resize, Cropping, Leveling, Title Edit, Text Stamp, Favorites, and Print Set (printing directly to a photo printer).

In addition, some of the My Color settings don't work with RAW files, including Pin Hole, Film Grain, and others. Third, you may have problems working with RAW files on your computer, though those can be overcome.

On the other hand, using RAW files has several very positive points. The main benefit is that RAW files give you an amazing amount of control and flexibility with your images. When you open up a RAW file in a compatible photo-editing program, the software gives you the opportunity to correct problems with exposure, white balance, color tints, and other settings. For example, if you had the aperture of the camera too narrow when you took the picture, and it looks badly underexposed, you can manipulate the Exposure slider in the software and recover the image to a proper exposure level. Similarly, you can adjust the white balance after the fact, and remove inaccurate color casts. You can even change the amount of fill lighting. In effect, you get a second chance at making the correct settings, rather than being stuck with an unusable image because of unfortunate settings when you pressed the shutter button.

The drawbacks to using RAW files are either not too severe, or they are counter-balanced by the great flexibility RAW gives you. The large size of the files may be an inconvenience, but the increasing size of hard drives and SD cards, with steadily dropping prices, makes file size much less of a concern than previously. I have heard some photographers grumble about the difficulties of having to process RAW files on the computer. That could be an issue if you don't regularly use a computer. I use my computer every day, so I don't notice. I have had problems with RAW files not loading when I didn't have the latest Camera RAW plug-in for Adobe Photoshop or Photoshop Elements, but with a little effort, you can download an updated plug-in and the software will then process and display your RAW images. The LX5 comes with SilkyPix, a program for processing RAW files, so you don't have to buy any additional software to process RAW files.

213

The bottom line is you certainly don't have to use RAW, but you may be missing some opportunities if you avoid it.

Using Flash

As I discussed earlier, the Flash setting, accessible through the Recording menu or the Quick Menu, controls the various settings for flash: Auto, Auto/Red-eye Reduction, Forced On, Slow Sync/Red-eye, Forced On/Red-eye Reduction (available only with the Party and Candle Light varieties of Scene mode), and Forced Off.

These choices can be broken down as follows: First, decide if you want to allow the flash to fire at all. If you don't want to, then don't pop up the built-in unit and don't attach an external unit. (Remember, there are some cases in which you can't make that decision because the camera won't let you. The obvious one is the Flash Burst setting in Scene mode. If you choose that setting without popping up the flash or attaching an external flash, the camera will not let you press the shutter button.)

If you decide to allow the use of flash, you may have some further decisions to make, depending on what shooting mode you're using. If you're using Intelligent Auto mode, once you've popped up the flash (or attached an external one), your flash decision-making is done. In that recording mode, the camera automatically selects Auto mode for the flash, will determine whether to fire it, and, if so, whether to use Slow Sync and/or Red-eye reduction.

With some Scene types, the camera will also make flash decisions for you. In Fireworks and Starry Sky modes, the flash is forced off, even if it's popped up. In the Portrait modes it's initially set to Auto with Red-eye Reduction, though you can use the Flash button to change it to Auto or Forced On.

214

To take back some of the decision-making authority from the camera, let's assume you're shooting in Program mode. Now you have to decide whether to choose Auto, Auto with Red-eye Reduction, Forced On, or Slow Sync with Red-eye Reduction.

Let's start with Forced On. Why would you want to force the flash to fire, when you could set it to Auto and let the camera decide whether it's needed? One case is when there is enough backlighting that the camera's exposure controls could be fooled into thinking the flash isn't needed. If, in your judgment, the subject will be too dark for that reason, you may want to force the flash to fire. Another such situation could be an outdoor portrait for which you need fill-in flash to highlight your subject's face adequately.

What about Slow Sync with Red-eye Reduction? Normally, the LX5's flash can synchronize ("sync") with the camera's shutter at any speed from 1/60 second to 1/4000 second. If you use the Slow Sync setting, the camera can sync at speeds as slow as one full second. With Slow Sync, the camera can set this relatively slow shutter speed so that the ambient (natural) lighting will have time to register on the image. In other words, if you're in a fairly dark environment and fire the flash normally, it will likely light up the subject (say a person), but because the exposure time is short, the surrounding scene may be black. If you use the Slow Sync setting, the slower shutter speed allows the surrounding scene to be visible also. For example, the two photographs on the next page were taken at the same time and in the same conditions; the only difference is that the one on the left was taken with the shutter speed set at 1/640 second, in normal flash mode. The one on the right was taken in Slow Sync flash mode with a shutter speed of 1 second, which allowed the ambient lighting from the windows of the house behind the telescope to appear in the image.

The other aspect of this setting is Red-eye Reduction. Red-eye is a familiar problem in color photos of people taken with flash. If the subjects are sitting in a dark place, their pupils are likely dilated, and the sudden bright flash bounces off of the red blood vessels in their retinas, giving an unnatural red tint to their eyes. When Red-eye Reduction is set, the camera fires a quick pre-flash before the picture is taken. The idea is that that flash will cause the subjects' pupils to contract, reducing the chance of the red-eye effect.

The other choices in Program mode are Auto and Auto with Red-eye Reduction. Auto gives the camera a chance to use its programming to determine the best setting. It may set Red-eye Reduction and/or Slow Sync, depending on conditions. If you choose Auto with Red-eye Reduction, the flash will fire only if needed, but if it does, it will fire twice to reduce red-eye. There are a great many considerations that go into the use of flash. The best advice I can give you is to consult an expert if you want to explore the subject further. An excellent book about the use of flash is *Mastering Digital Flash Photography*, by Chris George (Lark Books, 2008).

Infrared Photography

In a nutshell, infrared photography lets the camera record images that are illuminated by infrared light, which is invisible to the human eye because it occupies a place on the spectrum of light waves that is beyond our ability to see. In some circumstances, cameras, unlike our eyes, can record images using this type of light. The resulting photographs can be quite spectacular, producing scenes in which green foliage appears white and blue skies appear eerily dark.

Shooting infrared pictures in the times before digital photography involved selecting a particular infrared film and the appropriate filter to place on the lens. With the rise of digital imaging, you need to find a camera that is capable of "seeing" infrared light. Many cameras nowadays include internal filters that block infrared light. However, some cameras do not, or block it only to a relatively small extent. (You can do a quick test of any digital camera by aiming it at the light-emitting end of an infrared remote control and taking a photograph while pressing a button on the remote; if the remote's light shows up as bright white, the camera can "see" infrared light at least to some extent.)

The LX5 is quite capable of taking infrared photographs. In order to unleash this capability, you need to take a few steps. The most important is to get a filter that blocks most visible light, but lets infrared light reach the camera's light sensor. (If you don't, the infrared light will be overwhelmed by the visible light, and you'll get an ordinary picture based on visible light.)

As with most experimental endeavors, there are multiple ways to accomplish this. For example, if you search on the internet, you will find discussions of how to improvise an infrared filter out of unexposed but developed (*i.e.*, black) photographic film.

A more certain, though more expensive way to make infrared photographs with the LX5 is to purchase an infrared filter, along with an adapter that lets you attach the filter securely to the camera. There is an adapter available from Panasonic, and other companies may offer them also. I bought the official Panasonic adapter, Model No. DMW-LA6. All such adapters require you to unscrew the trim ring from the camera's lens, and screw on the adapter in its place. You can then attach any filter or accessory lens with a 52mm diameter that screws on.

The infrared filter I have seen most often mentioned is the Hoya R72, which is what I use. It is very dark red, and blocks most visible light, letting in infrared light rays in the part of the spectrum that tends to yield interesting photographs.

The next question is to figure out matters of exposure. Again, photographers have different approaches, and time spent looking on the internet for discussions of those approaches will be rewarding. I set a custom white balance, using brightly sunlit green foliage as the base. That is, I used the camera's White Balance menu setting in the Record menu, and, in the screen for setting a custom white balance, I aimed the camera at the bright green foliage and pressed the Menu/Set button. The results were essentially what I expected from infrared photography—scenes with tree leaves and grass that look white, and other unusual, but pleasing effects.

For exposure, I set the camera to shoot in Aperture Priority mode and let it select the necessary long shutter speed. (Necessary because of the dark filter.) I set the camera on a tripod and disabled the image stabilizer, because it is not needed when the camera is stabilized by a tripod. The LX5 did the rest. The shot on the next page was taken at f/2.0 with a shutter speed of 3.2 seconds, with an ISO setting of 400. You can often get interesting results if you include a good amount of green grass and trees in the image, as well as blue sky and clouds.

One problem that can arise with infrared photography using a camera like the LX5 is the presence of an unsightly bright "hot spot" in the middle of the image. One way around this problem is to zoom in; sometimes the spots are not as noticeable at longer focal lengths. In some cases, you can remove the spot in an editing program such as Photoshop or Photoshop Elements. Or, you may have to compose your shot so you can crop out the part with the hot spot.

Street Photography

One of the reasons many users prize the LX5 is because it is very well suited for street photography — that is, for shooting candid pictures in public settings, often surreptitiously. The camera has several features that make it well-suited for this type of work—it is lightweight and unobtrusive in appearance, so it can easily be held casually or hidden in the photographer's hand. Its 24mm equivalent wide-angle lens is excellent for taking in a broad field of view, for times when you shoot from the hip without framing the image carefully on the screen. Its f/2.0 lens lets in plenty of light, and it performs well at high ISO settings, so you can use a relatively fast shutter speed to avoid motion blur. You can make the camera completely silent by turning off the beeps and shutter sounds.

What are the best settings for street shooting with the LX5? If you ask that question on one of the online forums, you are, naturally, likely to get many different responses. I'm going to give you some fairly broad guidelines as a starting point. The answer depends in part on your own personal style of shooting, such as whether you will talk to your subjects and get their agreement to being photographed before you start shooting, or whether you will fire away from across the street with a palmed camera and hope you are getting a usable image.

Here is one set of guidelines you can start with and modify as you see fit. To get the gritty "street" look, set Film Mode to Dynamic B&W, but dial in -2 Noise Reduction and -1 Sharpening. Use RAW plus Fine JPEG for post-processing options. Set aspect ratio to 16:9 for a wide field of view. Set ISO to 800 for good image quality while boosting sensitivity enough to stop action with a fast shutter speed. Turn on Burst mode, so you'll get several images to choose from for each shutter press.

When you're ready to start shooting, go into manual focus mode and set the focus to approximately the distance you expect to shoot at, such as 6 feet (2 meters) on the MF scale. Then, when you're ready to snap a picture, use the Focus button to make a quick fine-tuning of the focus. Some street photographers maintain that this method is faster and more efficient than relying on the autofocus system. For exposure, set

the camera to Aperture Priority mode, with the aperture set to about f/4.5. When shooting at night, you may want to open the aperture a bit wider, and possibly boost the ISO to 1600. Of course, for any of this sort of shooting, you leave the lens zoomed back to its full wide-angle position.

Making 3D Images

There's been a lot of attention paid to three-dimensional (3D) movies and images lately, with the advent of 3D televisions and the renaissance in 3D movies. Some digital cameras have appeared recently that have special features for creating 3D panoramas and other stereoscopic images, including the Sony NEX-3 and NEX-5, and the Fujifilm FinePix Real 3D W3. The Lumix LX5 has no such built-in capability. But why should LX5 users feel left out of the 3D wave? It's not that hard to create 3D images using just the LX5 (well, okay, or any other camera, for that matter). Anyway, for you experimental types, here is one way to get into 3D with the LX5.

First, you need to take two pictures of the same scene from two different positions, separated by a short distance. What I did was set up two tripods next to each other at the same height, about six inches apart, with the subject about eight feet distant. Then I took two pictures, first one from the left tripod, then one from the right. The camera needs to be facing straight ahead each time, not angled in toward the subject. I used manual exposure and set the ISO to 200, to get good quality with no variation in the exposure. I saved the images as JPEG files.

Next, I used a Windows program called Stereo Photo Maker, which can be downloaded free at http://stereo.jpn.org/stphm-kr. From the program's File menu select Open Left/Right images. I opened my two JPEG images with this command, which lets you load multiple images at once. Then, I went

221

to the Stereo menu and, with both images appearing on the screen, I selected Color Anaglyph, and then, on the sub-menu that appeared, Dubois (red/cyan). The program produced the single image shown below, which looks blurry, with red and blue lines characteristic of 3D images you may have seen in comic books or other printed materials. (If you're using a Mac, there are other programs available, though I haven't used them. One possibility is Anabuilder, at http://anabuilder.free. fr. You also can use Photoshop, but you'll need to experiment a bit, or find instructions on the web.)

That's all there is to it! If you follow these steps with images that are properly aligned and taken from a good distance apart, the resulting image should be ready for viewing, either on screen or on paper, using old-fashioned red/blue 3D glasses. (The red side goes over the left eye.) If it doesn't pop out as a 3D image when viewed through the glasses, go to the Adjustment menu and try various adjustments, including Auto Alignment, Easy Adjustment, and others, until it looks good. (I had to use those commands to adjust the images that I worked with.)

Oh, by the way, if you can't find a pair of 3D glasses, I have a deal for you. Send a self-addressed, stamped, letter-size envelope to White Knight Press at the address in the front of this book, and I'll send you a free pair of paper 3D glasses. They're not fancy, but they work. (I'll definitely honor this offer until the end of 2011, and longer if I still have glasses available.)

Digiscoping and Astrophotography

Digiscoping is the specialized practice of attaching a digital camera to a spotting scope in order to get clear shots of remote objects, generally birds and other wildlife. Astrophotography involves photographing the stars, planets, and other celestial objects using a camera connected to (or aiming through) a telescope.

I can't say that using the LX5 is the best possible way to engage in either of these activities; if you want to take close-ups of animals, you might do better with a DSLR using a long telephoto lens, and for astrophotography you undoubtedly could do better with a special camera or imaging device that is designed for long exposures through a telescope. However, this book is about the LX5, and my goal here is to give you some suggestions about useful and enjoyable ways to use this camera, not to find the best possible methods for long-distance photography. That's not to say that the LX5 is a terrible camera for these types of photography; it does have some features that equip it nicely for taking pictures through a scope, including light weight, a high-quality lens, manual exposure, manual focus, RAW quality, and shutter speeds of up to 60 seconds.

One of the less-helpful features of the LX5 when it comes to astrophotography, however, is that it has a permanently attached lens. You cannot remove the lens and attach the camera's body directly to a telescope or spotting scope, as you can with a DSLR. So, you have to use the lens of the LX5, and somehow use it in conjunction with the eyepiece and main lens or mirror of the scope. There are many different types of scope and several different ways to align the scope with the LX5's lens. I will not discuss numerous combinations; I will talk mostly about the one combination I have recent experience with, and hope that it gives you enough general guidance to explore the area further if you want to pursue it.

223

I decided to use a Meade ETX-90/AT telescope, pictured below with the LX5 connected to its eyepiece. This telescope has a diameter of 90mm (3.5 inches), an effective focal length of 1250mm, and a focal ratio of f/13.8. It is of the Maksutov-Cassegrain design, which uses both mirror and lens to focus light into a relatively small tube (compared to the tube of a comparable reflector or refractor).

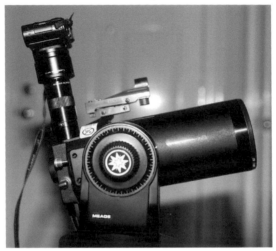

The challenge in using a camera like the LX5 to take photos through this telescope is to find a way to get the image that the eye can see through the scope's 1.25-inch (32mm) diameter eyepiece into the camera's lens. There are various types of adapter available to accomplish this, but my first attempts were by just handholding the camera as close as possible to the scope's eyepiece and snapping pictures until I got a usable image. Of course, this technique would not work with an exposure of any length, so the subject for these experiments was the moon, which does not require a long exposure.

I took the image on the next page with the LX5, handheld, through a 40mm eyepiece on the telescope and with an ND96 neutral density filter attached to the eyepiece. The camera was set through experimentation to manual exposure of 1/100 second at f/4.5, at ISO 400, with the LX5's lens zoomed out to

70mm. It was somewhat tricky to get the image of the moon in focus. My approach was to focus the image as sharply as possible using the focus adjustment on the telescope, and then to use the autofocus setting on the camera. I have seen recommendations by experts to set the camera's focus at infinity in manual focus mode, and then adjust the focus using the telescope's adjustment, but I found that using the camera's autofocus worked better for me. I used the self-timer, set to 2 seconds, to minimize camera shake as the exposure was taken.

There are other possible approaches to using the LX5 for photography through a telescope or spotting scope, which is generally called "afocal" photography, meaning that both the camera and the telescope are focusing on the subject. One approach is to use a "universal" digiscoping adapter, such as one made by Zhumell. I tried that setup, but found it did not work well for me, because of the weight and bulk of the adapter, and the fact that this adapter merely clamps the camera onto the telescope and does not provide a completely secure connection. It might be worth trying in some situations, though, and possibly might work better for terrestrial photography.

Another possibility is to obtain adapter rings that let you connect the camera directly to the telescope's eyepiece, providing a tight and continuous connection. For this approach, you

need the camera's lens adapter tube, model number DMW-LA46, or the equivalent, as well as adapter rings that let you connect that adapter's 52mm ring to the telescope's eyepiece. You can get the proper adapter rings by purchasing the 52mm Digi-Kit, part number DKSR52T, from the online site telescopeadapters.com. That is the setup that is shown earlier, in the picture that shows the LX5 connected to the telescope. The various connecting rings are shown in the images below, along with the telescope's eyepiece.

The image on the left on the next page was taken with the LX5 connected to the Meade telescope using the setup pictured above. The image on the right shows these flowers from the same vantage point using the camera's normal lens zoomed all the way in to its 90mm setting.

Connecting to a Television Set

The LX5 is quite capable when it comes to playing back its still images and videos on an external television set. The camera comes with an audio-video cable as standard equipment. The cable has a mini-USB connector at one end and two composite, or RCA, connectors at the other end. The white RCA plug is for audio (the camera's sound is monophonic, not stereophonic); the yellow one is for composite video.

To connect the cable to the camera, you need to open the little door on the right edge of the camera (when held in shooting position) and plug the small (mini-USB) connector into the smaller of the two ports inside the door.

You then need to connect the yellow and white connectors to the composite video and audio inputs of a television set. You may then need to set the TV's input selector to Video 1, or AUX, or some other setting so it will switch to the input from the camera.

Once the connections are set and the TV is turned on with the correct input selected, turn on the camera in Playback mode, and you can play back any images or video you have recorded. HD video will play back with no problems on a standard television set. You may need to switch the camera's aspect ratio to achieve the proper result on screen.

You can also purchase an optional mini-HDMI cable to connect the camera to a high-definition television set. That cable connects from the larger of the two openings in the right-side door on the camera, to an HDMI input on the HDTV set.

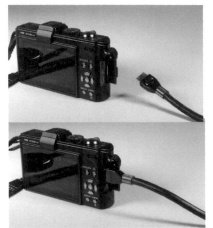

Once you have connected the camera to a TV set, the camera operates very much the same way it does on its own. Of course, depending on the size and quality of the TV set, you will likely get a much larger image, possibly better quality (on an HD set), and certainly better sound. This difference will be especially noticeable in the case of slide shows; the music sounds much better through TV speakers than from the camera's minuscule speaker.

One side note: When the camera is connected to a TV with the standard video cable, it can not only play back recorded images; it can also record. When it is hooked up to a TV while in recording mode, you can see on the TV screen the live image being seen by the camera. So you can use the camera as a video camera of sorts, and you can use the TV screen as a large monitor to help you compose your photographs or video shots. (This setup does not work with the HDMI connection, only with the standard AV cable.)

Appendix A: ACCESSORIES

When people buy a new camera, especially a fairly expensive model like the LX5, they often ask what accessories they should buy to go with it. The LX5 community is fortunate in that there are quite a few options available. I will hit the highlights, sticking mostly with items I have experience with. For information about a wide range of other accessories, including underwater housings, cable releases, digiscoping adapters, and other items, see the web sites listed in the Resources list later on. One site that maintains a good list of accessories for the predecessor model, the Lumix LX3, is http://www.lx3-photography.com/. Following is some information from my own experience.

Cases

There are endless types of camera case on the market. I like to keep any camera in a camera bag that has room for extra batteries, battery charger, connecting cables, the user's manual, flash, and other items. I also like a smaller case that can hold just the camera and maybe an extra battery. With the LX5, I have been using the Tamrac Digital 2 camera bag, model number 5692.

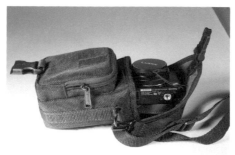

It is compact and can be carried easily on a belt using a flap that fastens with both snaps and Velcro. It has a main compartment that easily accommodates the LX5 as well as a smaller, zippered compartment that can hold an extra battery or memory card, etc. When I need to carry more equipment, I have been using a Kata waist pack, model no. DW-491, which has plenty of room for the camera and extra accessories, as well as small water bottles and other items for a day trip. Of course, there are countless other possibilities out there; these are just two items that have worked for me.

Batteries

Here's one area where you should go shopping either when you get the camera or very soon afterwards. I use the camera pretty heavily, and I run through batteries quickly. You can't use disposable batteries, so if you're out taking pictures and the battery dies, you're out of luck unless you have a spare battery (or an AC adapter and a place to plug it in; see below). Panasonic uses a "chipped" battery in this camera, meaning the camera expects to detect a signal from the battery indicating that it's a genuine one, so you can't easily find an off-brand version. Because I'm writing this quite early in the camera's life cycle, there are no alternatives to the Panasonic battery, model number DMW-BCJ13PP. I recommend you check the postings on dpreview.com to see if some of the users there locate a source of reliable, cheaper batteries as time goes by. Or, you could try a reliable retailer such as bhphotovideo.com and see if they sell a battery that is compatible with the LX5. Note, though, that batteries from earlier models, such as the LX3, definitely are not compatible with the LX5.

AC Adapter

The other alternative for powering the LX5 is the AC adapter. This accessory works well for what it does, in terms of provid-

ing a constant source of power to the camera. Unfortunately, the adapter for the LX5 is not as convenient as the one that was sold for the LX3, the predecessor model from Panasonic. With the LX5, you need to obtain not only the AC adapter, model no. DMW-AC5PP, but also another device called the "DC Coupler," model number DMW-DCC7, which looks like a battery, but has a connecting port in its side. You have to insert the DC Coupler into the battery compartment of the camera, then close the battery door, open up a small flap in that door, and connect the cord from the AC adapter to the port in the DC Coupler. This is not a very efficient (or economical) system, at least from the standpoint of the user. It is a clunky arrangement, and you can't get access to the memory card while the AC adapter is plugged in. But, if you need constant power for a long period of time, this is the only way to get it.

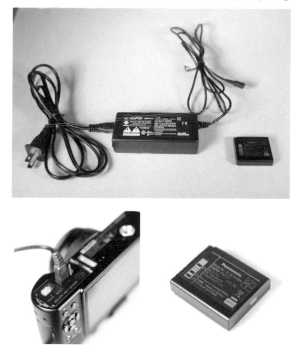

I should emphasize that providing power to the camera is all

this adapter does. It does not act as a battery charger, either for batteries outside of the camera or for batteries while they are installed in the camera. It is strictly a power source for the camera. It may be useful if you are doing extensive indoor work in a studio or laboratory setting, to eliminate the trouble of constantly charging batteries. Also, if you are taking advantage of the ability of the U.S. version of the LX5 to film very long videos, you will need the AC adapter; that is why I got one. For everyday applications and still shooting, though, the AC adapter should not be considered a high-priority purchase.

Viewfinders

The LX5 does not come equipped with a viewfinder. There is no window for you to look through at eye level to compose your shot, as there is with a DSLR or with many rangefinder cameras. Nowadays you can find many small digital cameras that rely solely on the LCD screen for composition. Some photographers don't mind the lack of a viewfinder, and some find that lack unbearable. You can get an external optical viewfinder from Panasonic, model number DMW-VF1, that fits into the hot shoe of the LX5.

Whether you need an external viewfinder with the LX5 is a matter of personal taste. Probably the main point weighing in

favor of having a viewfinder is it lets you see clearly the scene the camera is aimed at, even in bad lighting conditions. For example, in bright sunlight, the LCD screen may be totally washed out, making it practically impossible to see the image on the screen well enough to compose the picture properly. Similarly, in dim light, it may be hard to make out the scene on the LCD. Another point in favor of a viewfinder is comfort in your shooting position. Some photographers prefer to hold the camera up to their face and look through a little window when composing a shot. This may be from years of habit, or it may help them hold the camera steadier by bracing it against their forehead. The preference for a viewfinder also may have something to do with tradition; a person may feel more like a real photographer when using a viewfinder to evaluate the picture before pressing the shutter button. Finally, if you use an optical viewfinder rather than the LCD screen, you can turn off the LX5's screen, thereby saving battery power and extending the number of images you can record before changing batteries.

On the other side of the coin, the LCD screen provides a considerable amount of information, such as shutter speed, shooting mode, flash mode, etc., that the viewfinders available for the LX5 do not. (However, you could use the LCD screen to see that information and still use the viewfinder for composition.) Also, it may be possible to take candid pictures without detection more readily with the LCD screen, because you can casually aim the camera from waist level rather than holding it up to your eye. If you do get a viewfinder, one problem is that you cannot use any other accessory that uses the hot shoe, such as an external flash unit, at the same time. The viewfinder is light and easy to remove, though, so you can switch it out with the flash or other accessory.

Another option with the LX5 is to use Panasonic's electronic viewfinder, model number DMW-LVF1, which was developed for a different camera, the Panasonic Lumix DMW-GF1. This

viewfinder provides a clear, electronic view of what is seen by the camera's lens, along with all of the shooting information that ordinarily is displayed on the LCD screen. In effect, using this viewfinder gives the LX5 the functionality of a DSLR in the viewfinder arena. The view in the viewfinder is very clear and bright, and, of course, unlike the optical viewfinder, its view zooms in and out as you move the camera's Zoom lever.

As far as drawbacks are concerned, of course, like the optical viewfinder, the LVF1 occupies the only accessory shoe, so you can't use an external flash at the same time. In addition, it gets its power from the camera, so it drains the battery somewhat.

The final choice in this area comes down to personal preference. Overall, I prefer to skip the viewfinders, and just use the camera on its own, in order to keep down the bulk of the equipment and to leave the accessory shoe available for a flash if needed.

Add-on Filters and Lenses

There is no way to attach a filter or other add-on item, such as a close-up lens, directly to the lens of the LX5. In order to add such accessory items, you need to get an adapter. The adapter is like a short extension tube. You have to unscrew the thin trim ring from the camera's lens, and set it aside in a safe place. The adapter screws onto the exposed threads of the LX5's lens

assembly, and you can then screw any 52mm filter or accessory onto the end of the adapter. As I discussed earlier in the Infrared section, I have used the official adapter sold by Panasonic, model number DMW-LA6. For the LX3, a company named Lensmate sold its own adapter, and it may be that that company will make a new adapter that fits the LX5. Its web address is http://www.lensmateonline.com. The image below shows the LX5 with the DMW-LA6 adapter attached; a filter or other accessory screws in at the end of that tube.

One of the primary add-on items that you're likely to want to use with the adapter is Panasonic's own Wide Conversion Lens, model number DMW-LWA52. As you can see from the image on the next page, this is a fairly bulky and heavy item, but the camera feels well balanced if you cradle the add-on lens in one hand and hold the camera in the other. When this lens is attached, the focal length of the camera's lens is converted to 18mm rather than the normal 24mm. You need to set the Conversion item in the Recording menu to On, which disables the Zoom lever, so you are left with just the single focal length of 18mm. This is a substantial increase in the wide-angle capability of the lens, which can be of great benefit in taking photos of landscapes, and especially when photographing the interiors of rooms, perhaps for real estate listings.

Once you have the adapter, you also may want to try a UV (ultraviolet) filter, a neutral density filter, an infrared filter, a polarizer, or others, depending on your needs and interests. In addition, if you want some extra power for your macro shots, you might want to try the excellent Raynox Super Macro Conversion Lens, model number DCR-250, pictured below. You need to use the LX5's lens adapter, and the Raynox lens very easily snaps onto the end of the adapter tube. You use this add-on macro lens with the LX5 zoomed all the way in, so you can get magnified macro shots from a bit more distance than with the normal macro capability of the LX5. The images below show the Raynox lens, both off and on the LX5.

External Flash Units

Whether to buy an external flash unit is going to be very much a question of how you will use the LX5. For everyday snapshots that are not taken at long distances, the built-in flash should suffice. It works automatically with the camera's exposure controls to expose the images well, and it is even capable of taking short bursts of flash exposures. It is limited by its low power, though. Using the standards of ISO 100 at the wide-angle focal length, the range of the built-in flash is about 7.5 feet (2.3 meters), not very strong.

However, if you are using the camera to take photos of groups of people in large spaces, or otherwise need additional power or features, there are some options. One unit specifically designated by Panasonic to go with Lumix cameras like the LX5 is the Panasonic DMW-FL220, a small unit that fits very well with the camera in terms of looks and function. The FL220 fits into the camera's hot shoe and extends only about 3.75 inches (9.5 cm) above the camera's hot shoe. It weighs about 5.7 ounces (162 g) with batteries installed, provides more power than the built-in flash (its range at ISO 100 and f/2.0 is about 36 feet, or 11 meters), and communicates automatically with the camera in the same ways that the built-in flash does.

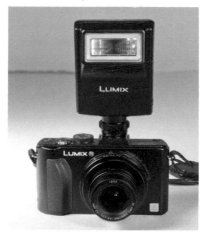

The main drawback with the FL220 is that it is a single unit with no rotating flash head, so there is no possibility of bouncing the flash off the ceiling or pointing it anywhere other than where the camera is pointing.

Other compatible external flash units are the Panasonic DMW-FL360 and similar models, including the Olympus FL-36R and the Metz Mecablitz 36 AF-4, pictured below. (You need to purchase the version of the Metz flash that is compatible with Olympus and Panasonic cameras.)

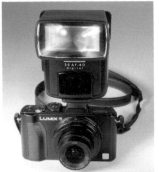

Like the DMW-FL220, these units function just like the built-in flash in terms of communicating with the camera for functions such as flash output and exposure control. The added benefit from the larger unit is that it looks like what you probably have come to expect from an external flash; it has a flash head that rotates up to a vertical position, aiming at the ceiling, so you can bounce the flash at various angles. And, of course, it is considerably more powerful than the built-in flash.

The only drawback to a flash unit such as this is its size. For example, the Metz Mecablitz 36 extends about 4.5 inches (10.8 cm) above the camera, as opposed to 3.75 inches (9.5 cm) for the FL220. The Metz flash with batteries installed weighs about 10.5 ounces (300 g), nearly twice as much as the FL220, and, in fact, more than the camera itself, which weighs slightly more than 9 ounces (266 g). When I hold the camera with the Metz flash attached, the whole assembly feels a bit overbalanced by

the flash. However, it is an excellent flash unit, and if you need the power and the flexibility that comes from having a rotating flash head, then this unit would be a good purchase.

Finally, here is one more area to explore in the flash arena: wireless triggers. Using a radio trigger on the LX5, you can trigger one or more flash units that are placed away from the camera, so you can have more control over the placement and effects of your flash illumination. I don't have a need to use this type of lighting very often, but in case your photography could benefit from this arrangement, here is information about a basic setup that I have used successfully with the LX5.

The images below show a wireless trigger connected to the LX5's hot shoe, and a matching wireless receiver connected by its hot shoe to a compatible flash unit, in this case the Panasonic DMW-FL220. I turned on the receiver and made sure both the trigger and receiver were set to the same channel using their DIP switches. Then I set the flash to its manual mode, and set the LX5 to Manual Exposure mode with the flash forced on. I set the flash unit on a stand well away from the camera, aiming at my subject, and turned it on. Whenever I pressed the shutter button on the LX5, the flash fired. I had to adjust my exposure a few times until I had it right, because there is no automatic exposure with this setup.

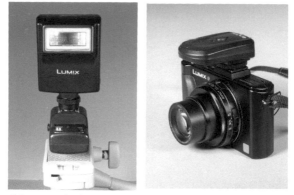

One problem with this setup is that it only works with both the

239

flash and the camera in Manual mode, and it won't work with a flash that has only TTL mode, such as the Metz Mecablitz 36 AF-4. But it worked fine with the Panasonic flash. The particular set of trigger and receiver that I used is the NPT-04, sold by CowboyStudio through Amazon.com. The documentation is sparse, but the trigger and receiver did work as expected.

Another approach that has worked for some users is to use the built-in flash on the LX5 to control a remote flash that can be triggered in that way, such as the Nikon SB-900.

Cable Release Adapter

When you're taking long exposures with the camera on a tripod, or taking macro shots or engaging in astrophotography, it's critically important to avoid camera shake that can disturb the image. Using the self-timer is one way to minimize vibrations when the shutter is released. Another way is to use a cable release, so you can trigger the shutter remotely, without exerting any force directly against the camera itself.

A gentleman named Richard Franiec manufactured a terrific accessory for the Lumix LX3—an adapter that connects to the camera's hot shoe and lets you connect a conventional cable release to the camera. The good news is that this accessory also works with the LX5. At this writing, the adapter is still available at http://www.kleptography.com/rf/#camera_lx3.

APPENDIX B: QUICK TIPS

In this section, I'm going to list some tips and facts that might be useful as reminders, especially to those who are new to digital cameras like the LX5. My goal here is to give you small chunks of information that might help you in certain situations, or that might not be obvious to everyone. I have tried to put down bits of information that might be helpful, but that you might not remember from day to day, especially if you don't use the LX5 constantly.

Use Burst shooting. The LX5 does not have the greatest continuous-shooting capability of the cameras currently available, but it is more than adequate for many needs. I recommend that you consider turning Burst shooting on as a matter of routine, unless you are running out of storage space or battery power, or have a particular reason not to use it. In the days of film, burst shooting was expensive and inconvenient, because you had to keep changing film, and you had to pay for film and processing. With digital cameras like the LX5, it just gives you more options. Even with stationary portraits, you may get the perfect fleeting expression on your subject's face with the fourth or fifth shot. So, press the Q.Menu button, scroll over to Burst, and turn it on.

Avoid the Recording menu. You can't completely avoid it, but do your best to use the Quick Menu instead, because it gives

241

you much faster access to the settings you're most likely to need regularly, including Picture Size, Metering Mode, White Balance, and Film Mode. Also, set the Fn button to call up an often-used option, and use the ISO button rather than the Recording menu's ISO item. When you do use the Recording Menu, speed through it by using the Zoom lever to move a whole screen at a time, and wrap around to reach items that are far from your current position. And use the Custom Memory Set feature to set up your four most important groups of settings. For example, right now I have the C1 slot set up for my latest settings for street photography: Film Mode = Dynamic B&W; ISO = 800; AF Mode = 23-Area; Burst=on; Shooting mode = P; Beep = all sounds mute.

Use macro shooting for subjects other than nature. Many photographers create beautiful images using the macro capabilities of the LX5, shooting insects, flowers, and other natural items. But, with its focusing down to 1 cm (0.4 in), its wide-angle lens, and its low-light performance, the LX5 can serve you in many other ways with its macro shooting. If you need a quick copy of a shopping list, memo, driving directions, receipt, or cancelled check, it might make sense to set the LX5's focus switch to AF Macro, maybe boost the ISO to 800 or so, and snap a quick image of it. When you get to your destination, you can play it on the LCD and enlarge it using the Zoom lever, then scroll around in the document with the cursor buttons. The LX5 becomes a business machine, if you want it to.

Explore the LX5's creative potential. The LX5 is a very sophisticated camera, with several advanced features that give you the ability to explore experimental photographic techniques. Here are a few suggestions: Use Manual Exposure mode with its shutter speeds as long as 60 seconds to take night-time shots with trails of lights from automobiles, storefronts, and other sources. Use the shutter speeds as fast as 1/4000 second to freeze airplanes' propellers and other speedy objects in their tracks. Try "camera tossing," in which you toss the camera in

the air, set to a multi-second shutter speed, to capture trails of light and color as the camera spins around. (But be sure to catch it on the way down!) Try zooming in or out during a multi-second exposure. Use long exposures (on a tripod) to turn night into day.

Adjust the camera's color settings. The LX5 has several settings that let you fine-tune them with further adjustments: White Balance, Film Mode, and the Custom setting in My Color shooting mode. Try different settings for each of these until you find color combinations that convey what you would like to express with your images. Develop new settings, using the My Film 1 and 2 options in Film mode: Tweak the contrast, sharpness, saturation, and noise reduction settings until you find a combination that gives you the look you prefer. Some users like to use Standard Film Mode with sharpness at +1, noise reduction at -2, and the other settings at zero. You may want to try those settings and then experiment with variations. Once you have the settings the way you want them, save them to one of the four Custom slots on the Mode dial (C-1, C-2-1, C-2-2, or C-2-3), using the Custom Set Memory option on the Setup menu.

Take advantage of the RAW Quality setting. If you haven't previously used a camera that shoots RAW files, get to know the benefits of this capability and use them to improve your images. Install and use the SilkyPix software that comes with the LX5, or use other software, such as Adobe Photoshop or Photoshop Elements, to "develop" the RAW images. Learn how to fix problems with white balance, exposure, and other issues after the fact, using the flexibility of RAW shooting.

Remember all the drawbacks of using High ISO settings. If you have some experience with photography, you're aware that higher ISO settings (say, above 800) can introduce considerable visual "noise" into your images, and can detract from their appearance. What you may not always remember with

243

the LX5, though, is that using any ISO setting above 3200 automatically reduces the resolution of the images. You could have a rude awakening if you someday forget this, and set out to take RAW images or 10 MP JPEG images at the best quality, but, after setting the ISO to 3200 or above, find that the images were reduced in resolution to 3 MP.

Use 1-Area autofocus in conjunction with Spot metering. When you do this, you can move the focus and metering area around the screen with the cursor buttons, so you can focus and meter a small, specific area of your scene. This procedure can make a big difference in the precision of your metering and focusing, and give you more control over your results.

Use a neutral density (ND) filter for some shots. There are some times when you want a slow shutter speed, but, in bright light, you can't achieve it, because the aperture can only go as narrow as f/8 (or somewhat narrower for movies). One solution is to use an ND filter over the lens, to cut down on the light reaching the sensor, resulting in slower shutter speeds. You might want to do this to slow down the rush of a waterfall to a smooth, blended look, or to achieve a motion blur in a shot of a passing runner or walker.

Diffuse your flash. If you find the built-in flash produces light that's too harsh for macro or other shots, some users have reported success with using translucent plastic pieces from milk jugs, other food containers, or broken ping-pong balls as home-made flash diffusers. Just hold the plastic up between the flash and the subject. Another approach you can try when using fill-flash outdoors is to use the flash exposure compensation setting to reduce the intensity of the flash by -2/3 EV.

Use the self-timer to avoid camera shake. The LX5 has a solid self-timer capability that is very easy to use; just press the left cursor button and choose your setting. This feature is not just for group portraits; you can use it whenever you'll be using a

slow shutter speed and you need to avoid camera shake. It can be useful when you're doing macro photography, digiscoping, or astrophotography, also.

Always check your aspect ratio and autofocus switches. It's great to use the Custom Set Memory capability to store your favorite groups of settings in the four convenient slots. But remember that you can't store the setting of the aspect ratio switch or the autofocus switch, because they are controlled by physical switches. Whenever I turn my Mode dial to C1 or C2 to activate a group of settings, I also quickly check to be sure the aspect ratio is where I want it and that the autofocus switch is set properly. Of course, you also need to open the flash if it might be needed, and set the Zoom lever where you want it, but you're not as likely to forget those settings as the other two.

Set zone focusing. If you're doing street photography or are in any other situation in which you want to set the camera on manual focus for a specific zone or general distance, here is a quick way to do so. Set the focus switch to autofocus, then aim the camera at a subject that is approximately the distance you want to be able to focus on quickly. Once focus has been confirmed, slide the focus switch down to the manual focus position. Now you will have locked in the manual focus at your chosen distance, and you're ready to shoot any subject at that distance without the need to re-focus.

Appendix C: RESOURCES FOR FURTHER INFORMATION

Photography Books

A visit to any large general bookstore or library, or a search on Amazon.com or other sites, will reveal the vast assortment of currently available books about digital photography. Rather than trying to compile a long bibliography, I will list the few books that I consulted while writing this guide.

C. George, *Mastering Digital Flash Photography* (Lark Books, 2008)

C. Harnischmacher, *Closeup Shooting* (Rocky Nook, 2007)

C. Harnischmacher, *The Wild Side of Photography* (Rocky Nook, 2010)

D. Pogue, *Digital Photography: The Missing Manual* (O'Reilly Media, Inc., 2009)

D. Sandidge, *Digital Infrared Photography Photo Workshop* (Wiley, 2009)

S. Seip, *Digital Astrophotography* (Rocky Nook, 2008)

Web Sites

At this writing, I have not found many web sites with information specifically about the LX5. However, there are several sites with good information about the predecessor model, the

246

Lumix DMC-LX3. I'm including references to some of them with the hope that they will continue on with updates covering the LX5.

I will include below a list of some of the sites or links I have found useful, with the caveat that some of them may not be accessible by the time you read this.

LX3 Photography

http://www.lx3-photography.com

This is an excellent site with many resources and information about the Lumix LX3, predecessor to the LX5. I expect it will have increasing information about the LX5.

Digital Photography Review

http://forums.dpreview.com/forums/forum.asp?forum=1033

This is the current web address for the "Panasonic Talk" forum within the dpreview.com site. Dpreview.com is one of the most established and authoritative sites for reviews, discussion forums, technical information, and other resources concerning digital cameras.

The Official Panasonic Site

http://www2.panasonic.com/consumer-electronics/support/Cameras-Camcorders/Digital-Cameras/Lumix-Digital-Cameras/model.DMC-LX5K

The Panasonic company provides resources on its web site, including the downloadable version of the user's manual for the LX5 and other technical information.

Guy Parsons' LX3 Site

http://homepages.ihug.com.au/~parsog/panasonic/05-links.
html#lx5

Guy Parsons is a well-known contributor to the "Panasonic Talk" forum on dpreview.com who has compiled an excellent collection of tips and information about the LX3, and has started to gather information about the newly released LX5. His web site offers a wealth of excellent ideas and links.

Leica Rumors

http://leicarumors.com/leica-d-lux-4/

The "Leica Rumors" site at this writing includes a page dedicated to the Leica D-Lux 4, the Leica version of the Panasonic Lumix DMC-LX3, which compiles information about accessories and other resources for that camera. I expect this site eventually will cover the D-Lux 5, the Leica version of the LX5.

Infrared Photography

http://www.wrotniak.net/photo/infrared/

This site provides helpful information about infrared photography with digital cameras.

Digiscoping

http://us.leica-camera.com/sport_optics/televid_spotting_
scopes/digiscoping/

http://leicabirding.blogspot.com/2009/06/digiscoping-yet-another-review.htm

These sites provide information about equipment and techniques for digiscoping with the Leica D-Lux 4 and Leica spotting scopes.

Kleptography

http://www.kleptography.com/rf/#camera_lx3

This site provides excellent information about some custom-made accessories for the LX3 and LX5, including hot shoe cover and cable release adapter.

Reviews of the LX5

Following are links to reviews of the LX5:

http://www.imaging-resource.com/PRODS/LX5/LX5A.HTM

http://www.stevehuffphoto.com/2010/09/28/the-leica-d-lux-5-review/

http://www.cameralabs.com/reviews/Panasonic_Lumix_DMC_LX5/index.shtml

My LX5

http://mylx5.com

This site, a new one as I write this, appears to be promising; it looks as if it will have a comprehensive set of articles, reviews, and other information about the LX5.

Index

Symbols

3D glasses 221
3D photography 221

A

AC adapter 19, 206, 207, 230, 231, 232
 Panasonic DMW-AC5PP 231
Adapter rings
 for connecting telescope to camera 226
AF/AE Lock button 53, 113, 116, 145, 146
 changing function of 116
 use with AF Tracking 113
AF/AE Lock setting 116
AF area
 adjustments on Quick Menu 144
AF Assist lamp 74, 126, 149
Afocal photography 225
AF Tracking 8, 52, 53, 74, 112, 113, 146, 151, 195
 limitations 113
Anabuilder software 222
Aperture Priority mode 56
 for Motion Picture recording 197
 procedure for using 59
 uses 57
Apertures
 availablity at various zoom settings 60
Aspect Bracket 134, 135, 148, 186, 212
Aspect ratio 16, 22, 28, 50, 52, 75, 76, 99, 105, 114, 125, 136,
 137, 166, 178, 202, 220, 227, 245
 relationship to Picture Size 99
Aspect ratio switch 9, 27, 136
 checking before shooting 244
Astrophotography 223
Audio recording
 with Motion Pictures 199

Audio-video cable 227
Auto Bracket 54, 110, 111, 133, 134, 135, 148, 186
Auto-exposure lock 146
Autofocus
 procedure 33
Autofocus lock 146
Autofocus macro 137, 211
Autofocus Mode 112
Autofocus modes
 1-Area 32, 114
 23-Area 113
 AF Tracking 113
 Face Detection 112
Autofocus switch 29, 31, 35, 137, 210, 211, 245
 checking before shooting 245
Auto ISO 104, 106, 148
Auto LCD Off 185
Auto Review 183, 185, 186
 automatic activation in certain modes 186
Auto White Balance 108
AVCHD Lite 42, 47, 160, 201, 206

B

Battery
 charging 20
 Panasonic DMW-BCJ13PP 19, 230
Battery charger 19
Blurred background 58
Bokeh 58
Bracketing
 aspect ratio 134
 exposure 133
 white balance 110
Brightness
 adjusting 89, 96
Built-in memory
 amount of 21
 copying contents to SD card 171
 formatting 191
 printing images from 169

251

recording to 25
storage capacity 22
Burst shooting 122, 241
advantages of 241
availability in Intelligent Auto mode 52
Flash Burst 77
general procedures 122
Hi-Speed Burst 76
in street photography 220
limitations 123
selecting with Quick Menu 144
using with self-timer 150
with Scene mode settings 76

C

Cable release 240
Cable release adapter 240
Camera case 229
Categories of images 156, 158, 160
Category play 160
Clock Set 9, 10, 26, 135, 173, 178
Closeup photography 210
Color
adjusting 89, 96
Color Effect setting 52
Color settings 243
Compression of image files 103
Connecting camera to computer 187, 188
Connecting camera to HDTV 188
Connecting camera to TV set 188, 227
Contrast
adjusting 94, 95, 96, 243
Conversion lens
menu setting for 133
Panasonic DMW-LWA52 235
Copying from built-in memory to SD card 171
Copying images to built-in memory 171
CowboyStudio flash trigger 239
Creative Motion Picture Mode 138, 144, 151, 175, 177, 195, 196, 197, 199, 200, 202, 208, 209

Creative photography 242
Cursor buttons 146
Custom Set Memory
 checking switches when using 245
 items that can be stored 177
 procedure for using 176

D

Date and time
 setting 26
DC Coupler 206, 207
 Panasonic DMW-DCC7 231
Deleting images 145, 152, 155, 161
Deleting multiple images 145
Demo Mode 192
Depth of field 57, 58, 211
Digiscoping 223
Digiscoping adapter 225
Digital Zoom 102, 124
 inability to set 93
Display button
 screens displayed in Playback mode 151
 screens displayed in Recording mode 151
 screens displayed when playing motion pictures 151
 uses of 150
Door
 memory card/battery 20
DPOF (Digital Print Order Format) 169

E

Exposure bracketing 133
 procedure for using 134
Exposure compensation 34, 37, 38, 39, 54, 55, 59, 64, 65, 141,
 178, 199, 244
 not available in Manual Exposure mode 65
 setting with rear dial 59, 141
Exposure Value (EV) 38
External flash units 41, 131, 214, 233, 237
 Metz Mecablitz 36 AF-4 131, 238
 Nikon SB-800 240

Olympus FL-36R 238
Panasonic DMW-FL220 131, 237
using with wireless triggers 239
Extra Optical Zoom 100
Eye-Fi card 21, 23, 24

F

Face Detection 112, 119, 131, 203
Face Recognition 52, 111, 112, 159, 165, 170, 178
Favorite play 161
Favorites 145, 148, 149, 155, 156, 159, 160, 161, 168, 169, 212
Film Mode settings
 Dynamic 96
 Dynamic BW 97
 Multi Film 98
 My Film 1 and 2 97
 Nature 96
 Nostalgic 97
 Smooth 97
 Smooth BW 97
 Standard 96
 Standard BW 97
 Vibrant 97
Filters 107, 108, 224, 234, 236
 infrared 217, 218
 neutral density 244
Firmware 190
 checking for updates 191
 updating 190
First curtain flash sync 129
Five-button array 46, 146, 150, 153, 158, 179
Flash
 built-in 39
 using 39
 diffusing 244
 external 41, 237
 Forced Off 41
 Forced On 215
 general considerations for using 214
 menu options 214

Metz Mecablitz 36 AF-40 238
Nikon SB-800 240
Olympus FL-36R 238
Panasonic DMS-FL360 238
Panasonic DMW-FL220 237, 239
Slow Sync with Red-eye Reduction 215
sync speed 215
wireless triggers 239
Flash Adjustment menu setting 130
Flash Burst 123
Flashing parts of images 183
Flash menu options 127
Flash options 41
Flash switch 29, 137
Flash Synchro setting 129
Fn button
 assigning a function to 242
 menu items that can be assigned to 148
Fn Button Set 10, 148, 178, 179
Focus
 choosing focus options 31
 off-center subject 33
Focus area
 changing size of 115
 moving around screen 115
Focus button 33, 37, 53, 113, 114, 115, 127, 132, 147, 151, 185,
 204, 220
 use to focus in manual focus mode 147
 use to play motion pictures 147
Focus point
 changing size 34
 moving 34
Focus range 211
Forced Flash Off 41, 128
Forced Flash On with Red-eye Reduction 128
Formatting a memory card 191
Formatting built-in memory 191
Franiec, Richard 240

G

"Grayed-out" menu items 93
Grid lines
 displaying 180

H

HDMI cable 188, 228
HDR 84, 85, 133
Hi-Speed Burst 123
Histogram 55, 151, 180, 181, 182, 183
 illustrations 182
Hot shoe 131, 239
Hoya R72 filter 218

I

Icons
 exposure compensation 39
 flash 40
 Intelligent Auto 40
 manual focus 35
 Program Shift 142
 writing to internal memory 25
 writing to SD card 24
I.Exposure (Intelligent Exposure) 119
Image numbers
 resetting 187
Image stabilization 125
 for Motion Picture recording 205
Infrared filter 218
Infrared photography 122
 "hot spots" 219
 information and procedures 217
 setting white balance for 218
Intelligent Auto mode 49, 51, 91
 for motion picture recording 42
 limitations 52
 using to take pictures 27
 using with flash 40
Intelligent Exposure 119
 and RAW quality 212
 inability to set 93

Intelligent Resolution 123
 in motion picture recording 205
Intelligent Zoom 9, 51, 102, 124, 125, 205
I.Resolution (Intelligent Resolution) 124
 in motion picture recording 205
ISO
 Auto ISO 106
 availability of RAW quality with high ISO 105
 general information 104
 high values, setting 243
 reduced resolution for high values 105
 settings 105
ISO button 148, 242
ISO Limit 106
I.Zoom. *See* Intelligent Zoom

J

JPEG files 103

K

Kata DW-491 waist pack 230
Kelvin measurement of color temperature 107

L

Language
 setting 26, 191
Latch
 battery compartment 20
LCD screen
 brightness 179
Leica D-Lux 4 15
Leica D-Lux 5 17
Lens adapter
 Panasonic DMW-LA6 133, 217, 226
Lens cap 18
 modified, automatic 19
Lens cap string 18
Lensmate company 235
Lens Resume 184

Linking focus area to spot metering area 118

M

Macro lens
 Raynox DCR-250 236
Macro photography 210
 uses for 242
Manual Exposure mode
 exposure scale on screen 67
 general information 65
 procedure for using 65
 using AF/AE Lock button with 146
Manual focus 31, 35, 37, 39, 50, 64, 65, 127, 147, 178, 198, 199,
 209, 223, 225
 adjusting with rear dial 39, 140
 and astrophotography 225
 and Lens Resume feature 184
 and macro photography 211
 and MF Assist feature 184
 and street photography 220
 procedure for using 35
 use of Focus button with 37
 using rear dial to adjust 59, 64
 while recording motion pictures 198, 199, 209
 zone focusing 245
Meade ETX-90/AT telescope 224
Memory card
 inserting 21, 24
 reader
 Sonnet 23
 SDHC (Secure Digital High-Capacity) 21
 SD (Secure Digital) 21
 SDXC (Secure Digital Extended Capacity) 21, 23, 27, 206, 207
 speed of 22
 storage capacity 22
Menu/Set Button 26, 32, 146
 general uses 150
Menu system
 navigating 93
 setting for returning to last screen viewed 189

Metering mode 116
 Center-weighted 116
 Multiple 116
 selecting 117
 Spot 116
Metz 15 MS-1 Ringlight 211
MF Assist 36, 184
Minimum Shutter Speed menu option 121
Minimum Shutter Speed setting 56
Mode dial 28, 30, 41, 49, 51, 54, 56, 58, 62, 65, 68, 79, 80, 91, 92, 95, 122
 use with Custom Set Memory feature 175, 176, 243, 245
 use with motion picture recording 80, 81, 194, 195, 196, 200
Mode play 160
Motion JPEG 42, 46, 160, 201, 202, 208
Motion Picture menu 199
 general information 199
Motion Picture menu items
 AF/AE Lock 204
 AF Assist Lamp 205
 AF Mode 203
 Continuous AF 204
 Conversion 205
 Digital Zoom 205
 Exposure Mode 202
 Film Mode 200
 Intelligent Zoom 205
 I.Resolution 205
 ISO Increments 203
 Metering Mode 204
 Recording Mode 201
 Recording Quality 201
 Sensitivity 203
 Stabilizer 205
 White Balance 203
 Wind Cut 206
Motion Picture recording
 recommended settings 208
Motion Pictures
 Aperture Priority mode 197

audio recording 199
autofocus 204
autofocus while recording 195
effect of Recording menu options 195
exposure compensation 199
manual focus 199
recording 193
Recording Time 206
shooting mode for recording 194
special aperture range 197
special range of shutter speeds 197
special shooting modes 196
using Creative Motion Picture mode for recording 196
Movie button 42, 43, 81, 138, 195, 199
Multiple Exposure menu option 120
My Color mode
and recording motion pictures 80
compared to Film Mode 95
effect of RAW quality setting 81
general information 79
procedure for using 80
My Color mode settings
Custom 89
Dynamic Art 86
Dynamic (B&W) 87
Elegant 83
Expressive 82
Film Grain 88
High Dynamic 84
Monochrome 84
Pin Hole 88
Pure 83
Retro 82
Silhouette 87

N

Neck strap 19
Neutral density filter 244
Noise reduction
adjusting 95

O

Optional Viewfinder menu option 132, 151
Overexposure
 flashing of image to indicate 183

P

Panasonic DMW-LVF1 133
Panasonic Lumix DMC-LX3 13, 15
Panasonic Lumix DMC-LX5
 contents of package 18
 documentation 17
 features lacking 16
 general attributes 15
 user's manual 18, 32, 41, 59, 70, 95, 98, 100, 102, 117, 129, 186,
 212, 229, 247
Panasonic VIERA HDTV
 connecting camera to 188
Panorama
 procedure for making 71
PhotoAcute software 133
PHOTOfunSTUDIO software 72
PhotoMatix software 133
Photoshop Elements software 72, 213, 219, 243
Photoshop software 52, 72, 84, 95, 121, 131, 133, 213, 219, 222,
 243
Picture Size 99
 distinguished from Quality 103
 relationship to aspect ratio 99
Playback
 general procedures 43, 153
 index view 44
 magnified image 45
 motion pictures 46
 viewing controls 46
Playback menu 149, 154, 155, 156, 159, 161, 162, 163, 165, 166,
 167, 168, 169, 170, 171, 172, 189
 general information 161
Playback menu items
 Calendar 162

Cropping 166
Favorite 168
Leveling 166
Print Set 169
Resize 165
Rotate display 167
Text Stamp 164
Title edit 162
Video divide 163
Playback mode 155
Category play 160
Favorite play 161
Mode play 161
Normal play 155
[Play] All 155
Slide show 155
starting camera in 186
Playback Mode menu 154, 155, 156, 159, 161
Play button 43, 140
use to turn on camera 187
Power save mode 140, 185
Power switch 26, 28, 128, 139, 140, 186
Pre AF 115
Program mode 30, 31, 37, 38, 41, 52, 54, 55, 56, 85, 92, 122, 123,
 141, 142, 215, 216
advantages 55
drawbacks 55
Program Shift 9, 55, 141, 142
Protect
Playback menu item 170
Purple lines
in Motion Pictures 207

Q

Quality 102
distinguished from Picture Size 103
Quick Menu 9, 143, 144, 150, 179, 190, 214, 241
additional adjustments for items 144
Quick Menu/Trash button 142
QuickTime software 47

Quick tips 241

R

RAW plus JPEG 103
RAW quality 52, 54, 103, 119, 133, 243
 and Dynamic BW setting 97
 availability with Scene mode 69
 benefits of 213
 drawbacks 213
 effect on Film Mode settings 95
 effect on other settings 93
 functions that do not work with 212
 general information 212
 in My Color mode 81
Rear-curtain flash sync 129
Rear dial 34, 35, 36, 37, 38, 39, 43, 44, 45, 59, 60, 62, 64, 65, 66,
 67, 115, 140, 141, 142, 144, 147, 153, 155, 162, 197, 199,
 203
 use for setting manual focus 64
 use for setting shutter speed 64
 use in Manual Exposure mode 65
 use in setting aperture 59
 use in setting exposure compensation 59
Recording menu options
 AF/AE Lock 116
 AF Assist Lamp 126
 AF Mode 112
 Auto Bracket 133
 Burst 122
 Conversion 133
 Digital Zoom 102, 124
 Extra Optical Zoom 100
 Face Recognition 111
 Film Mode 94
 Flash 127
 Flash Adjustment 130
 Intelligent Exposure 119
 Intelligent Resolution 124
 Intelligent Zoom 124
 ISO Increments 107

ISO Limit Set 106
Metering Mode 116
Minimum Shutter Speed 121
Multiple Exposure 120
Optional Viewfinder 132
Picture Size 99
Pre AF 115
Quality 102
Red-eye Removal 131
Stabilizer 125
White Balance 107
White Balance Bracket 110
Recording modes
 introduction 49
Red-eye Reduction 131
Red-eye Removal menu option 131
Resetting camera settings to defaults 187
Resolution 101, 102, 103, 105, 124, 136, 165, 167, 244
Ring flash 211
Rotate display
 Playback menu item 168

S

Saturation
 adjusting 89, 95, 96
Scene mode
 general information 67
 making selections of scene types 68
Scene mode settings
 Aerial Photo 79
 Baby 1 and Baby 2 73
 Beach 78
 Candle Light 73, 128
 Fireworks 78
 Flash Burst 77
 Food 73
 High Sensitivity 75
 Hi-Speed Burst 76
 Night Portrait 72
 Panorama Assist 71

Party 73, 128
Pet 74
Portrait 69
Scenery 70
Self-Portrait 70
Snow 79
Soft Skin 70
Sports 72
Starry Sky 77
Sunset 74
Second curtain flash sync 129
Self-timer
 how to operate 149
 in macro shooting 211
 use to avoid camera shake 244
 using burst mode with 150
Self-timer button
 use to operate self-timer 149
Self-timer lamp 149
Sensitivity (ISO)
 general information 104
Setup menu items
 Auto Review 185
 Beep 174
 Clock Set 173
 Custom Set Memory 175
 Demo Mode 192
 Display Size 180
 Economy 185
 Fn Button Set 179
 Format 191
 Guide Line 180
 HDMI Mode 188
 Highlight 183
 Histogram 181
 Language 191
 LCD Mode 179
 Lens Resume 184
 Manual Focus Resume 184
 Menu Resume 189

MF Assist 184
Number Reset 187
Play on LCD 185
Recording Area 183
Remaining Display 183
Reset 187
Scene Menu 189
Start Mode 186
Travel Date 174
TV Aspect 188
USB Mode 187
User's Name Recording 190
Version Display 190
VIERA Link 188
Volume 175
World Time 173
Sharpness
 adjusting 95
Shutter button 29, 30, 33, 34
 general information 138
 use to start and stop motion picture recording 199
 use with Multiple Exposure feature 120
Shutter Priority mode
 general information 61
 procedure for using 62
 range of available shutter speeds 122
 use in recording motion pictures 197, 198, 199
 use of rear dial in 64, 141
Shutter speed
 effect of different speeds 62
Shutter speeds
 availability 61, 63
 availability at various apertures 61
 display 63
 for Motion Picture recording 197
 table of fractions of second 64
SilkyPix software 213
Sleep mode 140, 185
Slow Sync flash setting 215
Spot metering 244

procedure for using 118
used with 1-Area AF 118
Step Zoom menu option 125
Stereo Photo Maker software 221
Street photography 219
settings for 96, 220, 242, 245
Sync speed for flash 215

T

Taking pictures
preliminary steps 50
Tamrac Digital 2 camera case 229
Telescope
connecting to camera 223
Three-dimensional photography 221
Trash function 145
Trimming videos 163
TV set
using as monitor for camera 228

U

USB cable 18, 23, 24, 188
using to connect camera to computer 188
User's manual 41
User's Name Recording 190

V

Version Display 190
Video divide menu item 163
Videos
editing 163
Viewfinder
electronic 185
Panasonic DMW-FVF-1 optical 133
Panasonic DMW-LVF1 133, 185

W

White balance
adjustments on Quick Menu 144

and RAW quality 110
Auto White Balance 108
custom setting 109
fine adjustments 109
general information 107
setting by color temperature 109
settings 108
White Balance Bracket 110
Wide-angle add-on lens 235
Wi-Fi network 23
Wireless triggers for flash 239
Wrist strap 19

Z

Zhumell digiscoping adapter 225
Zone focusing 245
Zoom lever 29, 44, 45, 60, 93, 101, 125, 139, 151, 166, 168, 175,
 211, 234, 235, 242, 245
use for moving quickly through menus 93
use to control movie audio volume 151

LaVergne, TN USA
28 January 2011
214415LV00001B